Paintings from
The Frick Collection

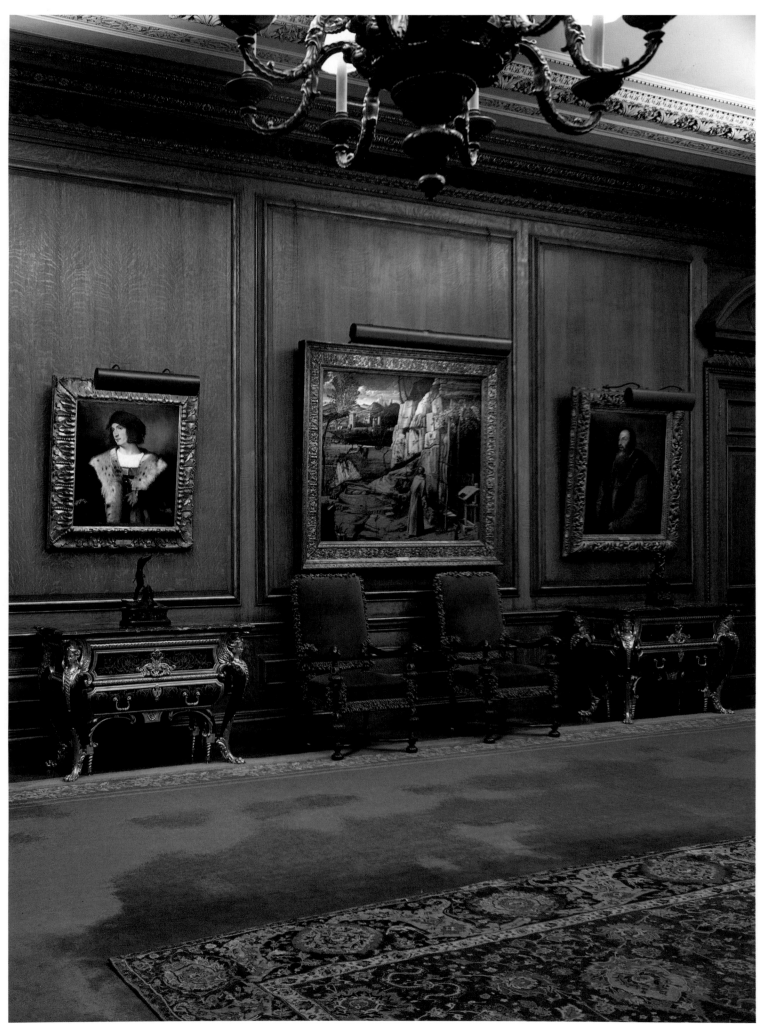

LIVING HALL • THE FRICK COLLECTION

Paintings from
The Frick Collection

Introduction by Charles Ryskamp
Text by Bernice Davidson, Edgar Munhall, and Nadia Tscherny

Harry N. Abrams, Inc., Publishers, New York
in association with
The Frick Collection

Photographs by Richard di Liberto
Editor: Joseph Focarino (The Frick Collection)
Production Editor: Sheila Franklin Lieber (Harry N. Abrams, Inc.)
Designers: Samuel N. Antupit and Doris Leath Strugatz

Library of Congress Cataloging-in-Publication Data

Frick Collection.
 Paintings from the Frick Collection/introduction by Charles
 Ryskamp; text by Bernice Davidson, Edgar Munhall, and Nadia
 Tscherny.
 p. cm.
 Includes bibliographical references.
 ISBN 0–8109–3710–7. — ISBN 0–8109–2461–7 (pbk.)
 1. Painting—New York (N.Y.)—Catalogs. 2. Frick Collection—
 Catalogs. I. Davidson, Bernice F. II. Munhall, Edgar.
 III. Tscherny, Nadia. IV. Title.
 N620.F6A87 1990
 750'.74'7471—dc20 90–386
 CIP

Published in 1990 by Harry N. Abrams, Incorporated, New York
A Times Mirror Company

Printed and bound in Japan

On the cover: Giovanni Bellini. Detail from *St. Francis in the
Desert*. c. 1480. Tempera and oil on panel.

TABLE OF CONTENTS

INTRODUCTION

Although The Frick Collection contains sculpture, furniture, enamels, porcelains, and rugs of the highest quality, it is best known to the public for its paintings. "Painting for painting," a distinguished art historian has recently written, "the Frick Collection is quite simply the greatest in the world. Hardly a single work in this dazzling array of Old Master paintings can be considered less than a masterpiece." The paintings chosen from the Collection for this book consist of about nine-tenths of those displayed in the public rooms of what was once the New York home of Mr. and Mrs. Henry Clay Frick.

Mr. Frick (1849–1919), who was a pioneer in developing the coke and steel industry of Pittsburgh, came from a rural community in southwestern Pennsylvania, and there is nothing in his background or in his brief formal education to account for his keen interest in art, which was already commented on when he was in his early twenties. At that time he could have had few opportunities to see pictures of any kind in the Pittsburgh area, except, perhaps, for the work of local artists; it is most likely that his knowledge of art was acquired from reproductions in books and from engravings. He took his first trip abroad at the age of thirty, after having already made at least a million dollars as a major supplier of coke to steel mills in Pittsburgh. For several months he traveled through Europe with three friends—among them Andrew Mellon—and this trip no doubt helped to lay the foundation of collecting that resulted both in The Frick Collection and in The National Gallery of Art.

Shortly thereafter Mr. Frick began to buy pictures. In 1881 he married Adelaide Howard Childs, and in the next decade they established themselves at their house, Clayton, in Pittsburgh. His fortune grew rapidly, and in 1889 he became especially involved in the steel industry as Chairman of the Board of Carnegie Brothers; but he is not known to have acquired many paintings in those years. In the five years from 1895 to 1900, however, he bought an average of two pictures a month. These were for the most part contemporary works, principally by French painters. The earliest acquisition (1896) to remain in The Frick Collection is *The Washerwomen* by Daubigny; Corot's *Ville-d'Avray*, bought in 1898, is the earliest one to be seen regularly in the galleries today.

After 1900 Mr. Frick turned more to English eighteenth-century portraits and the Dutch seventeenth century; he also bought paintings by Turner and Monet. He added several important works: *Antwerp: Van Goyen Looking Out for a Subject* by Turner; *Girl Interrupted at Her Music* by Vermeer; *Village among Trees* by Hobbema; and *The Village of Becquigny* by Rousseau. Essential qualities of The Frick Collection were therefore established by the founder soon after the turn of the century, but the great paintings did not begin to come into the collection until 1905.

In that year he purchased his first Van Dyck, his first Italian Renaissance picture—the portrait of Pietro Aretino by Titian—Cuyp's *Dordrecht: Sunrise*, and El Greco's *St. Jerome*. In the autumn of 1905, he and Mrs. Frick rented the former Vanderbilt residence at 640 Fifth Avenue, New York, where they lived for the next nine years. It had a large picture gallery in which they could show their rapidly expanding collection.

During the following year true masterpieces were acquired, like the monumental self-portrait by Rembrandt, enthroned as if he were an Oriental monarch, and the very large Corot of *The Lake*, painted in 1861. In 1908 Mr. Frick obtained what is probably the most beautiful of several paintings Constable made of the south façade of Salisbury Cathedral. And in the next years, 1909–11, he continued to buy a number of works of the finest quality. The portraits of Frans Snyders and his wife by Van Dyck, El Greco's *Purification of the Temple*, and Turner's *Mortlake Terrace: Early Summer Morning* were all acquired in 1909. Two portraits by Hals and Rembrandt's *Polish Rider* came in 1910. And in 1911, Mr. Frick purchased the marvelous portrait by Velázquez of King Philip IV of Spain, in the silver-and-rose costume he wore in his important campaign and victory over the French at Fraga in 1644. There was also Vermeer's radiant painting of an *Officer and Laughing Girl*, as well as works by Gainsborough, Hobbema, Raeburn, and Romney. Dutch seventeenth-century and English eighteenth- and early nineteenth-century paintings therefore continued to dominate Mr. Frick's collecting.

After that there was a far greater range in school and period among the paintings he was able to find and which he wished to add to his collection. The years 1912–13 brought, first of all, such world-famous paintings as Holbein's portrait of Sir Thomas More and the two large allegories by Veronese—those of *Wisdom and Strength* and *Virtue and Vice (The Choice of Hercules)*. Then there were Van Dyck's huge portrait of the seventh Earl of Derby with his lady and child and El Greco's portrait of Vincenzo Anastagi, which probably dates from the painter's last years in Italy (c. 1571–76). In 1914 we find a scarcely credible number and range of works: celebrated portraits like Van Dyck's *Paola Adorno*, Hogarth's *Miss Mary Edwards*, Gainsborough's *Lady Innes*, and two portraits by Goya and two by Whistler; also Renoir's *Mother and Children*, Goya's extraordinary painting of *The Forge*, the two enormous views of Cologne and Dieppe by Turner, Manet's *Bullfight*, Degas' *Rehearsal*, Whistler's *Ocean*, and Maris' *Bridge*. Outstanding works of Impressionism were therefore bought at the same time as one of the finest examples of the Hague School. At other times, distinguished pictures of the Barbizon School were added in the same year that Mr. Frick bought avant-garde Impressionist paintings. The acquisitions of *The Forge*, *The Ocean*, and *The Bullfight* were also certainly daring ones for their time.

The year that followed was even more amazing: *The Progress of Love*, the series of masterpieces of Fragonard, which had been in J. Pierpont Morgan's house in London; Gerard David's large painting on canvas of *The Deposition*; Bellini's *St. Francis in the Desert*; Titian's *Portrait of a Man in a Red Cap*; and Bronzino's portrait of Lodovico Capponi. These were all bought in one year, along with paintings by Holbein and Hoppner, superb bronzes and other sculptures, etchings, drawings, and some of the very best French furniture, clocks, and porcelain. The death of Mr. Morgan and the dispersal of part of his vast collections made many of these acquisitions possible, and the war made it difficult, if not impossible, for many in Europe to buy works of art. But few collectors or museums at any time in history have added so many masterpieces within such a very few months.

The house to hold all of these treasures, at Seventieth Street and Fifth Avenue, now The Frick Collection, was constructed in 1913–14 on the former site of the Lenox Library. It was designed by Thomas Hastings of the firm of Carrère and Hastings, who were also the architects of the building for The New York Public Library at Forty-second Street and Fifth Avenue. The Fricks' house was planned as a setting for the collection of paintings (which was enlarged all through World War I) and, eventually, as a public gallery. The idea of giving it to the public had been inspired by an early visit to the Wallace Collection in London.

The panels by Boucher showing *The Arts and Sciences*, which according to tradition were painted for Madame de Pompadour's Château de Crécy, were bought by Mr. Frick in 1916 and were then installed to decorate Mrs. Frick's boudoir on the second-floor corner (Seventieth Street and Fifth Avenue) of the house. It was not until the house was converted to a public museum that these paintings were brought down to their present location near the entrance to the Collection.

In 1916, Mr. Frick also bought one of Gainsborough's greatest paintings, *The Mall in St. James's Park*. During the years 1917 to 1919, outstanding portraits by Hals, Van Dyck, Gainsborough, Gilbert Stuart, and Whistler came to the Collection, as well as the very beautiful oil sketch by Tiepolo for a ceiling fresco in the Palazzo Archinto, Milan. Mr. Frick's last acquisition, Vermeer's *Mistress and Maid*, left unfinished when the artist died, was the only one recorded for 1919, the year of his own death. In these final years he had also bought superlative Renaissance bronzes and other sculpture, Limoges enamels, porcelains, furniture, and a few drawings and prints. The paintings were therefore shown in a setting of elegance and distinction, comparable to the remarkable standard of the paintings, which eventually ranged in date from the early fourteenth to the end of the nineteenth century.

After his death, Mr. Frick bequeathed in trust his residence and works of art to establish a gallery for the purpose of "encouraging and developing the study of the fine arts," to be known as The Frick Collection, "for the use and benefit of all persons whomsoever." In addition he left an endowment, the income from which was to maintain the Collection and, in an unusual provision, to provide funds for acquisitions of works of art. Although Mrs. Frick lived in the house until her death in 1931, the Trustees continued to add to the Collection, through purchase on the endowment or by gift and bequest. It had been Mr. Frick's custom to keep paintings under consideration in the house for several months before he made his final decision about them, and the sure and serene harmony of the whole Collection today undoubtedly results from his careful reflective discernment. A similar judgment is evident on the part of the Trustees and staff, who after his death were determined to maintain the quality of the Collection and to respect Mr. Frick's taste. As a consequence, early and late acquisitions appear to form a seamless whole.

Before the museum opened to the public on December 16, 1935, various architectural changes— including two galleries for paintings—were made by John Russell Pope, who later designed The National Gallery. Subsequent expansion to meet the needs of a larger public and to provide a new garden on Seventieth Street was completed in 1977.

No painting was added in the first four years after Mr. Frick's death. In 1924 Fra Filippo Lippi's *Annunciation* was purchased. Notable acquisitions in following years included paintings by Duccio and by Ingres in 1927, one by Veneziano in 1930, and the large figure of a saint by Piero della Francesca in 1936. The portraits of Madame Boucher by Boucher and of Comtesse Daru by David came in 1937, and Monet's *Vétheuil in Winter* in the following year. The year 1943 was especially remarkable: among the acquisitions were *The White Horse* by Constable, *The Wool Winder* by Greuze, *General John Burgoyne* by Reynolds, *Nicolaes Ruts* by Rembrandt, and *Don Pedro, Duque de Osuna* by Goya, as well as the glorious sculpture of an angel by Jean Barbet. During the years 1945 to 1949, the Chardin still life, two more portraits by Gainsborough, *The Education of the Virgin* by La Tour, and Ruisdael's *Landscape with a Footbridge* were purchased. In 1954 the painting by Van Eyck came into the Collection, and the great landscape with the Sermon on the Mount by Claude was bought in 1960. A year later the Rockefeller bequest brought the small *Crucifixion* by Piero della Francesca as well as the two notable portrait busts by Laurana and Verrocchio. In 1965 we acquired the painting by Pieter Bruegel the Elder, the next year those by Drouais and Gentile da Fabriano, and in 1968 the *Portrait of a Man* by Memling. The only other important painting added after that time was in 1981, the *Pietà* from the circle of Konrad Witz, the gift of Miss Helen C. Frick.

It is worth going into such detail about the history of the acquisitions of the paintings because, contrary to widely held public opinion, The Frick Collection is not static; it has grown in a very important way during the years since Mr. Frick's death in 1919. The paintings have been frequently moved, in Mr. Frick's lifetime and afterwards. The frontispiece to this volume shows one of the few places where the installation remains as it was when Mr. and Mrs. Frick lived here. The paintings and furniture of the Living Hall—with the celebrated works by Bellini, Titian, Holbein, and El Greco—are unchanged; only some of the bronzes have been moved from time to time.

Another myth about The Frick Collection concerns the influence of Joseph Duveen in shaping the museum. It was not until 1910 that Mr. Frick began dealing with him. Throughout his life, Mr. Frick remained close to the firm of M. Knoedler and Co., and he most frequently purchased paintings from that gallery. The stories about Lord Duveen and Mr. Frick are for the most part severely slanted or simply untrue. Duveen, however, did play a major role in the acquisition of the bronzes, furniture, enamels, and porcelain from the Morgan collection, as well as the purchases of the series of panels which today constitute the rooms devoted to Fragonard and Boucher. Mr. Frick bought from many dealers and galleries, and occasionally from owners of pictures directly. But it was his own taste that shaped the museum; it set the standard and it has created the boundaries of our collecting in the seventy years since his death.

Charles Ryskamp
Director

DUCCIO DI BUONINSEGNA

c. 1255–1319

Although Duccio was the leading Sienese master of his time, little is known about his life. The earliest record of the artist dates from 1278. In 1285 he received the commission for a painting believed to be the Rucellai Madonna *now in the Uffizi. His greatest work, however, is the* Maestà, *a large altarpiece first mentioned in a document of 1308 and finished by June 9, 1311, when it was carried triumphantly through the city streets to the Duomo of Siena.*

THE TEMPTATION OF CHRIST ON THE MOUNTAIN

Painted between 1308 and 1311. Tempera on panel
17 × 18 1/8 in. (43.2 × 46 cm.)
Acquired in 1927

The Temptation of Christ is one of a series of panels illustrating the life of Christ painted for the *Maestà,* a huge double-sided altarpiece commissioned for the high altar of Siena Cathedral. The importance of this monumental work for the history of Sienese painting can scarcely be exaggerated. The front of the complex altarpiece, now in the Museo dell'Opera del Duomo, Siena, consists of an enthroned Madonna and Child flanked by orderly rows of saints and angels, with half-length figures of Apostles above them and pinnacle scenes depicting the death and glorification of the Virgin; below is a predella narrating events from the birth and infancy of Christ. On the back of the altar were other small panels illustrating the life and Passion of Christ. For two hundred years Duccio's *Maestà* remained in its post of honor, influencing generations of artists in Siena, but thereafter it suffered a series of vicissitudes, and eventually partial dismemberment. Although more than fifty panels have survived, most of them in Siena, several of the smaller panels have been dispersed or lost.

The original arrangement of the panels on the altarpiece and the question of what part assistants played in executing this radically innovative work are problems that may never be resolved. But Duccio himself must have been the guiding genius who designed the novel range of settings and compositions and who infused the familiar subjects with new drama and emotion.

In the Frick panel, a majestically towering Christ is shown rejecting the devil, who offers Him "all the kingdoms of the world" if Christ will worship him (Matthew 4:8–11). Duccio retains medieval conventions in depicting the figures as large and the spurned kingdoms as small, thus suggesting a scale of values rather than naturalistic proportions. Yet the story is presented in terms that are immediately meaningful. Christ expresses a sorrowful solemnity, and the cities in the foreground—packed with turrets, domes, and crenellations—vividly evoke the festive colors and crowded hill-sites of Siena.

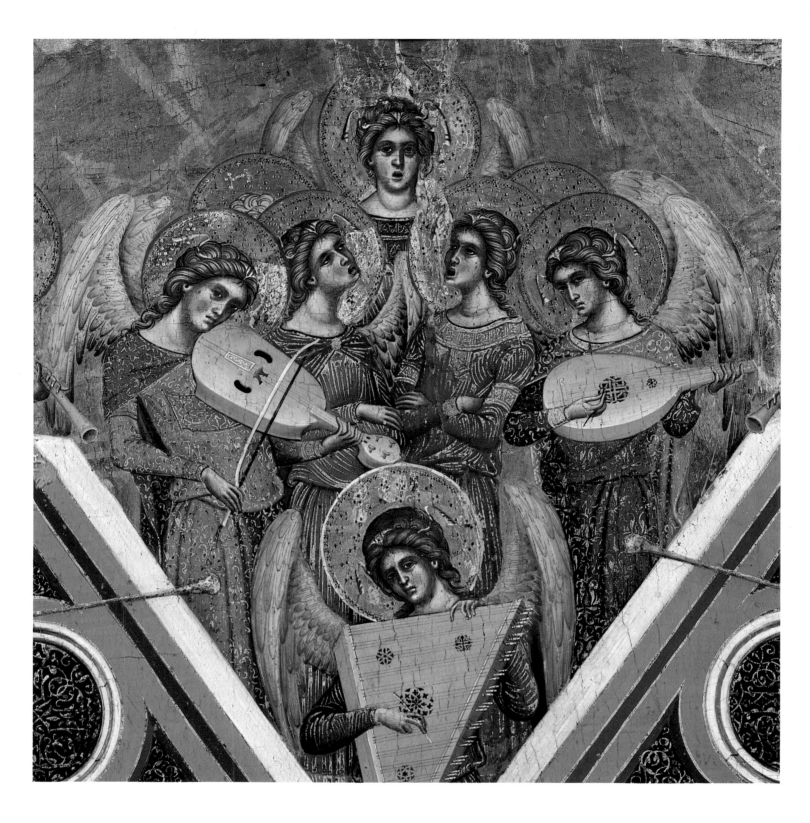

PAOLO AND GIOVANNI VENEZIANO
Paolo active 1321–1358

Paolo Veneziano is considered the leading figure of Venetian trecento painting. Among his most important works is the painted cover for the Pala d'Oro in S. Marco, Venice (signed with his sons Luca and Giovanni and dated 1345). The 1358 Coronation of the Virgin in The Frick Collection is Paolo's last dated work. In addition to his brother Marco and his sons Luca and Giovanni, several other artists were trained in his influential workshop.

THE CORONATION OF THE VIRGIN

Dated 1358. Tempera on panel
43 1/4 × 27 in. (110 × 68.5 cm.)
Acquired in 1930

The Coronation of the Virgin is recounted not in the New Testament but in the apocryphal story of the Virgin's death. In many Coronation scenes painted by Paolo and other Venetian artists a sun and a moon accompany the principal figures, the sun from early times being associated with Christ and the moon with the

Virgin. The angels singing and playing musical instruments in the Frick panel symbolize the harmony of the universe; their instruments are the authentic components of a medieval orchestra, accurately depicted and correctly held and played. The inscription along the base of the throne is drawn from the Eastertide antiphon *Regina coeli*. The decorative sparkle of the surface—with its brilliant, expensive colors, patterned textiles, and lavish gold leaf—reflects the Venetians' love of luxury, a taste that enriches as well much of fourteenth- and fifteenth-century architecture in Venice.

GENTILE DA FABRIANO

c. 1370–1427

Gentile was born in Fabriano, near Urbino. Nothing is known of his youth or education, which may have been as peripatetic as his subsequent career. He is first recorded in 1408 in Venice, and he also worked in Brescia and probably in other North Italian towns. About 1420 he moved to Tuscany, receiving important commissions from churches and great families of Siena, Florence, and Orvieto. By 1427 he had left for Rome, where he worked for Pope Martin V and members of the papal court.

MADONNA AND CHILD, WITH STS. LAWRENCE AND JULIAN

Painted c. 1423–25. Tempera on panel
35 3/4 × 18 1/2 in. (90.8 × 47 cm.)
Acquired in 1966

This small but richly painted altarpiece was designed perhaps for some private family chapel. It must be close in date to Gentile's best-known work, the *Adoration of the Magi* of 1423, now in the Uffizi. Like the *Adoration*, this panel, with its lyrical linear patterns and elegantly ornamented surface, perpetuates late Gothic traditions, most obviously in the gentle, graceful figures of the Madonna and Child. The adoring saints, however, seem more advanced than work of the same date by Gentile's Florentine contemporaries; the portrait-like heads and solidly modeled bodies are strikingly natural and eloquent. St. Lawrence, the third-century Roman deacon, kneels at left beside the grid on which he was burned alive. At right is St. Julian the Hospitaler, who built a refuge for travelers in penance for unwittingly murdering his parents.

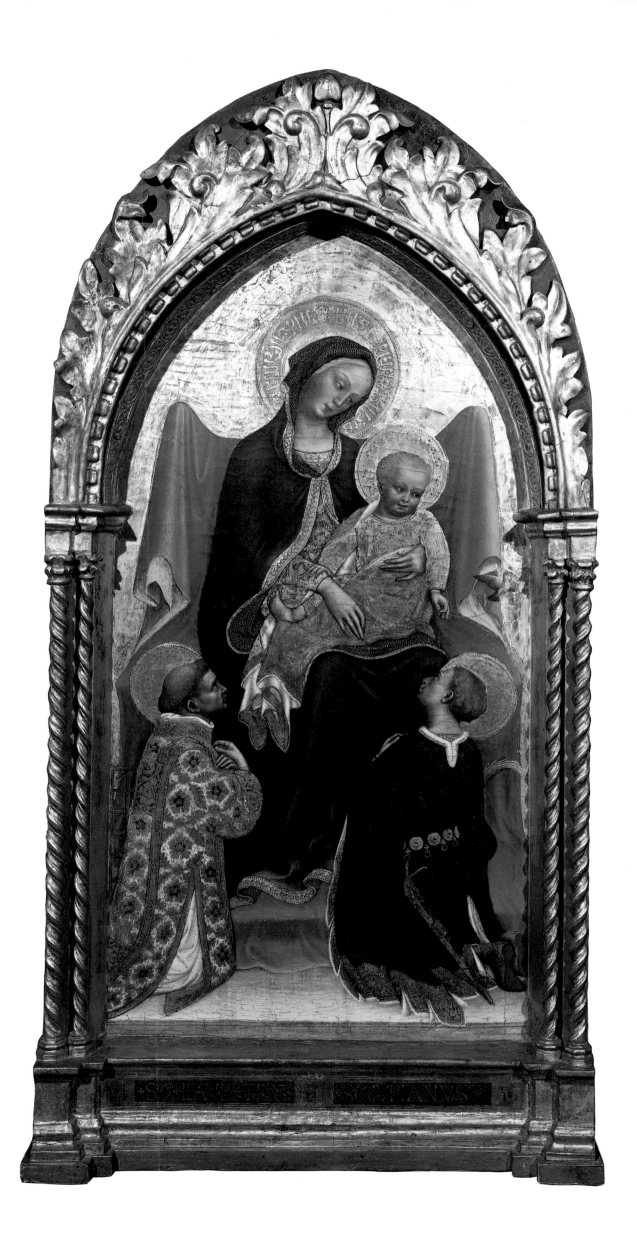

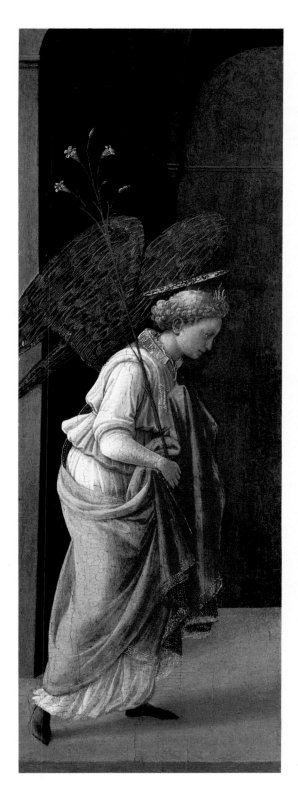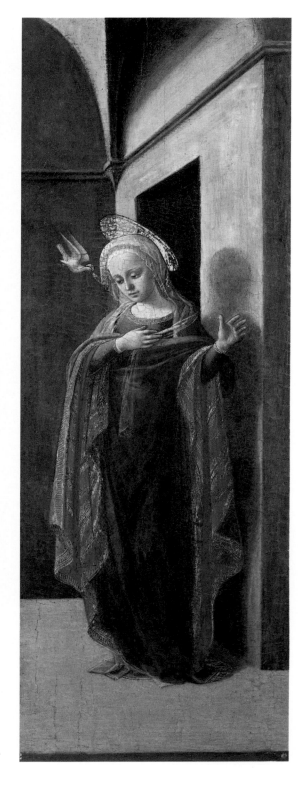

FRA FILIPPO LIPPI

c. 1406–1469

Florentine by birth, Fra Filippo took the vows of a Carmelite monk at about the age of fifteen. He was in Padua in 1434, but three years later he returned to Florence, where he was employed by the Medici and other prominent families. In 1452 he was invited to execute the choir frescoes for the Duomo in Prato. His last two years were spent in Spoleto painting frescoes in the Cathedral. Fra Filippo's son, Filippino, also became a noted painter.

THE ANNUNCIATION

Painted c. 1440. Tempera on panel
Left panel: 25 1/8 × 9 7/8 in. (63.8 × 25.1 cm.);
right panel: 25 1/8 × 10 in. (63.8 × 25.4 cm.)
Acquired in 1924

The two panels that compose the Frick painting, now framed together, probably originally formed the wings of a small altarpiece of which the central panel has been lost. Around the middle of the fifteenth century, the subject of the Annunciation had become exceedingly popular in the art of Florence. Fra Filippo, who often depicted the scene, usually placed the figures in elegant and complicated architectural settings, made festive with birds, flowering plants, and sunny landscapes seen in the distant background. The setting of the Frick *Annunciation* is instead bare and simple, painted in muted terracotta, violet, and gray, with nothing to distract the viewer from the gentle drama being enacted. The lily carried by the angel Gabriel symbolizes the Virgin's purity, while the dove represents the angel's words to her: "The Holy Ghost shall come upon thee."

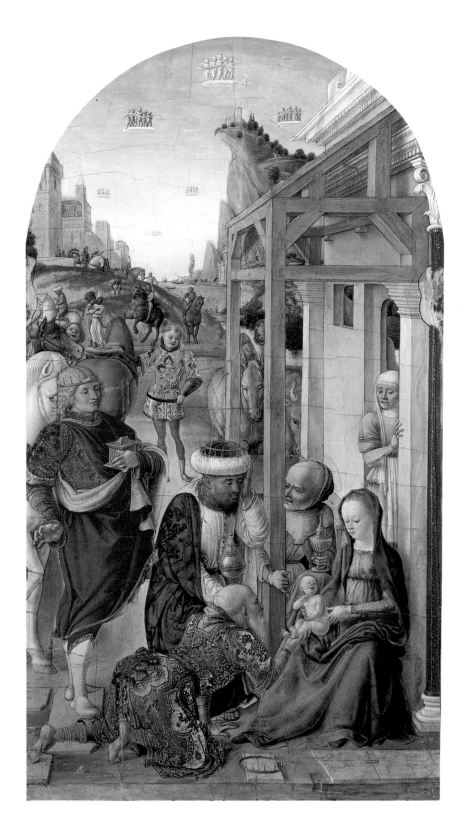

LAZZARO BASTIANI
d. 1512

Bastiani was born in Venice and achieved considerable prominence there. His rather conservative style is related to that of the Vivarini and to the work of Jacopo and Gentile Bellini, his better-known compatriots.

THE ADORATION OF THE MAGI

Painted probably between 1470 and 1480.
Tempera on panel
20 1/2 × 11 in. (52 × 28 cm.)
Acquired in 1935

During the fourteenth and fifteenth centuries the journey of the Magi to Bethlehem was commemorated by colorful processions with stops along the way to re-enact highlights of the voyage. Bastiani depicts the Adoration as though it were such a pageant, in which lavishly costumed performers and their exotic beasts wind through the landscape. The climax of the narrative takes place before the stable as the three kings, bearing gifts, pay homage to the King of Kings. St. Joseph, peering around the wooden support of the porch, has already taken custody of one precious vessel. The extravagant

textiles worn by the kings and their entourage suggest their Eastern origins. Above, angels hover on cloud platforms, red seraphim and blue cherubim prominent among them.

The Frick *Adoration* combines conservative with progressive features. The complexities of the landscape, the classical elements of the architecture, and the painstaking perspective construction of the painting suggest that Bastiani may have been influenced by the advanced ideas of Mantegna and Jacopo Bellini, while at the same time he retained the ornamental richness of late Gothic traditions.

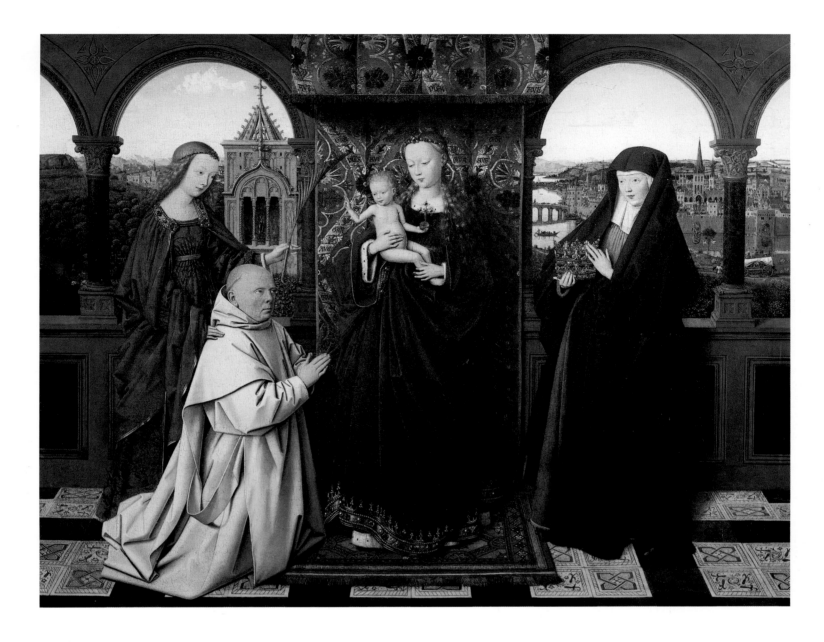

JAN VAN EYCK
active 1422–1441

Born probably at Maaseyck in the province of Limburg, Jan van Eyck is first recorded in 1422 working at The Hague for John of Bavaria, the Count of Holland. In 1425 he was named court painter and "valet de chambre" to Philip the Good, Duke of Burgundy, for whom he also undertook frequent diplomatic missions. Most of his datable paintings were executed during the 1430s in Bruges, where he spent the last decade or so of his life.

VIRGIN AND CHILD, WITH SAINTS AND DONOR

Painted c. 1441. Oil on panel
18 5/8 × 24 1/8 in. (47.3 × 61.3 cm.)
Acquired in 1954

The Virgin, holding the Child, stands in majesty on an Oriental carpet, enframed by a sumptuous brocade canopy and hanging inscribed AVE GRA[TIA] PLE[N]A (Hail [Mary] full of grace). She is attended by St. Barbara, with her attribute of the tower in which she was imprisoned rising behind her, St. Elizabeth of Hungary, who gave up her crown to become a nun, and a kneeling Carthusian monk. As yet no clear explanation has been found for the presence of the two saints. Elizabeth may have been included because she was the patron saint of Isabella of Portugal, the Duchess of Burgundy, who apparently made donations to Carthusian monasteries throughout the Netherlands and Switzerland. Barbara was protectress against sudden death and, among other roles, patron saint of soldiers, which may explain the statue of Mars visible in a window of her tower. She appears here as sponsor for the donor, and it is possible that both saints had some particular association with his monastery.

The Carthusian monk has been identified as Jan Vos (d. 1462), Prior of the Charterhouse of Genadedal—or Val-de-Grâce—near Bruges, and a well-known figure in fifteenth-century monastic life in the Netherlands. He held various important posts in Carthusian houses before his appointment to Genadedal in 1441,

the year of Jan van Eyck's death. Documents relate that the Frick painting was ordered as a "pious memorial of Dom Jan Vos, Prior of the Monastery," and that it was dedicated on September 3, 1443. Most scholars consider this one of Van Eyck's last paintings, begun by him in 1441 but completed after his death in his shop, possibly with the aid of Petrus Christus (d. 1472/73), who also worked in Bruges and who himself painted a portrait of the same donor, Jan Vos.

Many attempts have been made to identify the walled town beside the river at right. Such diverse cities as Maastricht, Prague, Lyon, Liège, and Brussels have been proposed. It has also been suggested that the large church to the right of St. Elizabeth represents old St. Paul's Cathedral in London. But despite the remarkably vivid details, the view appears to be imaginary.

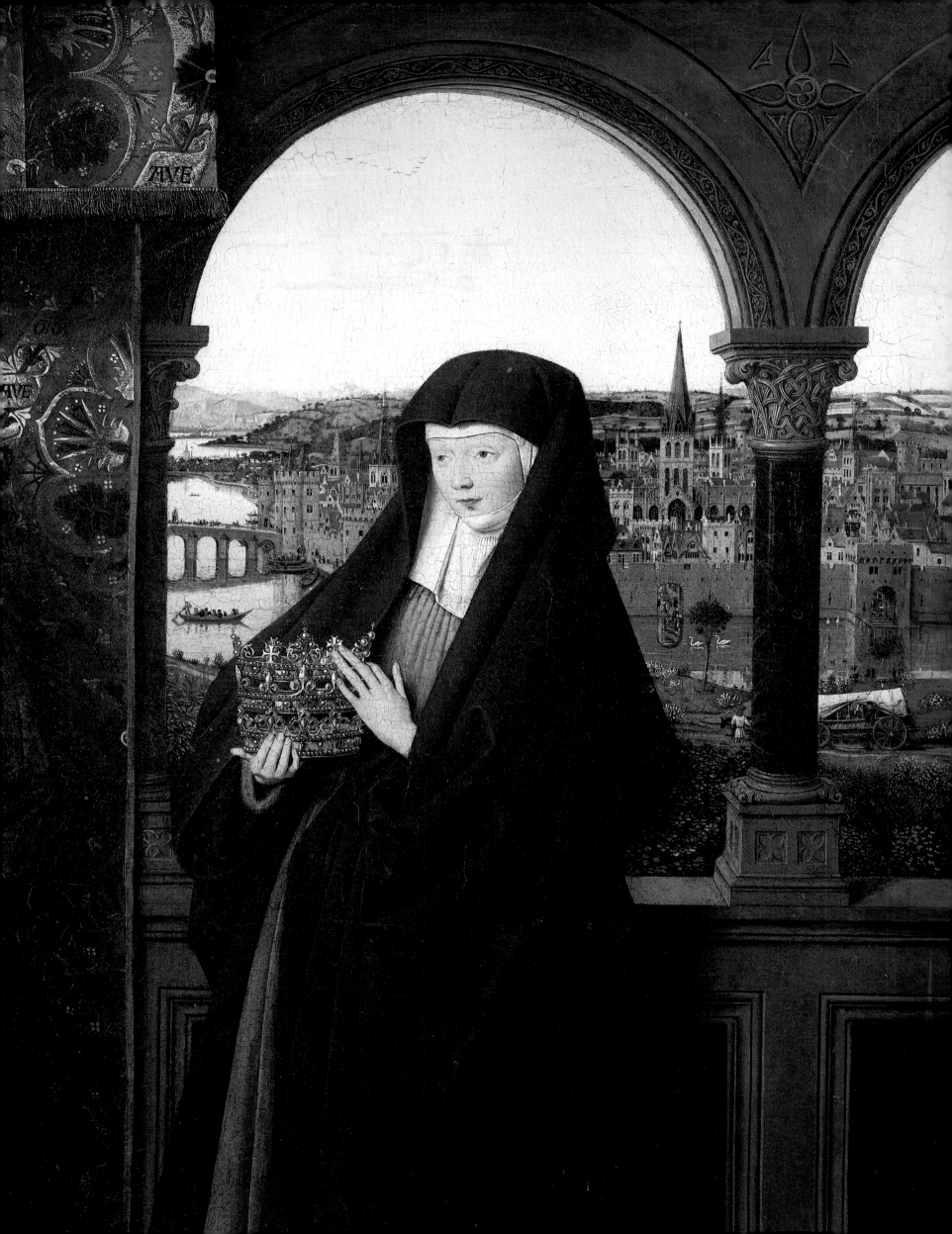

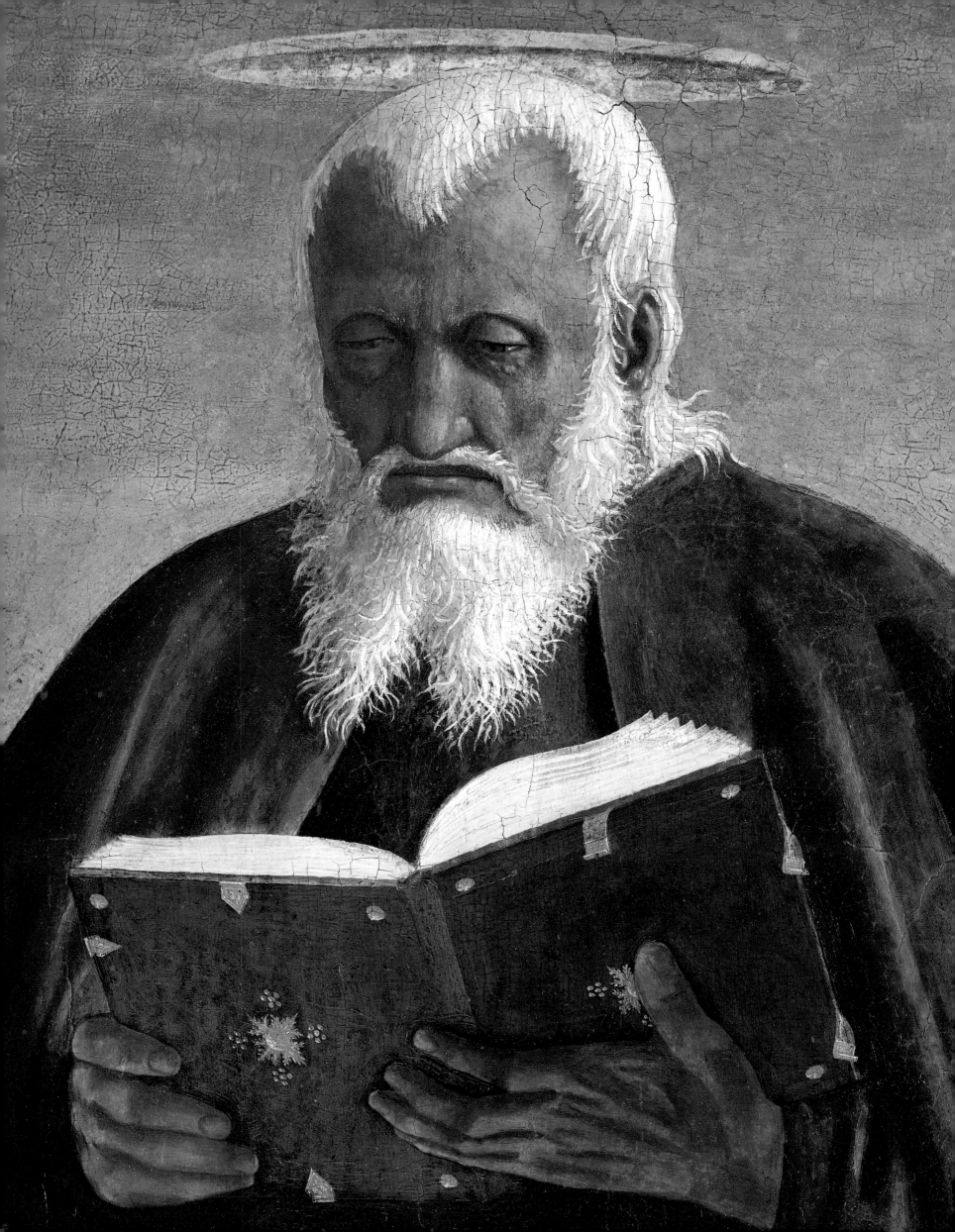

PIERO DELLA FRANCESCA

1410/20–1492

Born in the Tuscan town of Borgo Sansepolcro, Piero is first recorded in 1439 assisting Domenico Veneziano in Florence. He also worked in his birthplace and in Ferrara, Rimini, Rome, Urbino, and elsewhere. Piero's best-known paintings form the celebrated fresco cycle depicting the Legend of the True Cross in the church of S. Francesco at Arezzo. In addition to frescoes and altarpieces, Piero painted a number of portraits.

ST. SIMON THE APOSTLE (?)

Painted between 1454 and 1469. Tempera on panel
52 3/4 × 24 1/2 in. (134 × 62.2 cm.)
Acquired in 1936

In 1454 Angelo di Giovanni di Simone d'Angelo ordered from Piero a polyptych for the high altar of S. Agostino in Borgo Sansepolcro. The commission specified that this work, undertaken to fulfill the wish of Angelo's late brother Simone and the latter's wife Giovanna for the spiritual benefit of the donors and their forebears, was to consist of several panels with "images, figures, pictures, and ornaments." The central portion of the altarpiece is lost, but four lateral panels with standing saints—St. Michael the Archangel (National Gallery, London), St. Augustine (Museu Nacional de Arte Antiga, Lisbon), St. Nicholas of Tolentino (Museo Poldi-Pezzoli, Milan), and the present panel—have survived. Although the venerable figure in the Frick painting was given no identifying attributes, he is presumed to represent either St. Simon, patron saint of the deceased brother Simone, or possibly St. John the Evangelist, patron of the donors' father and of Simone's wife.

Evidence from a payment made to Piero in 1469 suggests that the altarpiece was finished late that year, fifteen years after the original contract. The lengthy delay resulted no doubt from Piero's many other commitments during this period, when he traveled to towns all across Central Italy and contracted obligations to patrons more important—and more exigent—than the family of Angelo di Giovanni and the Augustinian monks of his own small town, Borgo Sansepolcro. But it is obvious as well from the character of his art that Piero was not a quick or facile painter. His deep interest in the theoretical study of perspective and geometry and his pondered, contemplative approach to his paintings are apparent in all his work, including the panels of the S. Agostino altarpiece.

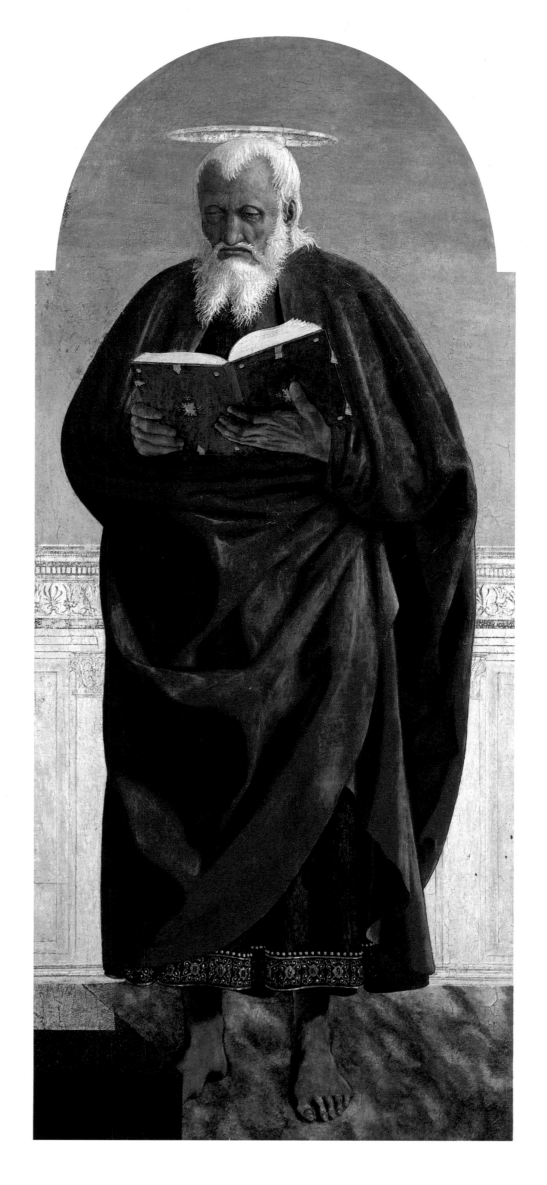

PIERO DELLA FRANCESCA

AUGUSTINIAN MONK

Date unknown. Tempera on panel
15 3/4 × 11 1/8 in. (40 × 28.2 cm.)
Acquired in 1950

AUGUSTINIAN NUN

Date unknown. Tempera on panel
15 1/4 × 11 in. (38.7 × 27.9 cm.)
Acquired in 1950

These two small panels probably belonged to a set of four recorded in the nineteenth century in the Franceschi-Marini collection at Borgo Sansepolcro. A *St. Apollonia* now in the National Gallery, Washington, is presumed to be another from this series; a fourth panel, of an unidentified saint, was cited in the same inventory but has since disappeared. All are believed to have formed subsidiary parts of Piero's S. Agostino altarpiece (see preceding entry).

While the subjects of the Frick panels wear Augustinian habits, they lack distinctive attributes. It has been suggested that they may represent the Blessed Angelo Scarpetti, the most revered local Augustinian monk, who was buried beneath the high altar of S. Agostino, and St. Monica, mother of St. Augustine and putative founder of the order of Augustinian nuns. St. Apollonia, a third-century martyr, has no known Augustinian connections. If these three small panels did originally form part of the S. Agostino altar, it is no longer possible to determine where they might have been placed; various writers have suggested as probable locations the sides, pinnacles, and predella. Unlike the large panels of saints from the altarpiece, these have gold backgrounds and the subjects lack haloes.

Although the figures in the small panels are close to Piero's style in their dignity and austerity, some have doubted that they were executed by Piero himself. A number of talented artists assisted Piero in his many commissions, which he often undertook to execute simultaneously in widely separated locations. Among the most gifted was Luca Signorelli, whom the biographer Vasari claimed "did him more credit than all the others," but the specific contributors to Piero's various projects have yet to be identified with any certainty.

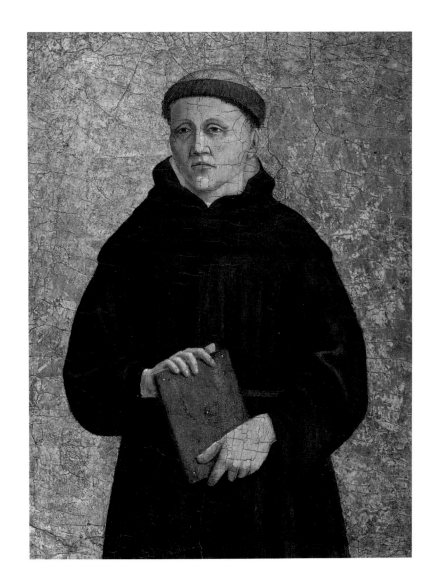

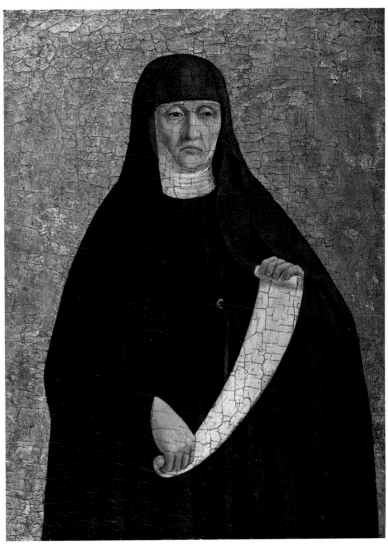

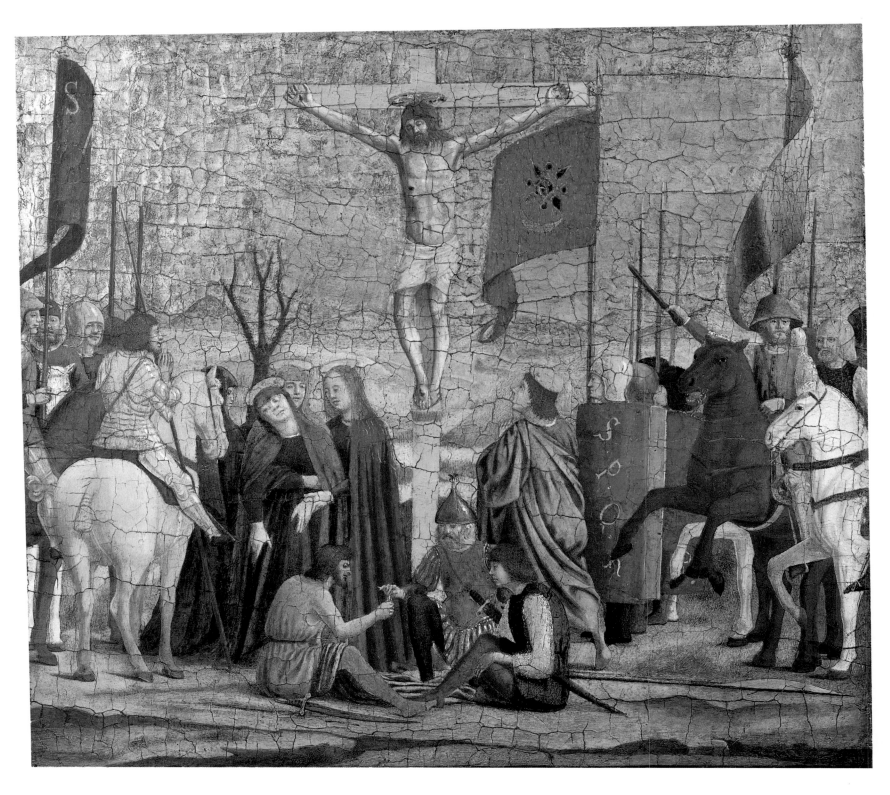

PIERO DELLA FRANCESCA

THE CRUCIFIXION

Date unknown. Tempera on panel (irregular)
14 3/4 × 16 3/16 in. (37.5 × 41.1 cm.)
Acquired in 1961

It has been proposed that this *Crucifixion*, like the preceding two panels portraying an Augustinian monk and nun, originally formed a part of Piero's S. Agostino altarpiece. The first known reference to *The Crucifixion* is found in a seventeenth-century document listing paintings in a collection at Borgo Sansepolcro. *The*

Crucifixion is described there in considerable detail, together with three other subjects: a *Flagellation*, a *Deposition*, and a *Resurrection*, all three now lost. The writer did not claim that these panels came from the S. Agostino altarpiece, although in the same collection were four larger panels of standing saints that he specified did come from the high altar of S. Agostino. While he names only St. Michael and St. Augustine correctly, these larger panels may be identified with the four saints discussed in the earlier entry on Piero's *St. Simon (?)*.

The seventeenth-century record does not, therefore, resolve the problem of whether or

not *The Crucifixion* belonged to the same altarpiece. Piero did, after all, paint other works for his native town, which might have had predellas incorporating such scenes. The question of possible workshop participation in painting *The Crucifixion* is also an unresolved issue. Some scholars argue that an assistant was responsible for the execution, although certain passages of this small yet monumental composition are painted with great refinement.

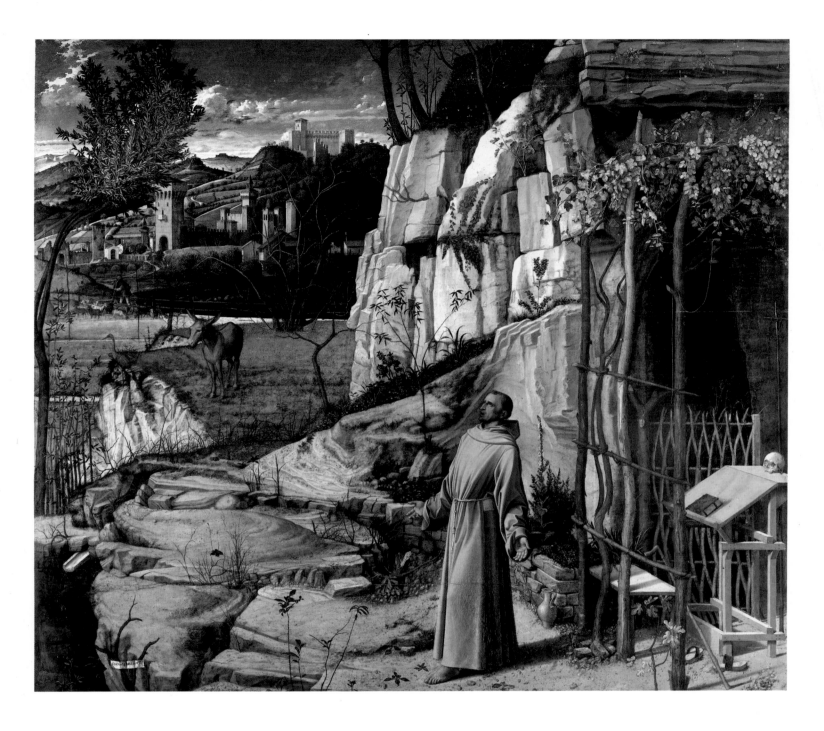

GIOVANNI BELLINI

C. 1430–1516

Giovanni Bellini began his career in the workshop of his father, Jacopo. First mentioned in Venice in 1459, he succeeded his brother Gentile as painter to the Republic in 1483. Thereafter he was constantly employed by the State, as well as by Venetian churches and private patrons. He was one of the first Italian artists to master the oil technique of the northern European painters.

ST. FRANCIS IN THE DESERT

Painted c. 1480. Tempera and oil on panel
49 × 55 7/8 in. (124.4 × 141.9 cm.)
Acquired in 1915

St. Francis of Assisi (1181/82–1226), founder of the Franciscan order, is believed to have received the stigmata—the wounds of Christ's Crucifixion—in 1224 during a retreat on Mount Alverna in the Apennines. It may be this event that Bellini evokes here through the naturalistic yet transcendental imagery of rays of light flooding the foreground from an unseen source at upper left. However, alternative explanations for the scene have been proposed.

The wilderness—or desert—of Mount Alverna is compared in early Franciscan sources to the desert of the Book of Exodus, and Moses and Aaron were seen by the Franciscans as their spiritual ancestors, who were believed to have lived again in their founder. A parallel was seen between the saint's stigmatization on Mount Alverna and Moses' communion with God on Mount Horeb. The quivering tree at upper left, shining in the mysterious light, may then be intended to recall not only the Cross but also the burning bush of Moses' vision at Horeb.

The landscape of Bellini's desert is filled with marvelous details—animals, birds, persons, plants, objects such as the skull and sandals, and strange rock formations—that yielded hidden meanings for those who understood their importance in Franciscan literature. The water trickling from a spout in the stones at left, for example, is compared to the miraculous fountain Moses brought forth from the rocks at Horeb, and the empty sandals behind the barefoot saint recall God's command to Moses to "put off the shoes from thy feet: for the place whereon thou standest is holy ground." It is perhaps this sense of significance in all things as well as the radiant light flowing over the landscape that imbues the painting with such magical appeal.

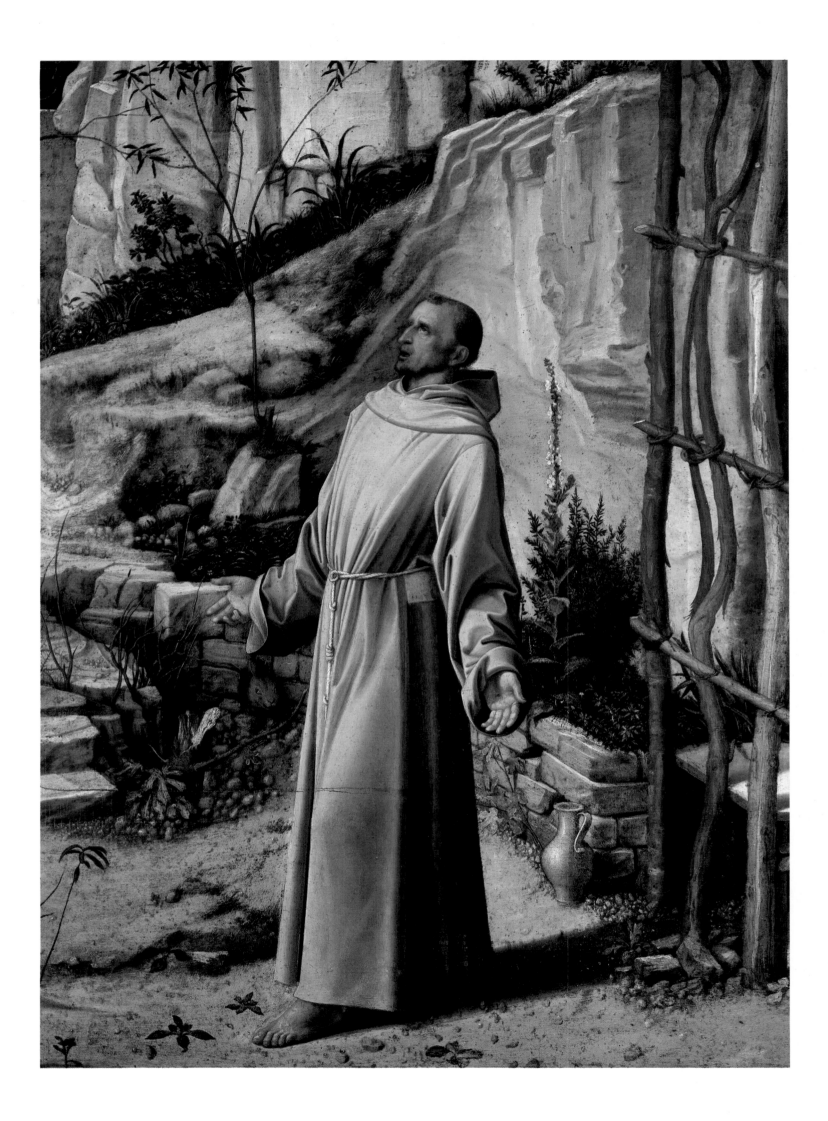

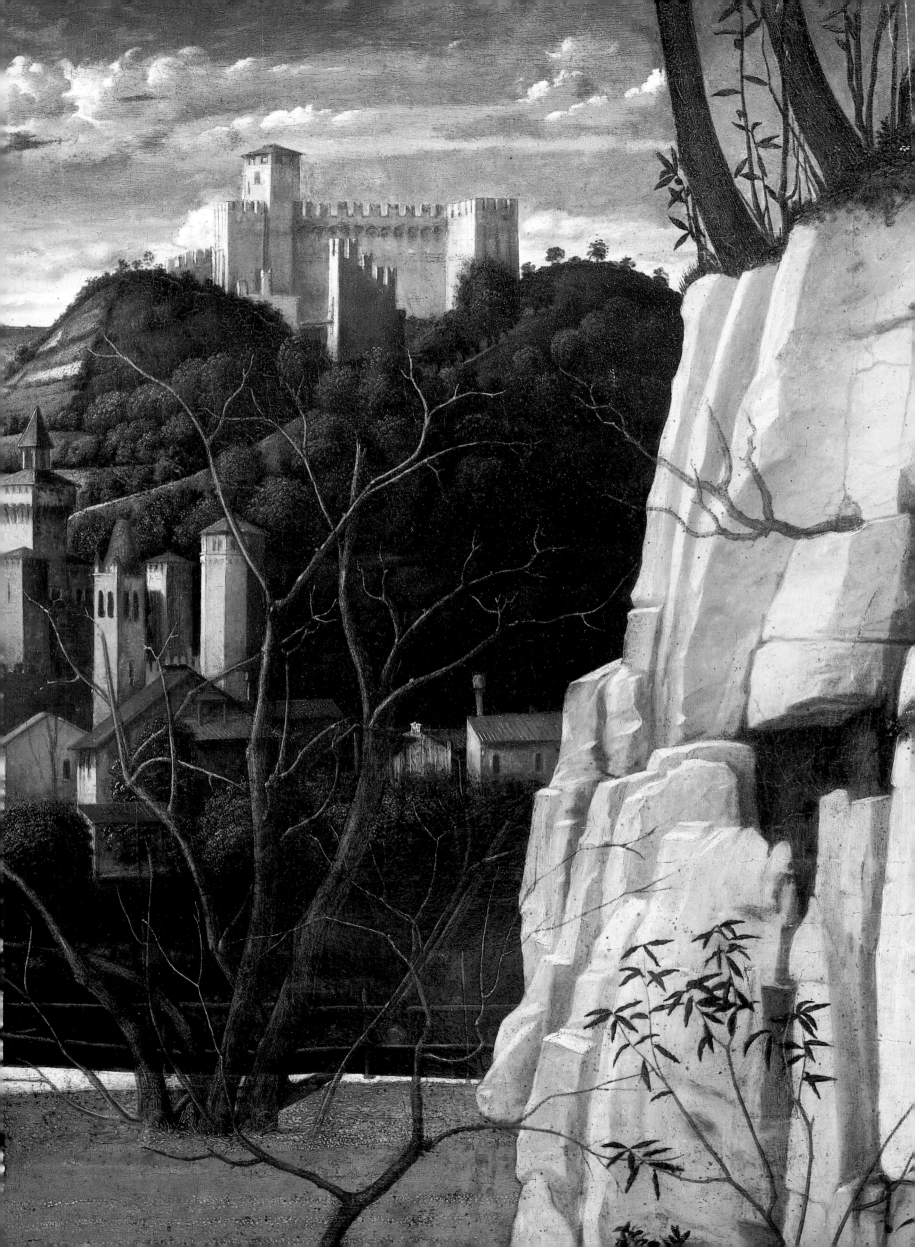

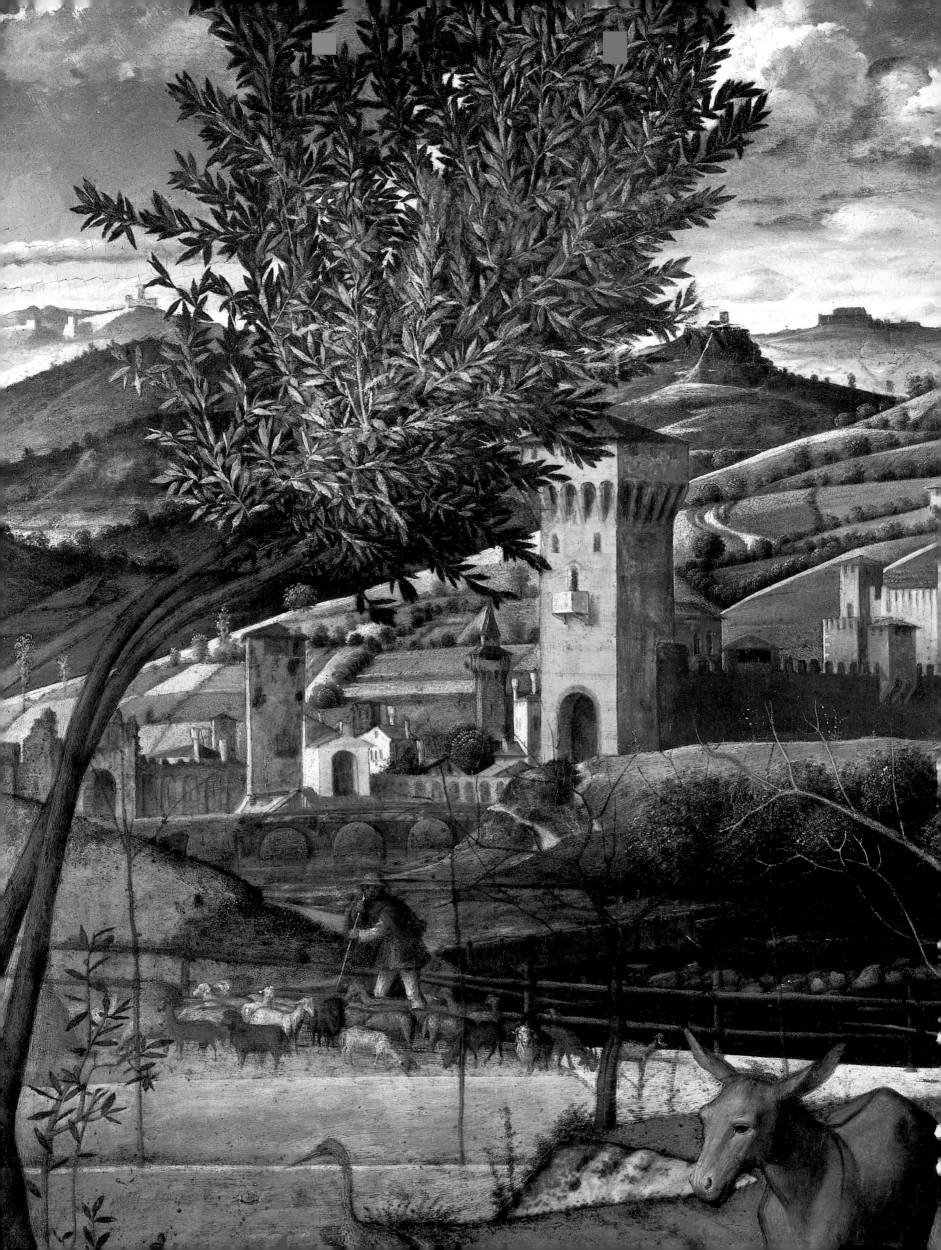

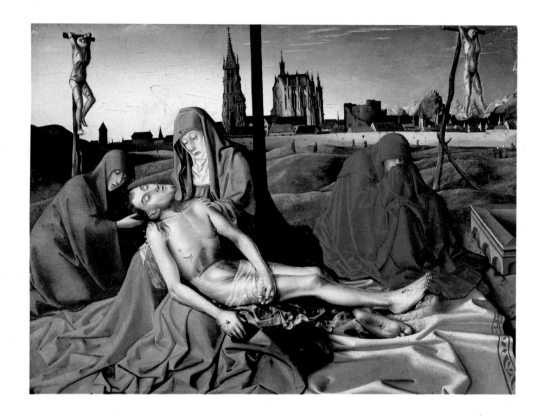

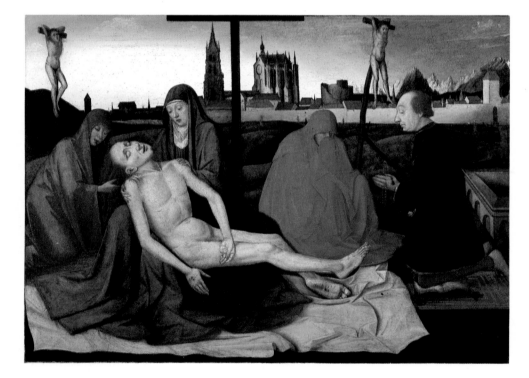

GERARD DAVID
active 1484–1523

David was born at Oudewater, near Gouda. By 1484 he was in Bruges, where in 1494 he became chief painter of the city. While documents show him working in Antwerp in 1515, he returned a few years later to Bruges, where he died.

THE DEPOSITION *(opposite)*

Painted between c. 1510 and 1515. Oil on canvas
56 1/8 × 44 1/4 in. (142.5 × 112.4 cm.)
Acquired in 1915

The somber dignity of the mourning figures and the austere simplicity of this composition greatly impressed David's contemporaries, who produced a number of copies and variants of *The Deposition.* The work is among the earliest extant northern European paintings executed in oil on canvas, rather than on panel; a water-based paint such as tempera is more commonly found in Flemish works on fabric supports at this period. In *The Deposition* the oil medium brings out the subtle ranges of the cold but vibrant hues and the nuances of the finely rendered details—seen, for example, in the skull and bones hauntingly prominent in the foreground.

KONRAD WITZ, CIRCLE OF
fifteenth century

PIETÀ *(above)*

Date unknown. Tempera and oil on panel
13 1/8 × 17 1/2 in. (33.3 × 44.4 cm.)
Acquired in 1981

FRENCH, PROBABLY SOUTH OF FRANCE
fifteenth century

PIETÀ WITH DONOR *(below)*

Date unknown. Tempera or mixed technique on panel
15 5/8 × 22 in. (39.7 × 55.8 cm.)
Acquired in 1907

The Pietà, a representation of the Virgin supporting the dead Christ in a pose that poignantly recalls the image of her holding the Child, is a motif that first appears in Germanic art of the fourteenth century. Here the figures are set in a landscape which includes Christ's sepulcher at right, a Gothic city representing Jerusalem, and distant snowcapped mountains.

The *Pietà* by a follower of Konrad Witz evidently was the model for the French variant, illustrated below, by a later artist who added a kneeling donor to the composition. Both paintings—individually and in their relation to each other—present many unsolved mysteries. The national origins of the two artists, the patrons who commissioned the panels, and the loca-

tions in which the works were executed are all unknown. North European characteristics seem stronger in the earlier version, which was long attributed to Witz himself. This *Pietà* is more dramatically intense, more emotional in the handling of the sharp-featured faces, the angular drapery folds, and the colder tonality of colors and light.

During the fifteenth century, artists of many nationalities traveled about to courts and towns throughout Europe, from Provence to Naples, from the Netherlands to Spain, blending in their works local and imported traditions. The authors of the *Pietàs* may have been such itinerant artists.

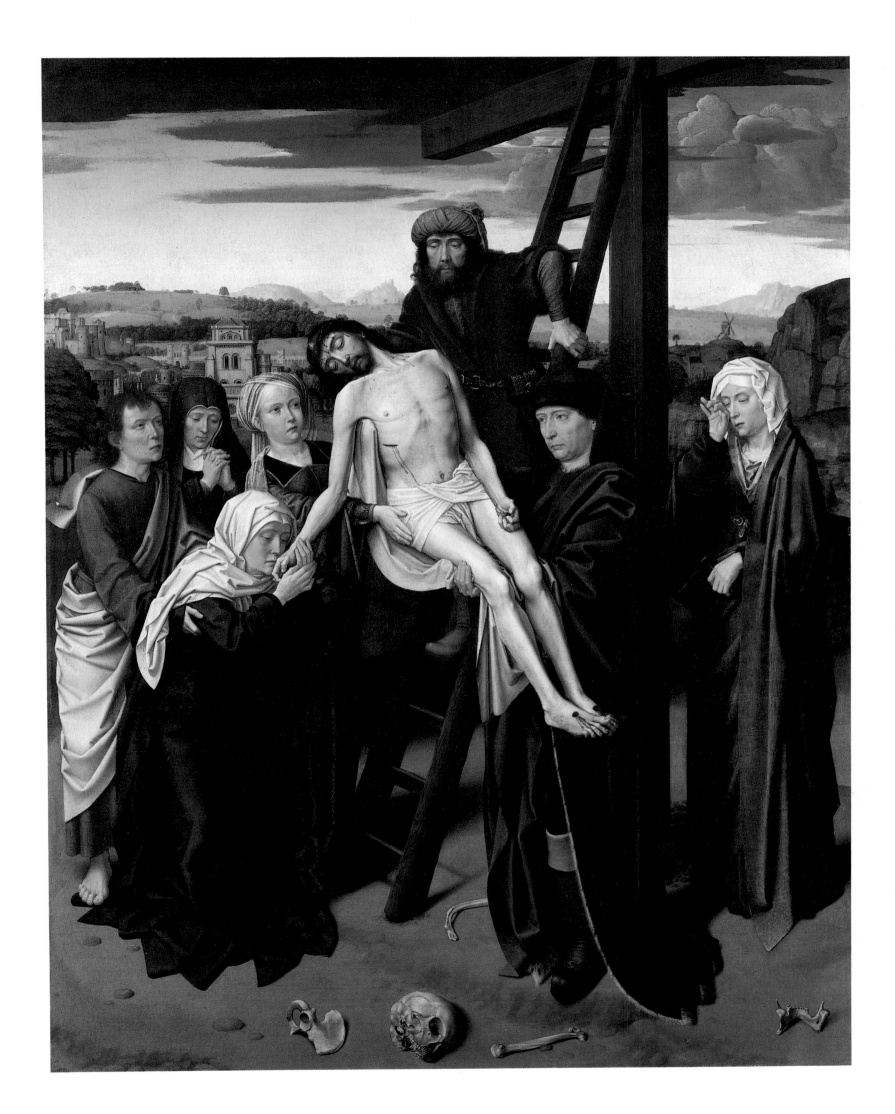

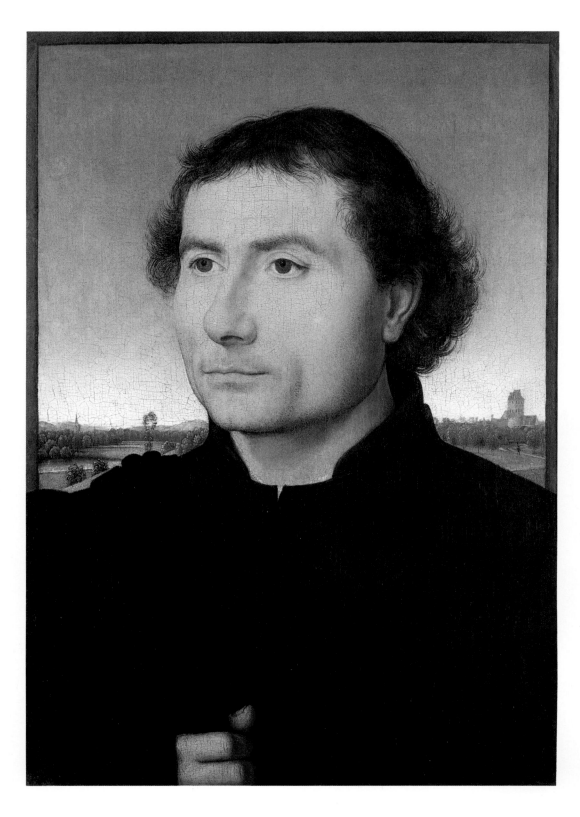

HANS MEMLING

c. 1440–1494

Born at Seligenstadt, near Frankfurt, Memling spent much of his life in Bruges, where he was recorded as a new citizen in 1465. Two years later he entered the Bruges painters' guild, and documents show that he became one of the city's more prosperous residents. In addition to portraits, Memling painted many religious subjects.

PORTRAIT OF A MAN

Painted c. 1470. Oil on panel
13 1/8 × 9 1/8 in. (33.5 × 23.2 cm.)
Acquired in 1968

The thriving trade centers of the Netherlands provided an international market for talented artists such as Memling. However, the plain coat worn by the subject of this portrait offers no clue to his nationality, occupation, or rank. The serious, firmly modeled head suggests a man who was not only forceful but thoughtful. Although he is physically placed close to the

viewer, his body pressed against the frame, he appears aloof and removed from the world. Panels such as this often served as covers or wings for small private altarpieces, but it seems probable that the Frick example, like many others dating from the second half of the fifteenth century, was commissioned as an independent painting. Memling was one of the most admired portraitists of his day, in Italy as well as in northern Europe, owing both to his skill in capturing physical likenesses and to his even rarer gift for conveying, as in this portrait, the intellectual and spiritual character of his subjects.

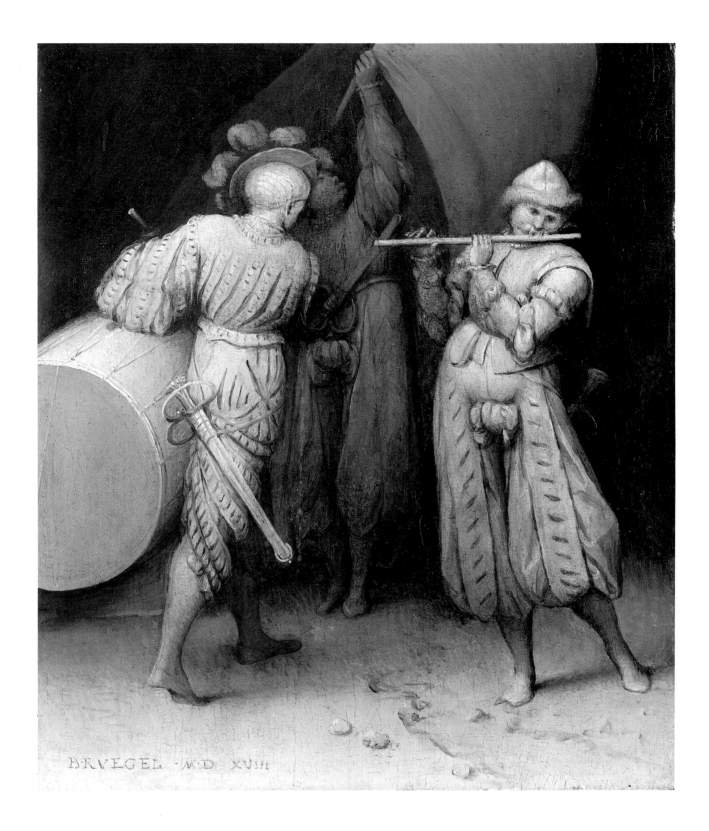

PIETER BRUEGEL
THE ELDER
active 1551–1569

Both the date and place of Bruegel's birth are uncertain. The earliest reference to him records his entry into the Antwerp painters' guild in 1551. He traveled to Italy around 1552, but by 1555 he was back in Antwerp. In 1563 he settled in Brussels, working thereafter both for eminent private patrons and for the city government. Bruegel's landscape paintings and peasant scenes had a powerful and lasting influence in the Netherlands.

THE THREE SOLDIERS

Dated 1568. Oil on panel
8 × 7 in. (20.3 × 17.8 cm.)
Acquired in 1965

Bruegel is best known for his large landscapes and town views populated by small, lively figures—often contemporary peasants—and illustrating Biblical, allegorical, and folkloric subjects. In addition to the Frick example, only three other *grisailles* by Bruegel are known, all on religious themes. This little panel, once in the collection of Charles I of England, repre-

sents a trio of *Landsknechte,* the mercenary foot soldiers whose picturesque costumes and swashbuckling airs provided popular images for printmakers in the sixteenth century. Bruegel may have executed the Frick *grisaille* as a model for such an engraving, although none is known, or simply as a cabinet piece. The attenuated grace of the figures in this painting may reflect currents in contemporary Italian art.

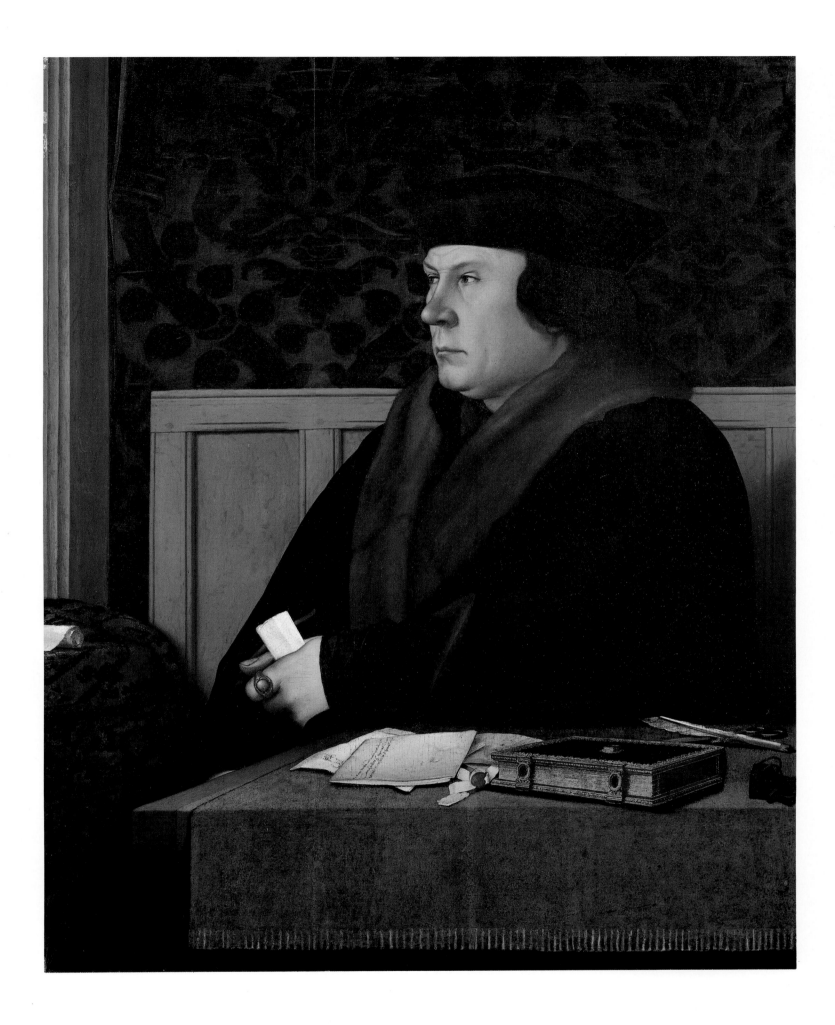

HANS HOLBEIN THE YOUNGER
1497/98–1543

Son of the Augsburg painter Hans Holbein the Elder, who probably gave him his first training, Holbein was working by 1515 in Basel, where he achieved great success and was part of the humanist circle of Erasmus. It is probable that about 1519 he traveled to Italy, where the art of the Italian Renaissance may have inspired the classic monumentality of his own style. In 1524 Holbein visited France, and from 1526 to 1528 he worked in England. Four years later he returned to settle there, eventually becoming court painter to Henry VIII. A remarkably realistic yet decorative series of portraits of Henry's court and family is Holbein's great legacy. He died of the plague in London.

THOMAS CROMWELL
Painted c. 1532–33. Oil on panel
30 7/8 × 25 3/8 in. (78.4 × 64.4 cm.)
Acquired in 1915

Thomas Cromwell (c. 1485–1540) was the son of a London blacksmith and tavern-keeper. He entered Cardinal Wolsey's service in 1514 and held various high offices under Henry VIII, culminating in his appointment as Lord Great Chamberlain in 1539. The Frick portrait was probably painted around 1532–33, while Cromwell was the Master of the Jewell House—the title by which he is addressed in the letter on the table before him—and before he was promoted to Chancellor of the Exchequer. With characteristic acumen Holbein has captured the personality of the King's most powerful and ruthless agent in the suppression of religious orders during the English Reformation. Cromwell was largely responsible for the execution of Thomas More. In 1540 Cromwell fell from Henry's favor and was himself accused of treason and beheaded. This picture was formerly thought to be an early copy but has recently been claimed as autograph.

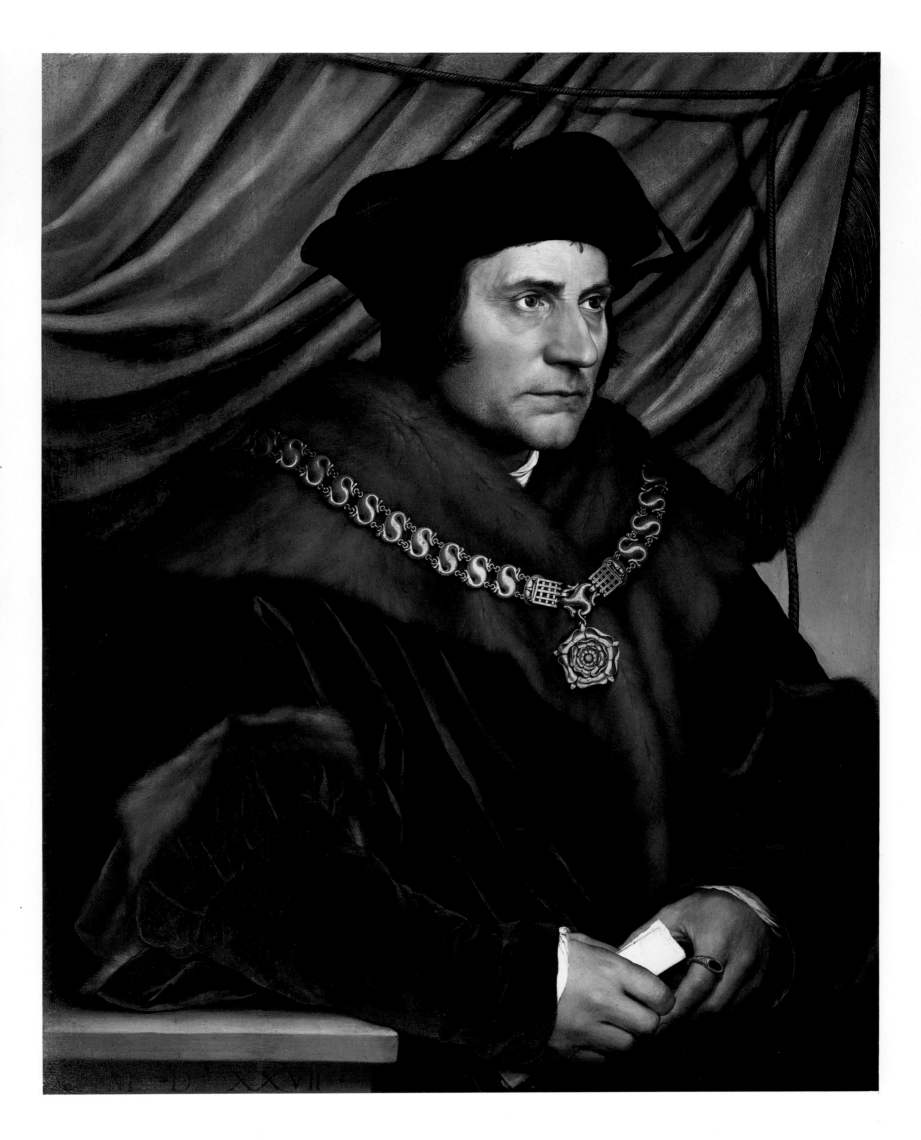

HANS HOLBEIN
THE YOUNGER

SIR THOMAS MORE

Dated 1527. Oil on panel
29 1/2 × 23 3/4 in. (74.9 × 60.3 cm.)
Acquired in 1912

Thomas More (1477/78–1535), humanist scholar, author, and statesman, served Henry VIII as diplomatic envoy and Privy Councillor prior to his election as speaker of the House of Commons in 1523. The chain More wears in this portrait is an emblem of service to the King, not of any specific office. In 1529 More succeeded Cardinal Wolsey as Lord Chancellor, but three years later he resigned that office over the issue of Henry's divorce from Catherine of Aragon, and subsequently he refused to subscribe to the Act of Supremacy making the King head of the Church of England. For this he was convicted of high treason and beheaded. Venerated by the Catholic Church as a martyr, More was beatified in 1886 and canonized in 1935 on the four-hundredth anniversary of his death. Holbein's sympathy for the man whose guest he was upon first arriving in England is apparent in the Frick portrait. His brilliant rendering of the rich fabrics and adornments make this one of Holbein's best and most popular paintings. Various versions of the portrait exist, but this is undoubtedly the original. A drawing in the Royal Library, Windsor, served as the cartoon for the painting.

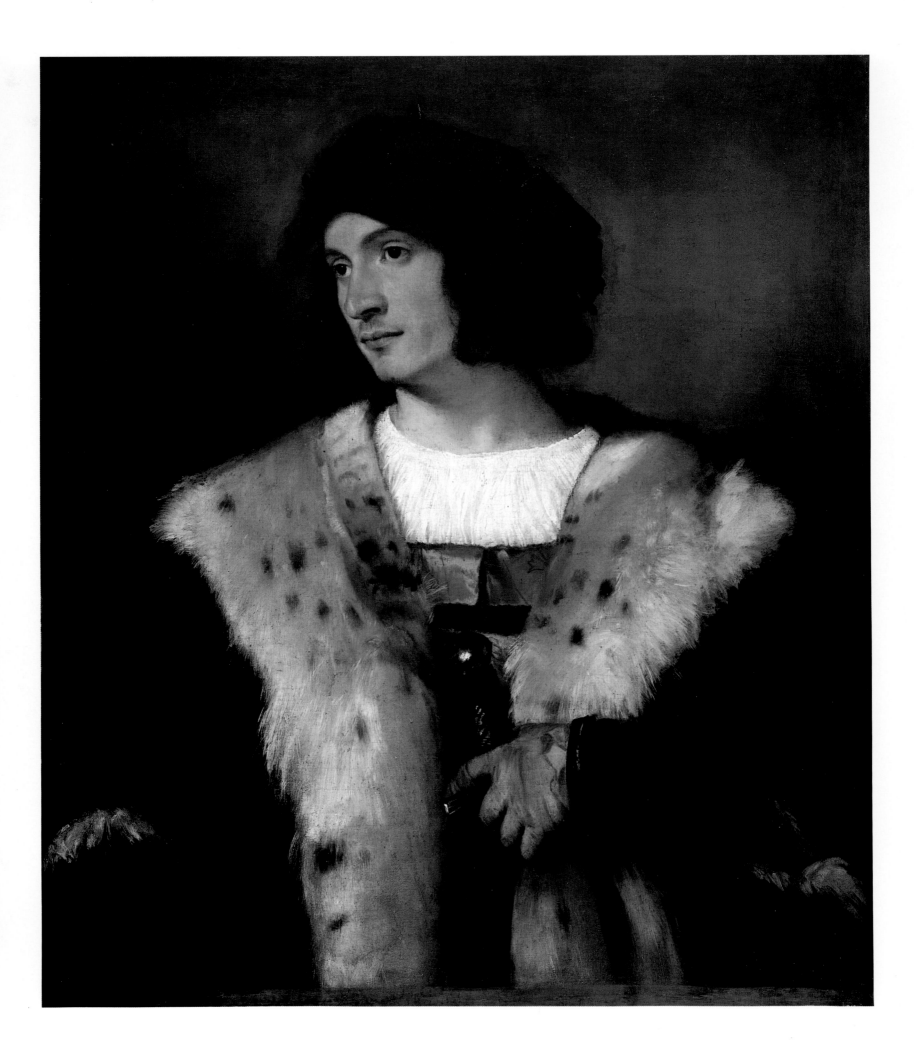

TITIAN
(TIZIANO VECELLIO)
1477/90–1576

Titian was born in the Alpine town of Pieve di Cadore; the date of his birth is uncertain. He succeeded Giovanni Bellini, under whom he had studied, as painter to the Republic of Venice, and he included among his many illustrious patrons the emperor Charles V, Charles' son Philip II of Spain, and Pope Paul III. He died in Venice in the great plague of 1576. After Giorgione's death in 1510, Titian was considered the greatest painter of his day in Venice.

PORTRAIT OF A MAN IN A RED CAP

Painted c. 1516. Oil on canvas
32 3/8 × 28 in. (82.3 × 71.1 cm.)
Acquired in 1915

Various identities for the richly dressed young man in this portrait have been proposed, but none with any certainty. Nevertheless, the portrait seems to have been well-known, at least in the seventeenth century; Carlo Dolci included a copy of the figure in the background of his *Martyrdom of St. Andrew* (Palazzo Pitti, Florence).

The painting is generally considered an early work of Titian. The contemplative mood of the subject and the diffused, gentle play of light over the broadly painted surfaces are strongly reminiscent of Titian's Venetian contemporary Giorgione. The canvas has in the past even been attributed to Giorgione. In mood, pose, and technique, the Frick portrait closely resembles the central figure of *The Concert* (Palazzo Pitti), a painting that also has been ascribed both to Titian and to Giorgione.

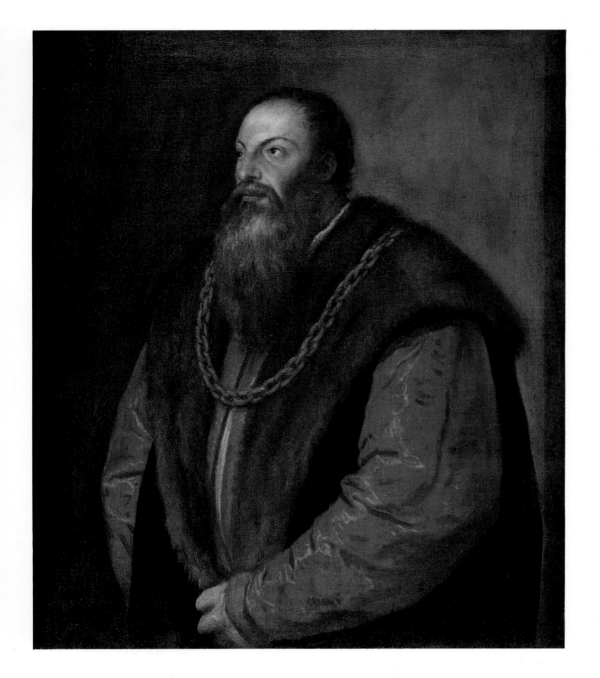

AGNOLO BRONZINO
1503–1572

Agnolo di Cosimo di Mariano, called Bronzino, was court painter to Duke Cosimo I de' Medici and became the foremost portraitist of Florence. He also executed religious and allegorical subjects as well as decorations for Medici festivities.

LODOVICO CAPPONI

Painted probably between 1550 and 1555. Oil on panel
45 7/8 × 33 3/4 in. (116.5 × 85.7 cm.)
Acquired in 1915

This proud young aristocrat is Lodovico Capponi (b. 1533), a page at the Medici court. As was his custom, he wears black and white, his family's armorial colors. His right index finger partially conceals the cameo he holds, revealing only the inscription SORTE (fate or fortune)—an ingenious allusion to the obscurity of fate. In the mid 1550s Lodovico fell in love with a girl whom Duke Cosimo had intended for one of his cousins. After nearly three years of opposition, Cosimo suddenly relented, but he commanded that their wedding be celebrated within twenty-four hours.

TITIAN

PIETRO ARETINO

Painted probably between 1548 and 1551. Oil on canvas
40 1/8 × 33 3/4 in. (102 × 85.7 cm.)
Acquired in 1905

Author of lives of saints, scurrilous verses, comedies, tragedies, and innumerable letters, Pietro Aretino (1492–1556) attained considerable wealth and influence, in part through literary flattery and blackmail. Little is known of his early years, but by 1527 he had settled permanently in Venice. Among Aretino's friends and patrons were some of the most prominent figures of his time, several of whom gave him gold chains such as the one he wears in this portrait. Clement VII made Aretino a Knight of Rhodes, and Julius III named him Knight of St. Peter. He was on intimate terms with Titian, who painted at least three portraits of him. Here the artist conveys his friend's intellectual power through the keen, forceful head and his worldliness through the solid, weighty mass of the richly robed figure.

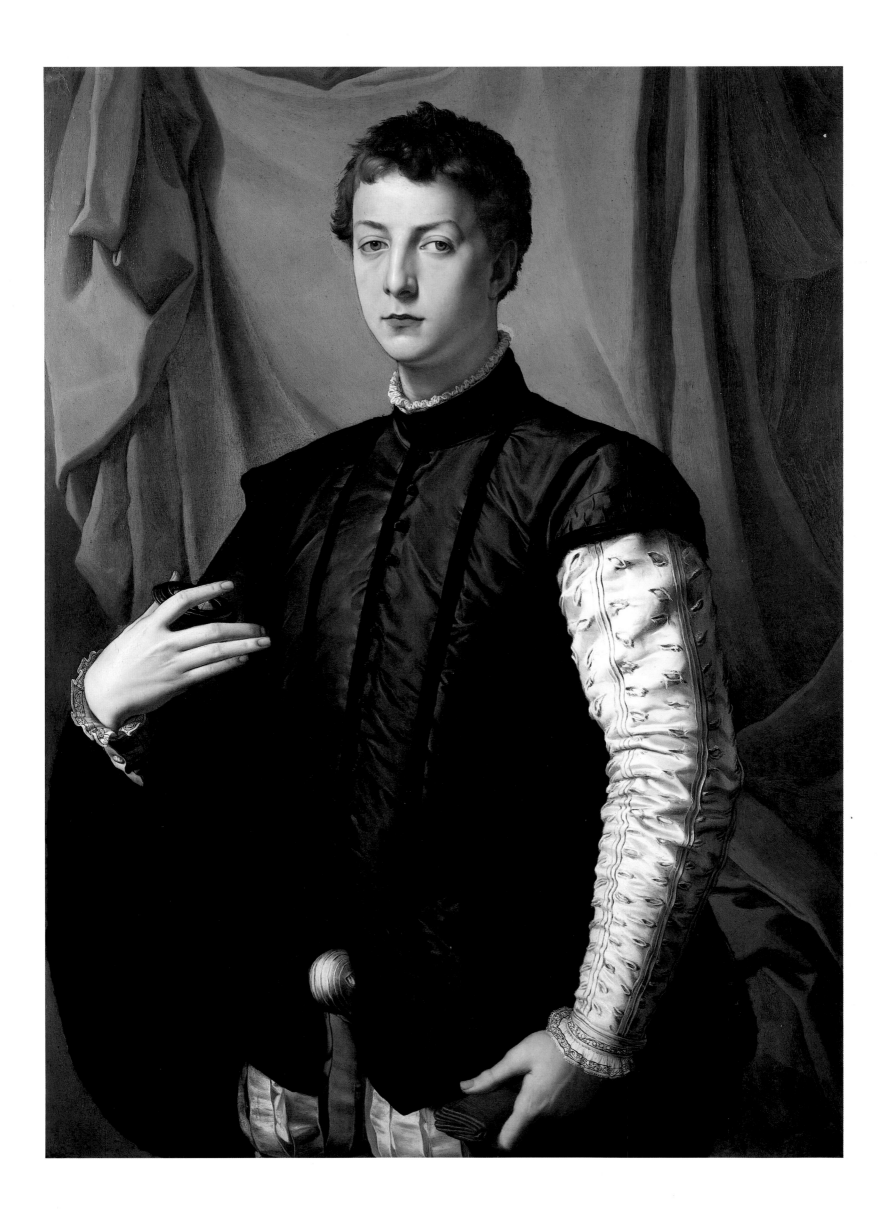

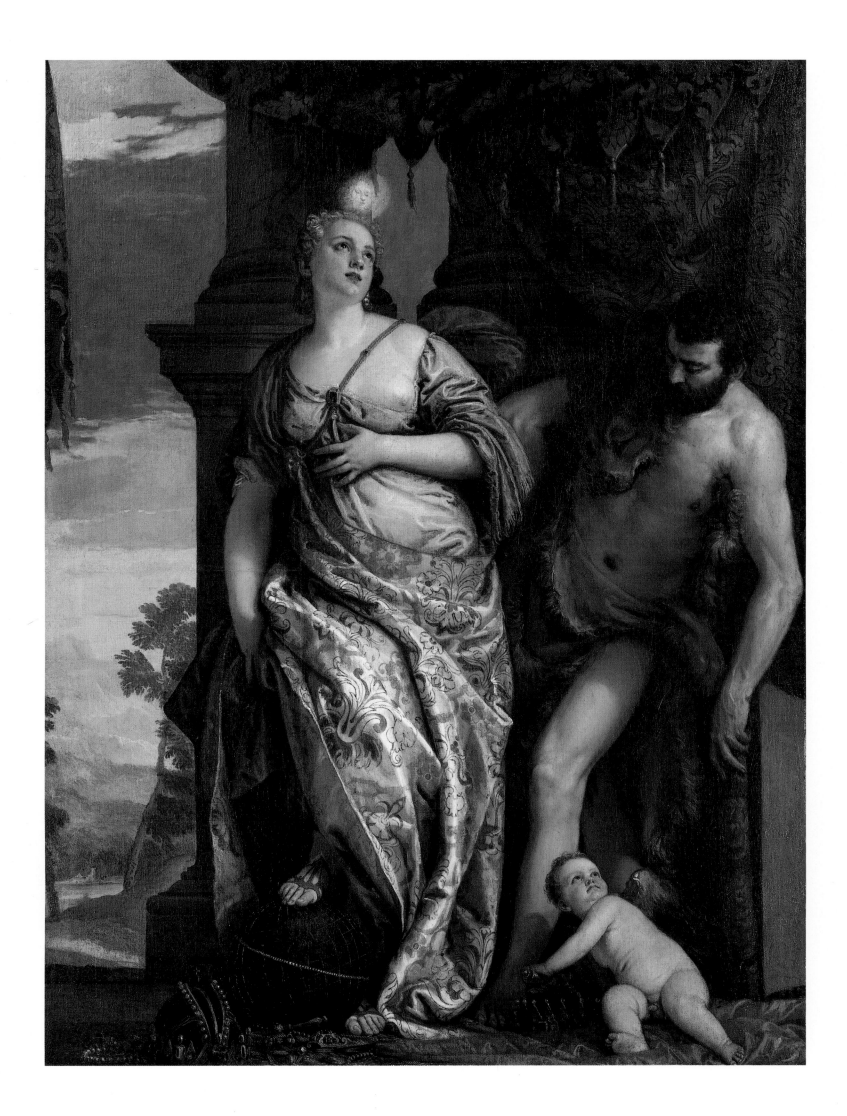

PAOLO VERONESE

ALLEGORY OF VIRTUE AND VICE (THE CHOICE OF HERCULES)

Painted c. 1580. Oil on canvas
86 1/4 × 66 3/4 in. (219 × 169.5 cm.)
Acquired in 1912

At a crossroads, Hercules encountered Vice, who offered a path of ease and pleasure, and Virtue, who indicated a rugged ascent leading to true happiness—a moral lesson underlined by the motto on the entablature at upper left: [HO]NOR ET VIRTUS/[P]OST MORTE FLORET (Honor and Virtue Flourish after Death).

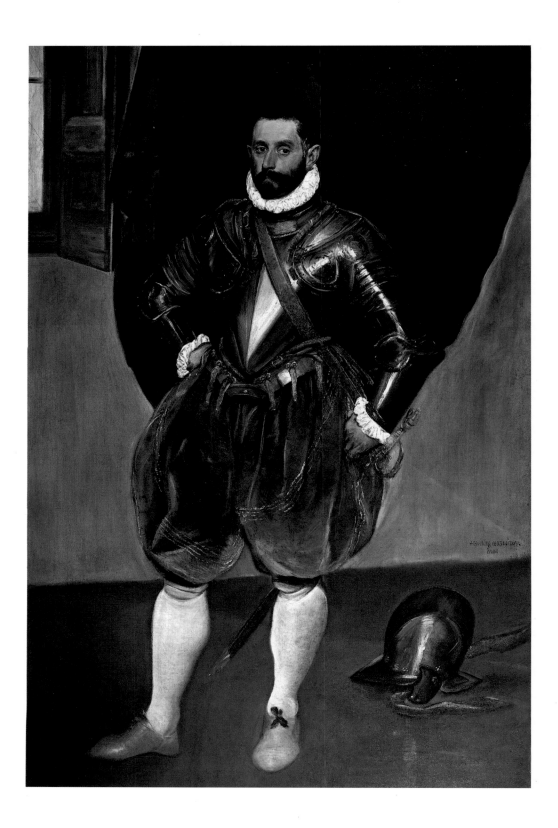

EL GRECO
1541–1614

Domenikos Theotokopoulos, called El Greco, was born in Crete, then a Venetian dependency. He reputedly studied with Titian in Venice, then moved to Rome in 1570. By 1577 he had settled in Toledo, where he spent his remaining years. His extensive production consisted almost exclusively of religious subjects and portraits.

VINCENZO ANASTAGI

Painted between c. 1571 and 1576. Oil on canvas
74 × 49 7/8 in. (188 × 126.7 cm.)
Acquired in 1913

Born in Perugia, Vincenzo Anastagi (c. 1531–86) joined the Knights of Malta in 1563 and was a leader in the heroic defense of that island during the massive Turkish siege of 1565. After holding various other responsible posts he was named Sergeant Major of Castel Sant'Angelo in Rome. Anastagi apparently was an expert on fortifications. This portrait, already characteristically intense and spirited in style, probably dates from El Greco's last years in Italy.

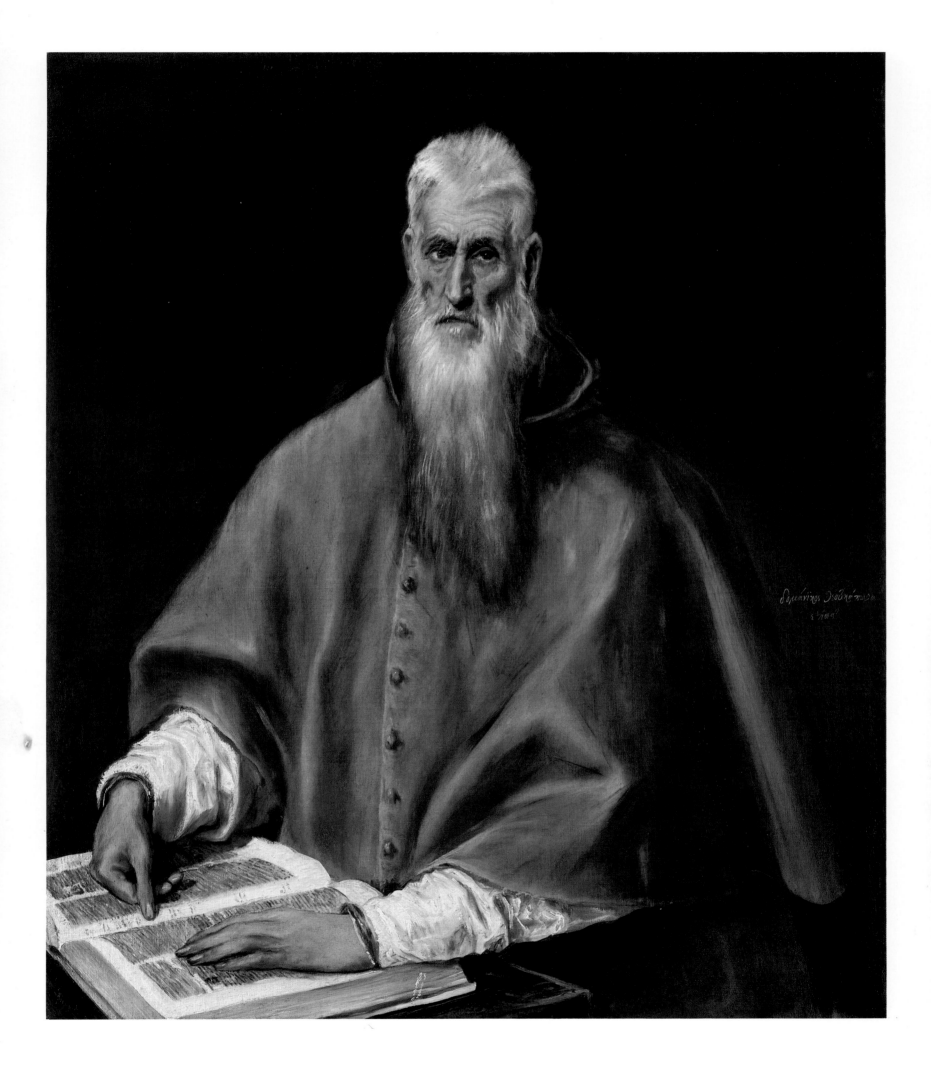

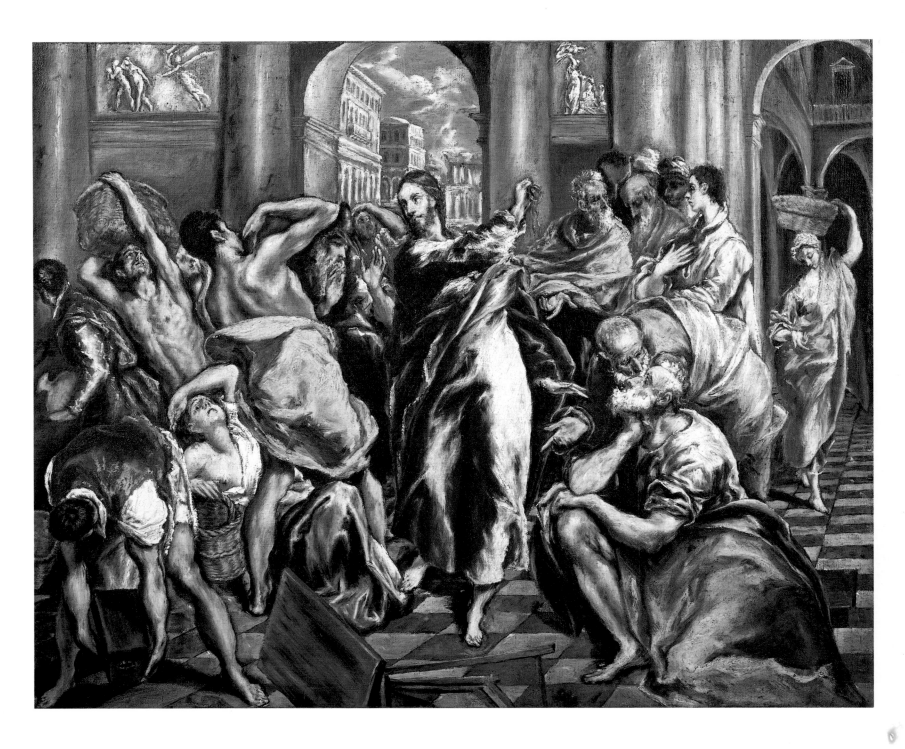

EL GRECO

ST. JEROME

Painted between c. 1590 and 1600. Oil on
canvas
43 1/2 × 37 1/2 in. (110.5 × 95.3 cm.)
Acquired in 1905

St. Jerome (c. 342–420), one of the four great
Doctors of the Western Church, is venerated
for his ascetic piety and for his monumental
Latin translation of the Bible, represented here
by the large volume on which he rests his hands.
Following an old convention the artist depicts
him in the robes of a cardinal. This composition
proved popular and was produced in at least
four versions by El Greco and his shop; one of
these is in the Metropolitan Museum.

EL GRECO

THE PURIFICATION OF THE
TEMPLE

Painted c. 1600. Oil on canvas
16 1/2 × 20 5/8 in. (41.9 × 52.4 cm.)
Acquired in 1909

The subject of Christ driving the traders and
moneychangers from the Temple assumed spe-
cial significance during the Counter Reforma-
tion as a symbolic reference to the purification
of the Church from heresy. El Greco has intro-
duced, in the bas-reliefs on the Temple wall, the
themes of the Expulsion of Adam and Eve from
Paradise and the Sacrifice of Isaac, both Old
Testament prefigurations of the Purification of
the Temple. The figures in the painting are
divided into two groups. At left, beneath the
Expulsion relief, are the frightened sinners. At
right, the believers quietly observe the scene
from beneath the Sacrifice of Isaac, an antetype
of the Crucifixion.

The theme of the Purification absorbed El
Greco throughout his career, as demonstrated
by the many versions of this composition that
issued from his shop. Although the chronology
of El Greco's work is far from clear, the Frick
canvas appears to be one of the later examples.
The painting is smaller in size than other similar
versions, but it generates remarkable dramatic
intensity through the explosive movement and
cold but brilliant coloring.

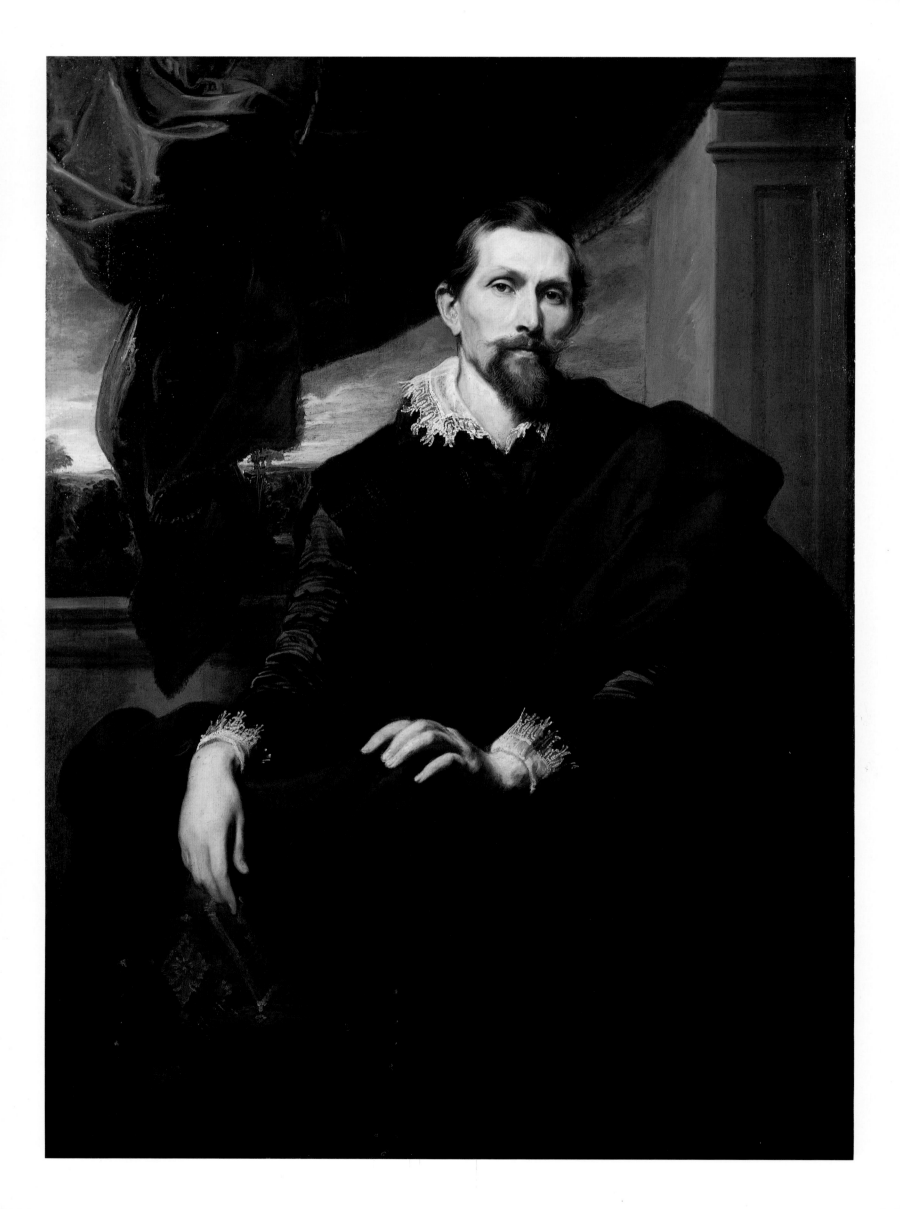

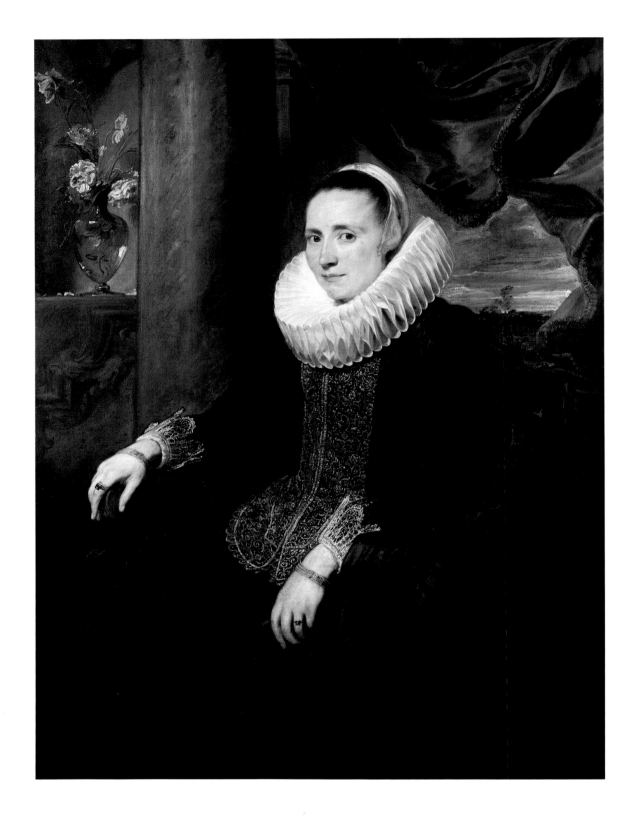

SIR ANTHONY VAN DYCK
1599–1641

Van Dyck was born in Antwerp, where he served an apprenticeship with Hendrik van Balen and was received as a master into the Guild of St. Luke by 1618. He visited London in 1620 and worked in Italy from 1621 until 1627, when he returned to Antwerp. From 1632 until his death he was active chiefly as a portrait painter in England.

FRANS SNYDERS

Painted c. 1620. Oil on canvas
56 1/8 × 41 1/2 in. (142.5 × 105.4 cm.)
Acquired in 1909

MARGARETA SNYDERS

Painted c. 1620. Oil on canvas
51 1/2 × 39 1/8 in. (130.7 × 99.3 cm.)
Acquired in 1909

These superb portraits represent Frans Snyders and his wife, Margareta de Vos. Snyders, a celebrated and prolific painter of still lifes, animals, and hunting scenes, was an intimate friend of Van Dyck. The influence of Rubens, whom Van Dyck assisted on occasion, is evident here in the fluently painted backgrounds and properties. Mr. Frick reunited these companion works, which had been separated since 1793.

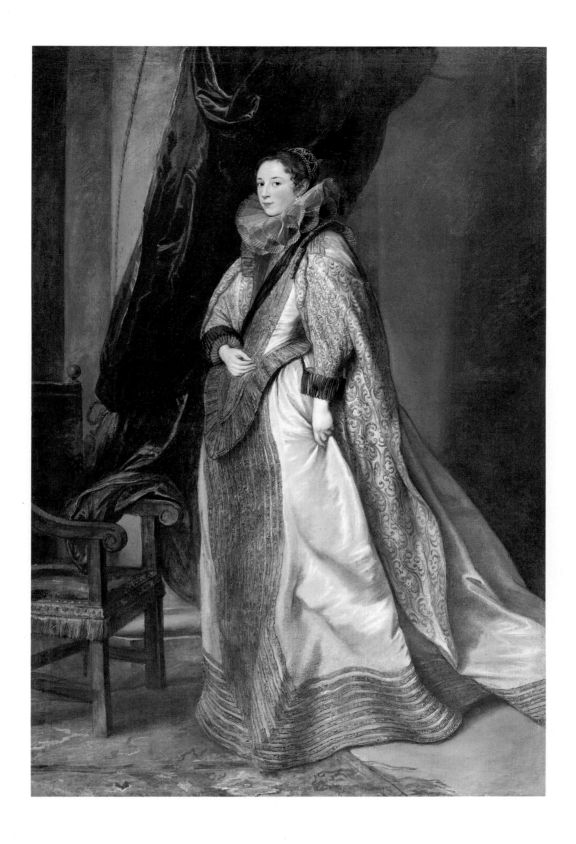

SIR ANTHONY VAN DYCK

PAOLA ADORNO, MARCHESA DI BRIGNOLE SALE

Painted between 1622 and 1627. Oil on canvas
90 7/8 × 61 5/8 in. (230.8 × 156.5 cm.)
Acquired in 1914

A member of one of the most distinguished
Genoese families, Paola Adorno married Anton
Giulio Brignole, a poet, writer, and political
figure. The richly decorated dress and opulent
setting enhance the Marchesa's patrician de-
meanor and elegant stance.

SIR ANTHONY VAN DYCK

JAMES, SEVENTH EARL OF DERBY, HIS LADY AND CHILD

Painted between 1632 and 1641. Oil on canvas
97 × 84 1/8 in. (246.2 × 213.7 cm.)
Acquired in 1913

This imposing work, typical of the large group
portraits Van Dyck painted during his last
English period, represents James Stanley, sev-
enth Earl of Derby (1607–51), with his wife
Charlotte de la Trémoille (1599–1664) and one
of their daughters. The Earl was a writer of

history and devotional works as well as an
ardent Royalist during the Civil War. He was
captured and executed by Commonwealth
forces in 1651. The Countess, who conducted a
spirited defense of the family's country seat,
lived to see the Restoration of the Stuart crown.
Among the emblematic details in their portrait
are the distant landscape, thought to represent
the Isle of Man, of which the Derbys were
hereditary sovereigns, and the color of the
child's dress, indicating her descent from the
House of Orange.

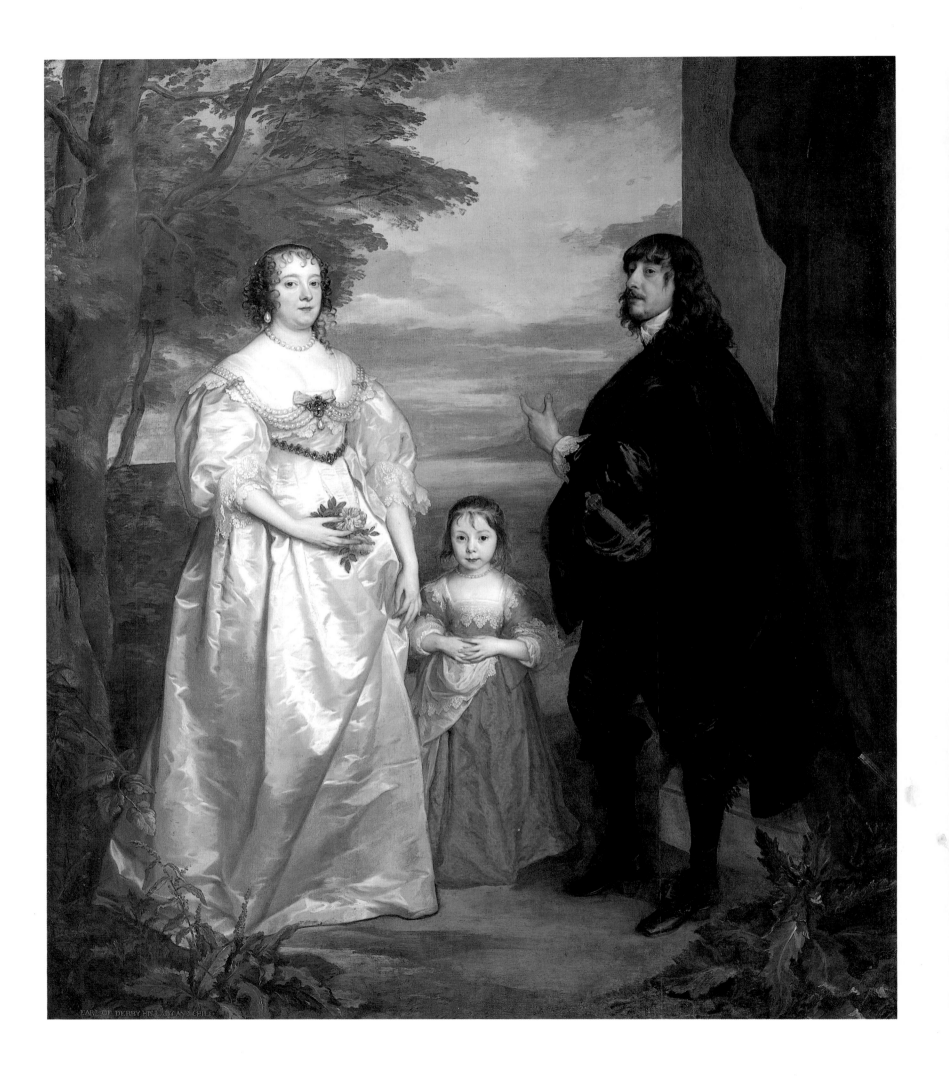

EARL OF DERBY HIS LADY AND CHILD

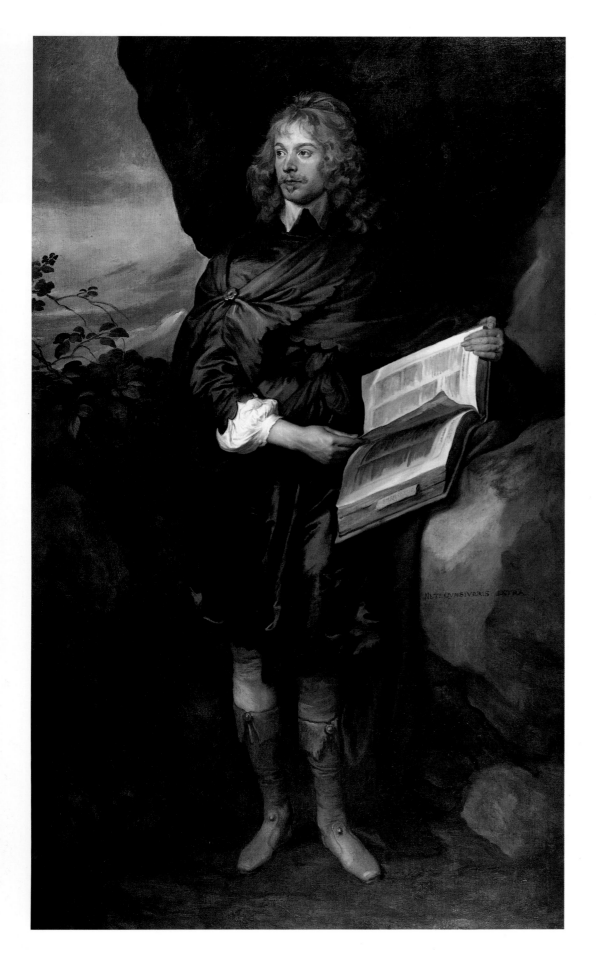

SIR ANTHONY VAN DYCK

SIR JOHN SUCKLING

Painted between 1632 and 1641. Oil on canvas
85 1/4 × 51 1/4 in. (216.5 × 130.3 cm.)
Acquired in 1918

In his own day John Suckling (1609–42) was
famous not only as a lyric poet, but also as a wit,
gambler, soldier, and gallant who conducted
himself with an extravagance remarkable even
at the court of Charles I. He was a member of
a prominent Norfolk family and held many
official posts, including those of Secretary of
State and Privy Councillor. Implicated in a plot
to put the King in command of the army, which
was then loyal to the Roundheads, Suckling fled
in 1641 to Paris, where he later reportedly
committed suicide. In this portrait Suckling
wears a costume suggestive of the stage and
holds a volume of Shakespeare opened to
Hamlet, no doubt in tribute to the writer who
strongly influenced his own work and to the
play from which he often borrowed language
and ideas.

SIR ANTHONY VAN DYCK

THE COUNTESS OF CLANBRASSIL

Painted probably in 1636. Oil on canvas
83 1/2 × 50 1/4 in. (212.1 × 127.6 cm.)
Acquired in 1917

Lady Anne Carey (d. 1689) was the eldest
daughter of Henry Carey (1596–1661), second
Earl of Monmouth, and his wife, Martha. The
Earl, who was celebrated for his knowledge of
languages, led the retired life of a scholar. Lady
Anne herself was described by an old source
as "very handsome, and witty . . . a woman
extraordinary in knowledge, virtue, and piety."
In 1635 she married James Hamilton, second
Viscount Claneboy, who twelve years later was
made Earl of Clanbrassil, in County Armagh.
After his death Lady Anne married in 1668
Sir Robert Maxwell, of Waringstown, County
Down. An almost identical background, proba-
bly a studio property, appears in at least two
other portraits by Van Dyck, including one of
Lady Anne's maternal aunt, Lady Frances Cran-
field. Van Dyck's sophistication and success in
portraying the English royal family and their
courtly supporters earned him a knighthood,
granted by Charles I in 1632. Portraits such as
this were greatly admired and emulated in the
eighteenth century by Thomas Gainsborough,
who adopted a similar rocky background for his
portrait of Mrs. Baker in The Frick Collection.

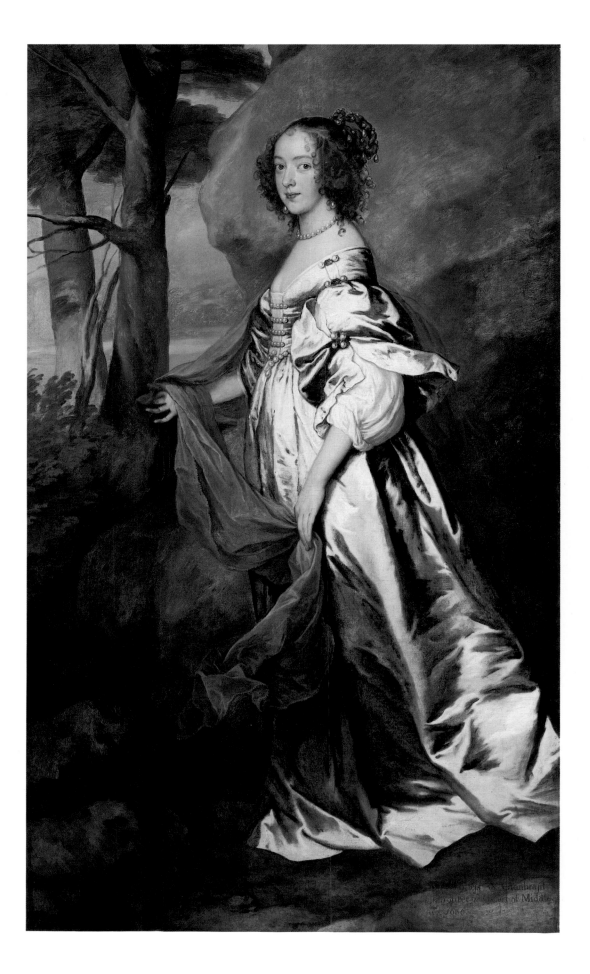

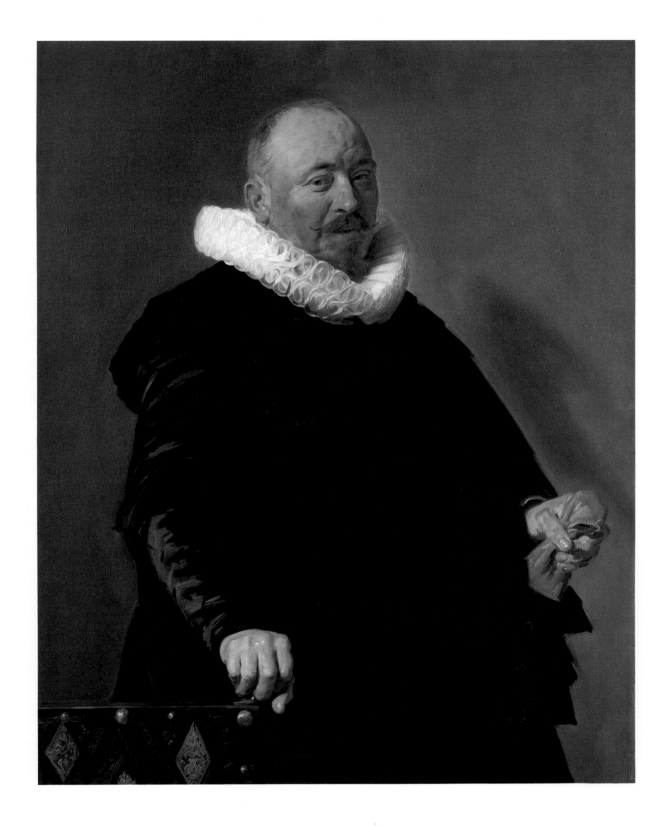

FRANS HALS
1581/85−1666

Records leave the place and date of Hals' birth in doubt, but he probably was born in Antwerp. He had moved to Haarlem with his parents (his father was a clothworker) by 1591, and at some time before 1603 he is thought to have studied with Carel van Mander. In 1610 he joined the Haarlem painters' guild; his first known dated work, a portrait, is from the following year. Hals worked in Haarlem until his death, chiefly painting portraits, including several group portraits of militia officers and governors of charitable institutions. His younger brother Dirck also was a painter, as were three of his sons.

PORTRAIT OF AN ELDERLY MAN

Painted between c. 1627 and 1630. Oil on canvas
45 1/2 × 36 in. (115.6 × 91.4 cm.)
Acquired in 1910

The technique of this portrait dating from Hals' early maturity is learned in part from Rubens. Halftones are superimposed in hatched strokes over lighter pigment applied in a thin, fluid coating. The warm but restricted color scheme and the subject's animated expression and self-confident air are typical of Hals' major works from this period. Matchmaking between male and female portraits is a popular pursuit among Hals scholars, who sometimes pair the Frick portrait with a female portrait dated 1633 in the Washington National Gallery. The evidence that the two were a couple is, however, far from conclusive.

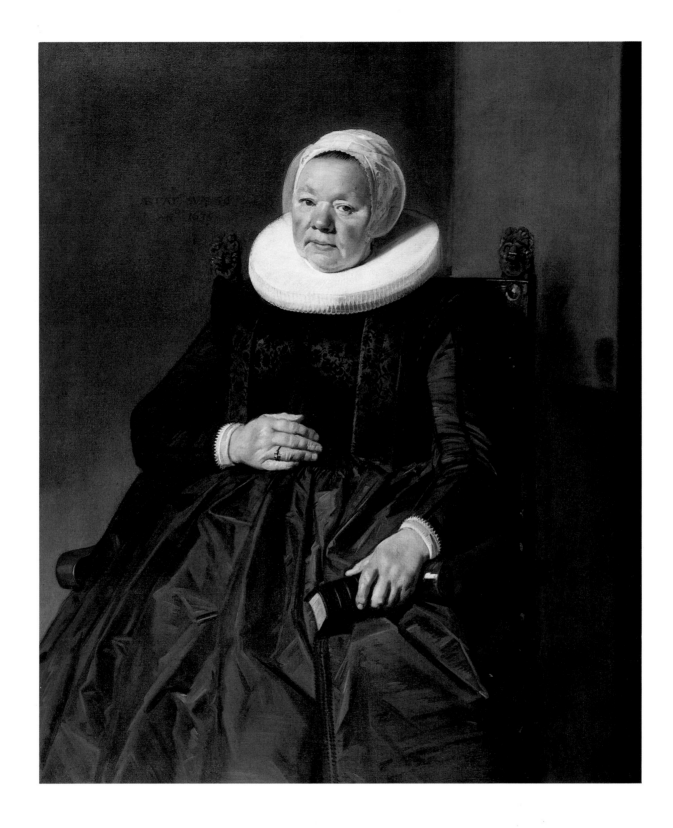

FRANS HALS

PORTRAIT OF A WOMAN

Dated 1635. Oil on canvas
45 7/8 × 36 3/4 in. (116.5 × 93.3 cm.)
Acquired in 1910

An inscription at upper left gives the age of the unidentified sitter as fifty-six. Soberly but richly dressed in black silk, with a brocaded bodice, the ruddy-cheeked lady, holding a Bible or prayerbook, appears well-established in a comfortable existence. Her solid, rounded form and four-square setting enhance the sense of a life led in a secure position within her society. The portrait records her features with objectivity and with a blunt, vigorous brushwork that seems in itself to reflect her character. Like most of Hals' works, this one employs a plain, unadorned background perfectly suited to his style of portraiture. Various suggestions have been made for a male companion to the portrait, but no agreement has been reached.

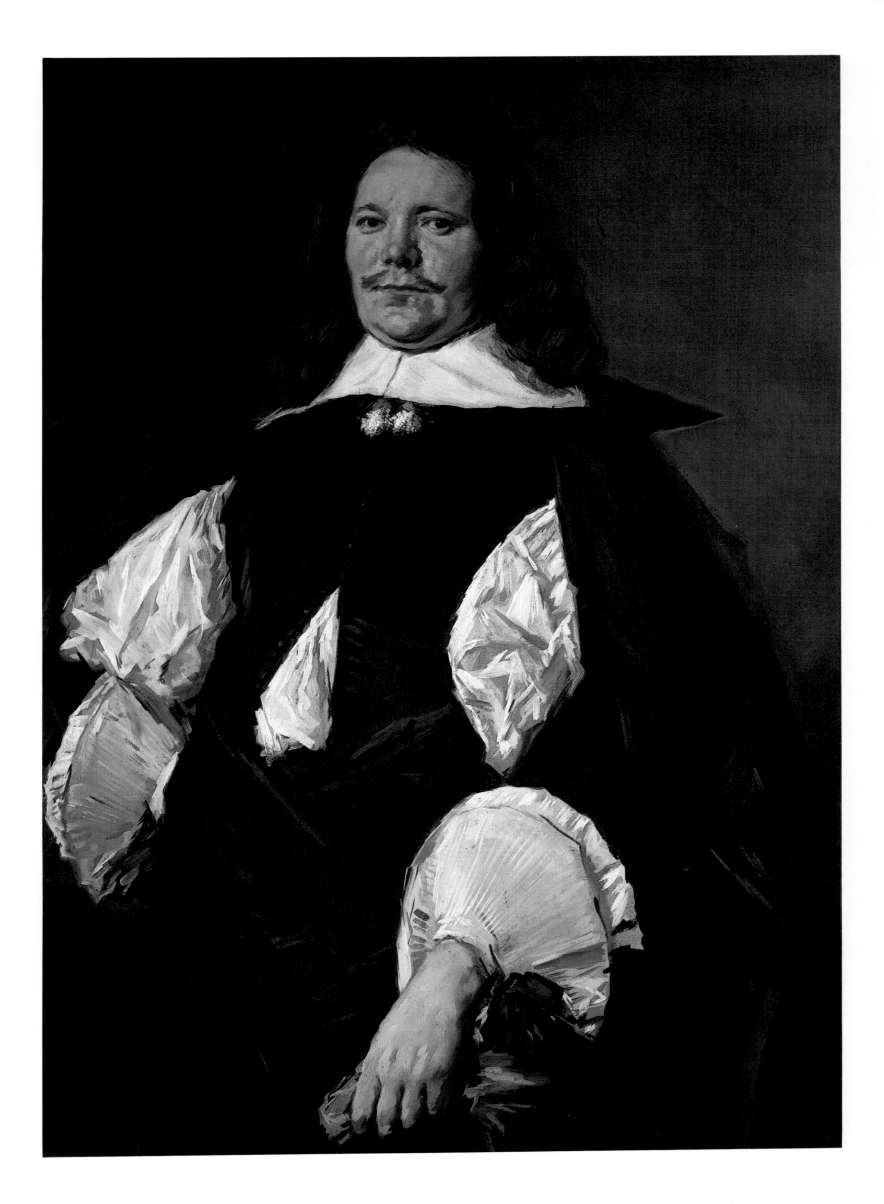

FRANS HALS

PORTRAIT OF A MAN

Painted c. 1660. Oil on canvas
44 1/2 × 32 1/4 in. (113 × 81.9 cm.)
Acquired in 1917

Haarlem, where Hals worked almost all of his life, was already a thriving town in the Middle Ages. By the painter's day it had developed into a prosperous industrial center, best known for its many breweries. Hals' clientele came primarily from the city's burgher class, most of whom, like the unidentified man in the Frick portrait, look as though they had enjoyed many a glass of the native beverage. Once erroneously believed to depict the seventeenth-century Dutch naval hero Michiel de Ruyter, the painting in fact resembles none of the known portraits of De Ruyter. The date of the portrait has also been the subject of discussion, but it appears to have been painted when Hals was already well over seventy. By then he had developed the flashing bravura technique particularly evident here in the crisp, white shirt, the subtle grays and black of the coat, and the impressionistically sketched yellow ochre gloves. Hals' paintings such as this one would later influence Manet.

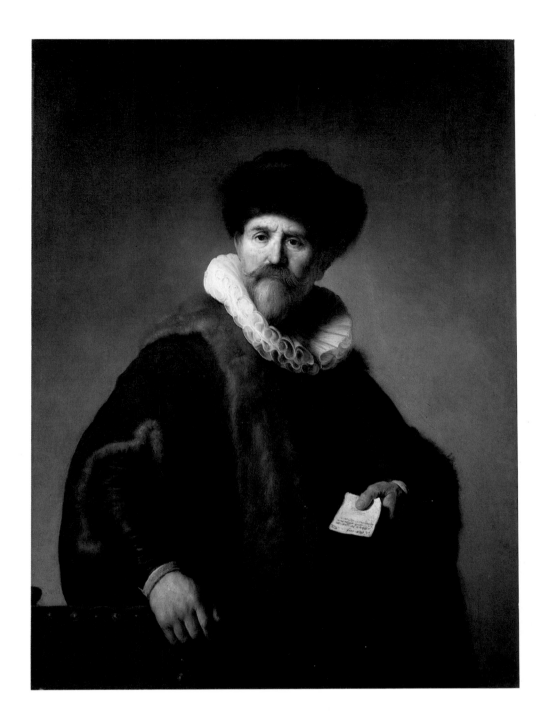

REMBRANDT HARMENSZ. VAN RIJN
1606—1669

Rembrandt first studied art in his native Leyden and later worked under Pieter Lastman in Amsterdam. Around 1625 he returned to Leyden, but in 1631/32 he settled permanently in Amsterdam. Although he enjoyed a great reputation and pupils flocked to him, he suffered financial difficulties that led to insolvency in 1656. By 1660 most of his debts were settled, and his last years were spent in relative comfort. Rembrandt painted many portraits, Biblical scenes, and historical subjects.

NICOLAES RUTS

Dated 1631. Oil on panel
46 × 34 3/8 in. (116.8 × 87.3 cm.)
Acquired in 1943

Born in Cologne, Nicolaes Ruts (1573–1638) was a merchant who traded with Russia, the source, no doubt, of the rich furs in which he posed for this portrait. Rembrandt's likeness of him, perhaps the first portrait commission the artist received from someone outside of his own family, was painted presumably for Ruts' daughter Susanna. A 1636 inventory of her property listed the picture of her father as "the portrait of Nicolaes Ruts made by Rembrant." The dramatic contrasts in lighting and the detailed rendering of the varied textures are characteristic of Rembrandt's early work, differing markedly from the warm, diffused light and broad brushwork that distinguish the Frick *Self-Portrait* executed over a quarter of a century later.

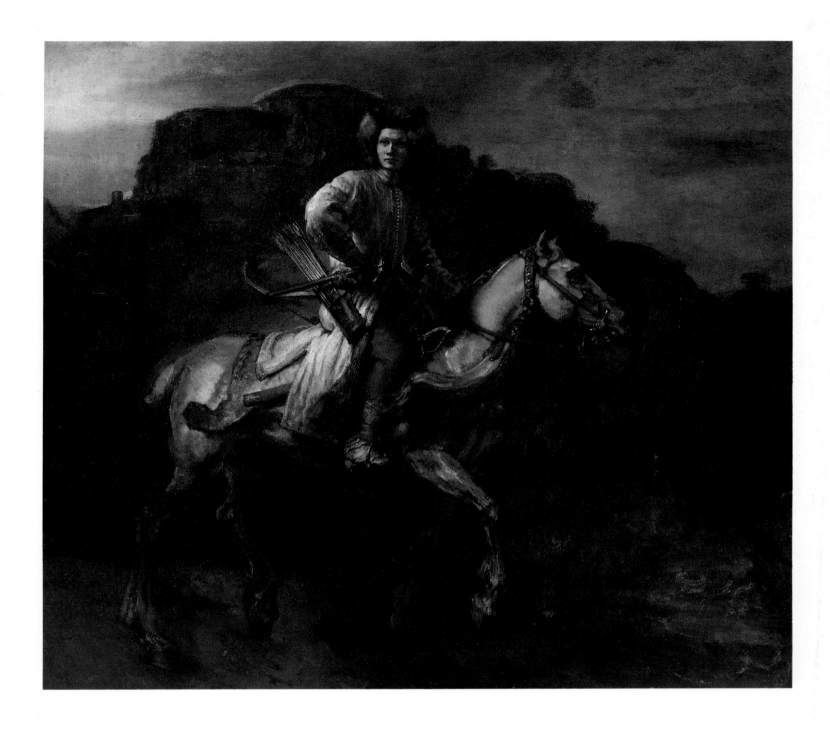

REMBRANDT HARMENSZ. VAN RIJN

SELF-PORTRAIT *(opposite)*

Dated 1658. Oil on canvas
52 5/8 × 40 7/8 in. (133.7 × 103.8 cm.)
Acquired in 1906

Between 1625, the date of his earliest known work, and 1669, the year of his death, Rembrandt painted over sixty self-portraits and drew and etched his own likeness repeatedly. The portraits range as widely in character as in date. The artist's youthful self-portraits concentrated more on reproducing physical appearance, and many seem to have been experiments in which he practiced dramatic lighting effects or transitory facial expressions,

using himself as a model. The later portraits are more subtle and searching.

In the Frick portrait, Rembrandt created an image of strength and worldly power that seems to contradict the external facts of his life. A small man, he portrayed his figure in monumental dimensions. Only fifty-two, he painted a face blurred and eroded by age, sorrows, and illness. A bankrupt, he pictured himself in a costume he seems elsewhere to have associated with ancient or Oriental kingship. The hieratic frontal pose, unusual in self-portraiture of the time, also suggests an enthroned ruler, and the artist holds his stick as if it were a scepter. It gleams as though made of gold, and the warm gold and vermilion colors of his garments further contribute to the impression of richness and power.

REMBRANDT HARMENSZ. VAN RIJN

THE POLISH RIDER *(above)*

Painted c. 1655. Oil on canvas
46 × 53 1/8 in. (116.8 × 134.9 cm.)
Acquired in 1910

The romantic and enigmatic character of this picture has inspired many theories about its subject, meaning, history, and even its attribution to Rembrandt.

Several portrait identifications have been proposed, including an ancestor of the Polish Oginski family, which owned the painting in the eighteenth century, and the Polish Socinian theologian Jonasz Szlichtyng. The rider's costume, his weapons, and the breed of his horse

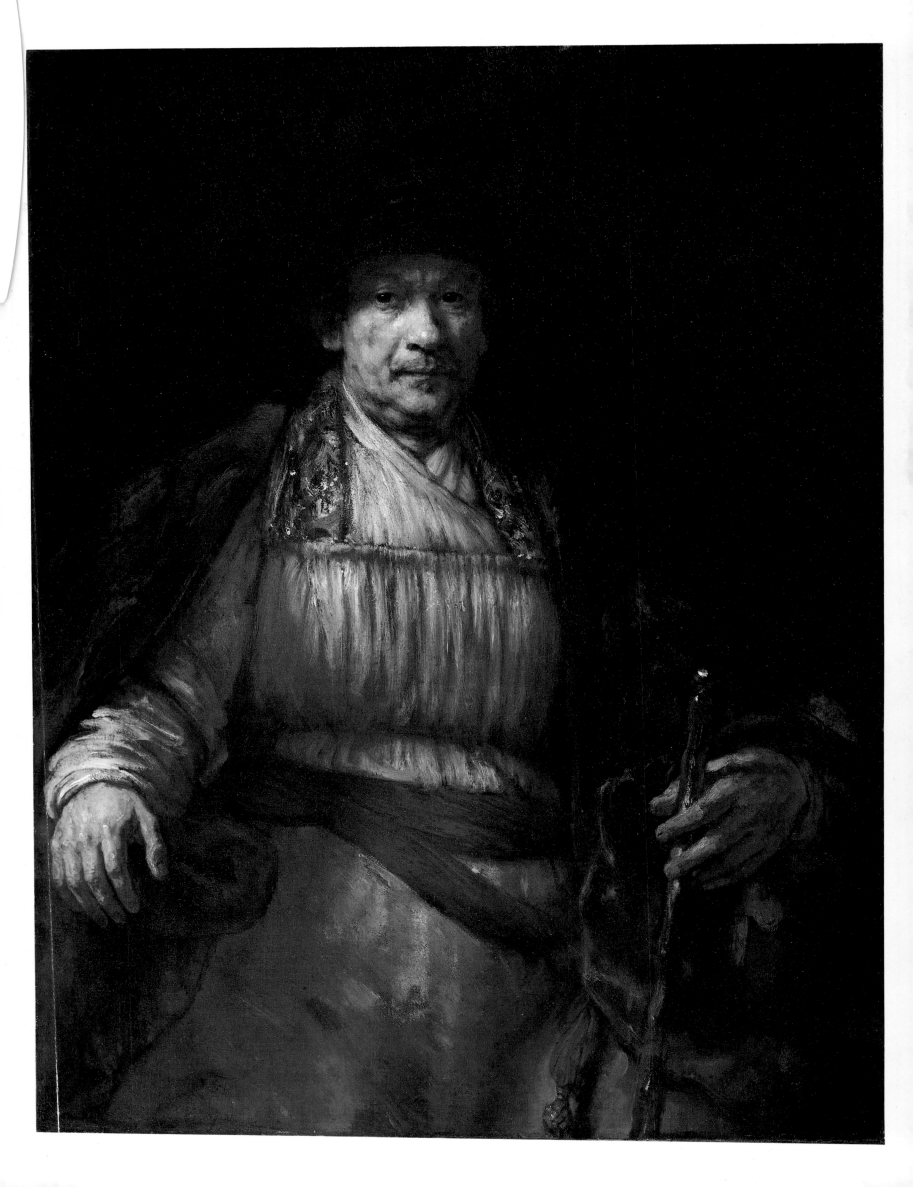

have also been claimed as Polish. But if *The Polish Rider* is a portrait, it certainly breaks with tradition. Equestrian portraits are not common in seventeenth-century Dutch art, and furthermore, in the traditional equestrian portrait the rider is fashionably dressed and his mount is spirited and well-bred.

The painting may instead portray a character from history or literature, and many possibilities have been proposed. The broad spectrum of candidates suggested ranges from the Prodigal Son to Gysbrech van Amstel, a hero of Dutch medieval history, and from the Old Testament David to the Mongolian warrior Tamerlane.

It is possible that Rembrandt intended simply to represent a foreign soldier, a theme popular in his time in European art, especially in prints. Nevertheless, Rembrandt's intentions in *The Polish Rider* seem clearly to transcend a simple expression of delight in the exotic. The painting has also been described as a latter-day *Miles Christianus,* an apotheosis of the mounted soldiers who were still defending Eastern Europe against the Turks in the seventeenth century. Many have felt that the youthful rider faces unknown dangers in the strange and somber landscape, with its mountainous rocks crowned by a mysterious building, its dark water, and the distant flare of a fire.

In recent years some Rembrandt scholars have questioned the attribution, but to date no one has published a reasoned argument in support of this doubt, nor one that convincingly demonstrates which of Rembrandt's pupils might have been capable of painting *The Polish Rider.*

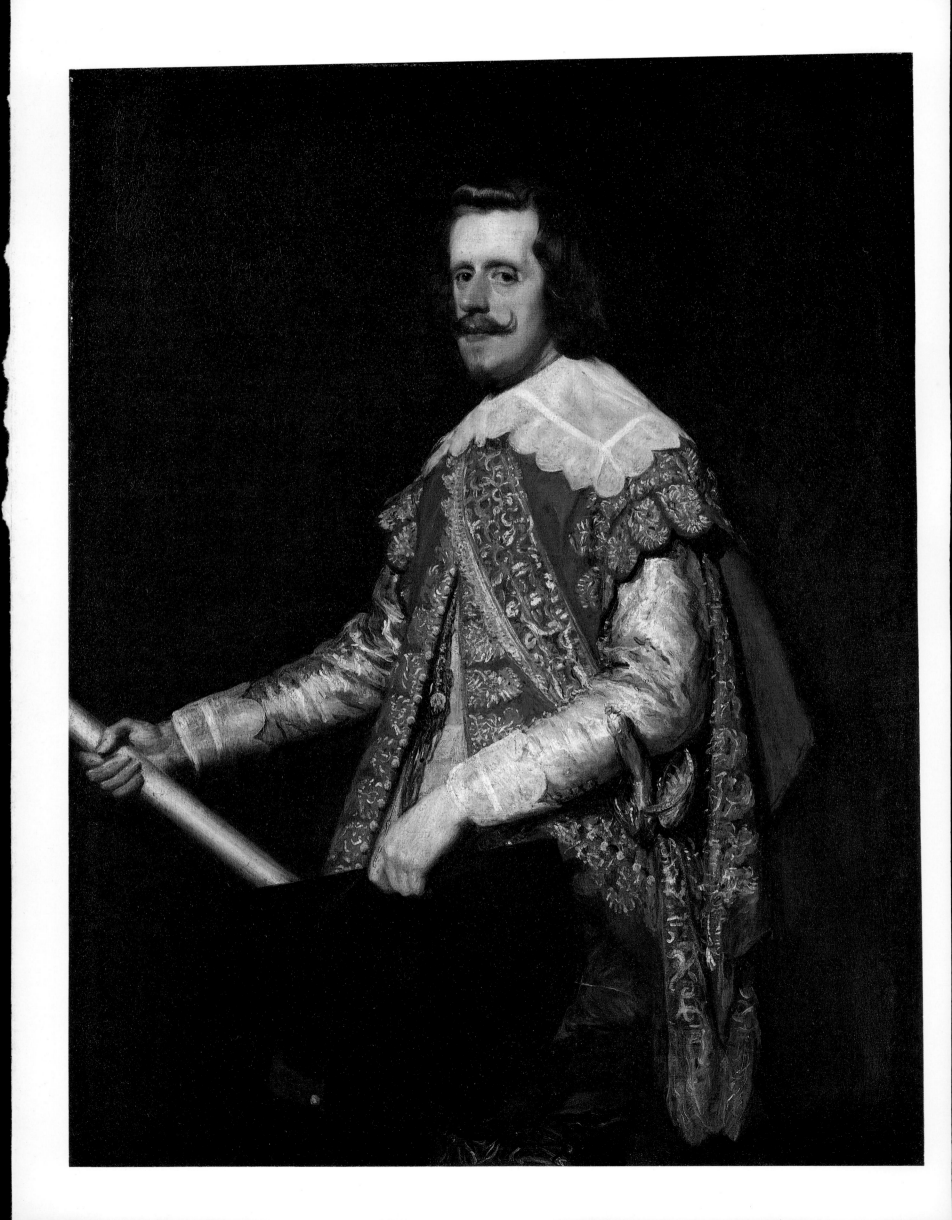

DIEGO RODRÍGUEZ DE SILVA Y VELÁZQUEZ
1599–1660

Born in Seville, the son of a lawyer of Portuguese descent, Velázquez was apprenticed at the age of eleven to the painter Francisco Pacheco. In 1623 he was called to Madrid, where he soon painted his first portrait of King Philip IV. Velázquez became not only court painter, but also a close friend of the King, who ennobled him and made him a knight of the Military Order of Santiago and a gentleman in waiting. His work undoubtedly profited from study of the royal collection, which was rich in works of the Venetians, and he probably also was influenced by Rubens during the latter's visit to Madrid in 1628–29. Apart from sojourns in Italy in 1629–31 and 1649–51, Velázquez remained at the Spanish court until his death.

KING PHILIP IV OF SPAIN

Painted in 1644. Oil on canvas
51 1/8 × 39 1/8 in. (129.8 × 99.4 cm.)
Acquired in 1911

Philip IV (1605–65), who succeeded to the throne in 1621, was a weak ruler but a lavish patron of the arts and letters. He promoted the Spanish theater, built the Palacio del Buen-Retiro, enlarged the royal collections, and was Velázquez' most ardent supporter. In 1644 Velázquez accompanied the King on a campaign to Catalonia, where the Spanish army led a successful siege of Lérida against the French. In the town of Fraga, the King's headquarters, in a dilapidated, makeshift studio, Philip posed for this portrait dressed in the silver-and-rose costume he wore during the campaign. Although Velázquez painted numerous portraits of Philip IV, this is the only one dating from the 1640s.

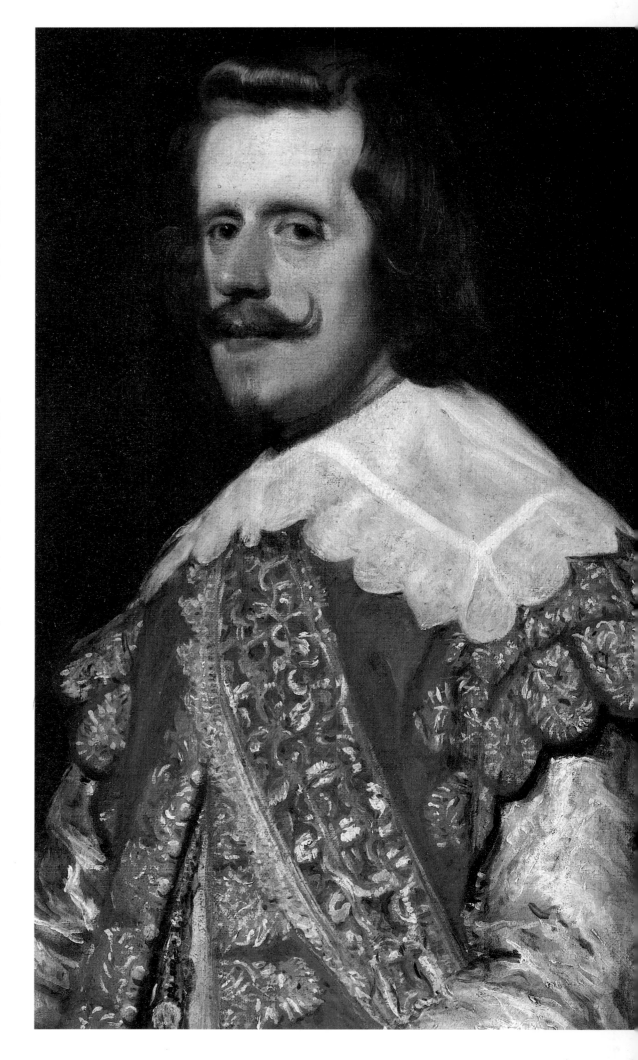

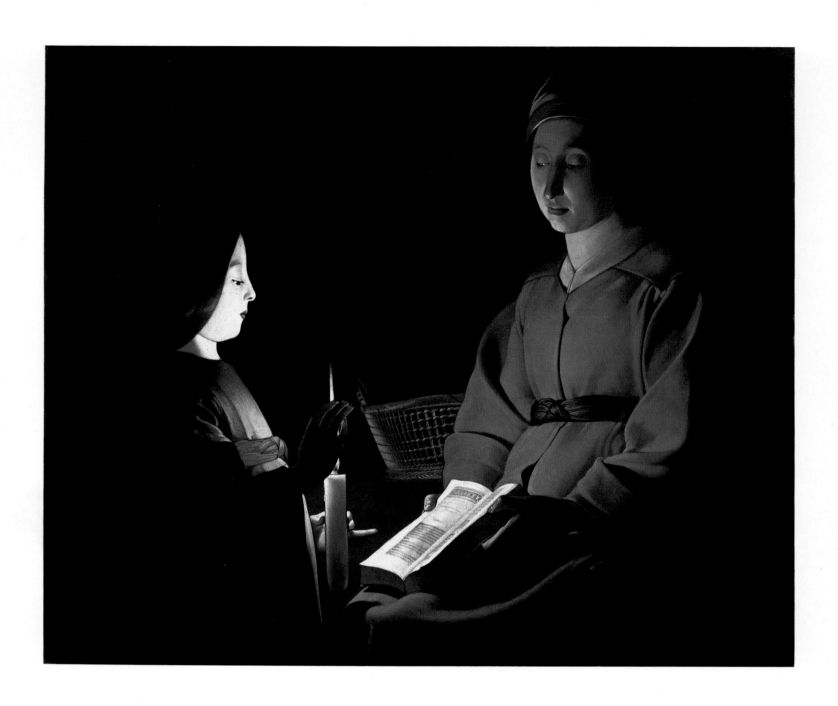

ÉTIENNE DE LA TOUR (?)
b. 1621

Little is known of Étienne de La Tour, son of the illustrious Georges de La Tour (1593–1652), except the date of his baptism in Lunéville—March 2, 1621—and the references that are made to him as "painter" in 1646 and "master painter" in 1652. He appears to have moved to Vic-sur-Seille soon after his father's death.

THE EDUCATION OF THE VIRGIN

Painted c. 1650. Oil on canvas
33 × 39 1/2 in. (83.8 × 100.4 cm.)
Acquired in 1948

Recent studies of the several surviving versions of this dramatic composition suggest that all may be replicas of a lost original by Georges de La Tour. The Frick canvas has been attributed to the artist's son Étienne primarily because of the form of its signature.

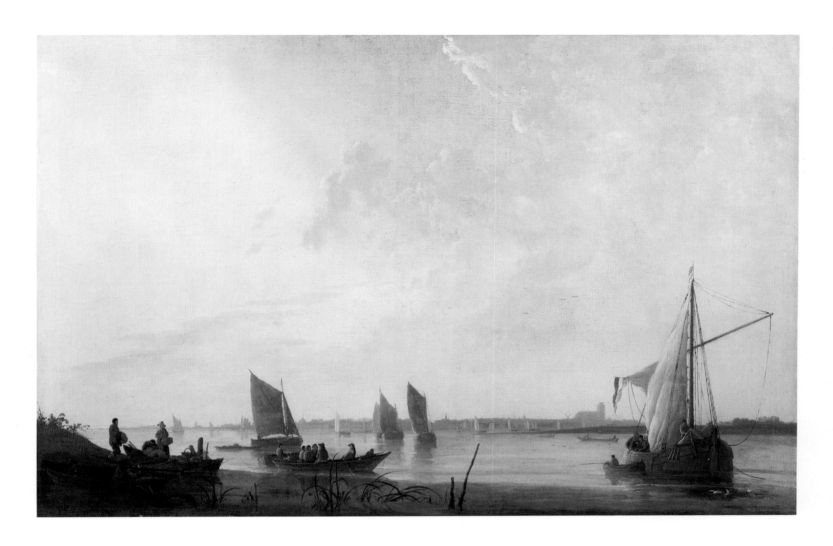

AELBERT CUYP
1620–1691

Cuyp was born in Dordrecht and spent his entire life there. His early pictures recall those of his father, Jacob Gerritsz. Cuyp, and of Jan van Goyen. In the 1640s, under the influence of the Italianized landscapes of Jan Both and others, he developed the luminous style that characterizes his best-known works. He produced landscapes and occasional portraits until the mid 1660s, when he appears to have ceased painting.

DORDRECHT: SUNRISE

Painted c. 1650. Oil on canvas
40 1/8 × 63 3/8 in. (102 × 161 cm.)
Acquired in 1905

This early morning scene, with its golden expanse of sky and water, is one of Cuyp's most ambitious attempts to render light and atmosphere. The painting may ultimately reflect the influence of Claude Lorrain, whose landscapes impressed many Dutch artists. Cuyp depicts the port city of Dordrecht as seen from the north, looking across the river Merwede. Most prominent among the recognizable buildings is the Groote Kerk, the church on the horizon to the left of the large boat in the foreground.

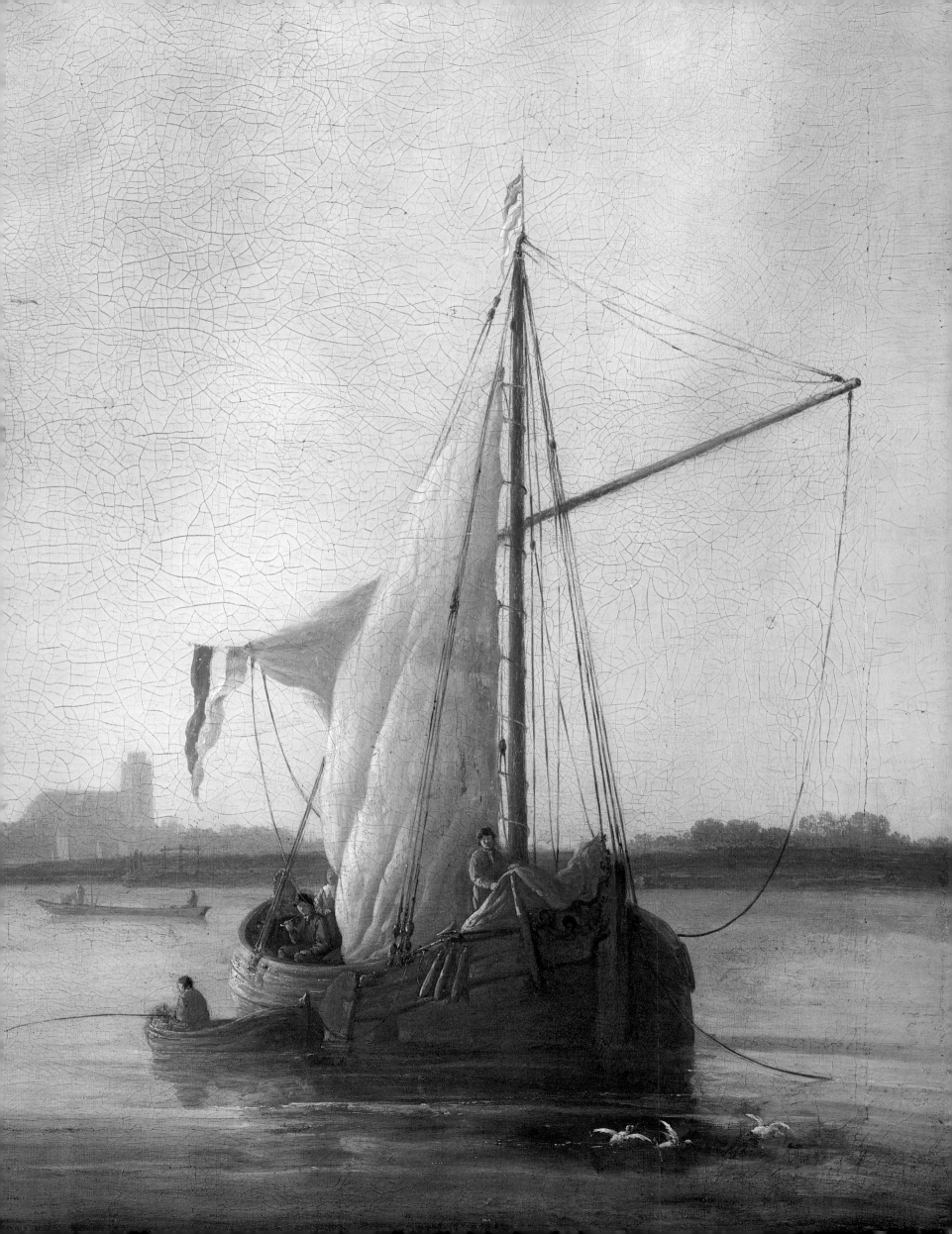

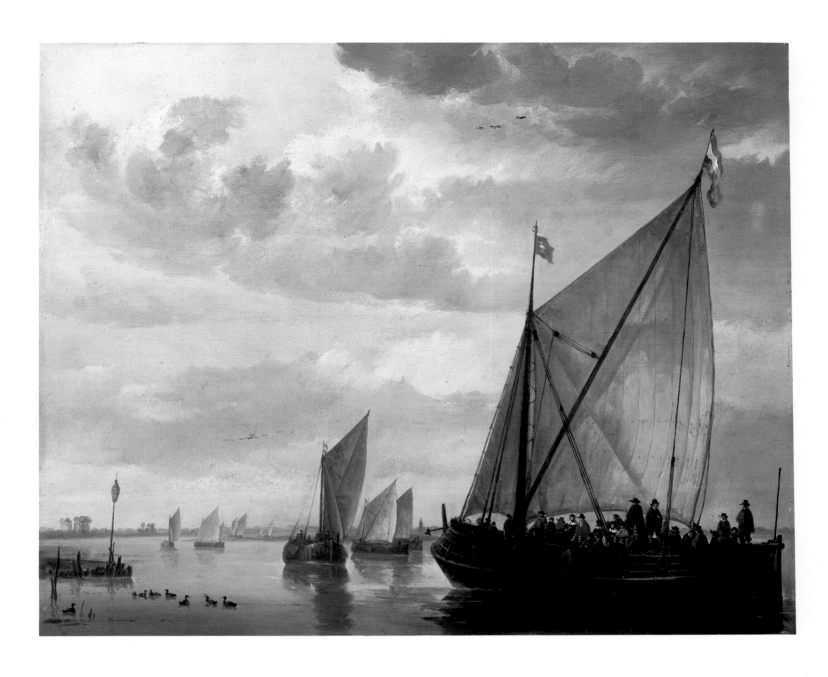

AELBERT CUYP

RIVER SCENE

Date unknown. Oil on panel
23 1/8 × 29 1/8 in. (58.7 × 74 cm.)
Acquired in 1909

Scenes of vessels plying the inland waterways
around Dordrecht were among Cuyp's special-
ties and permitted him to exploit intricate
effects of light, such as those on the sails in this
panel. Ferries of the type depicted in the right
foreground were among the chief means of
public transportation in the Netherlands until
the expansion of stagecoach routes in the eigh-
teenth century.

MEYNDERT HOBBEMA
1638–1709

In 1657 Hobbema was apprenticed in his native Amsterdam to Jacob van Ruisdael, whose style and subject matter had a profound influence on him. Hobbema painted landscapes prolifically until 1668, when he was appointed municipal assessor of wine-measures. Relatively few works appear to date from his last forty years.

VILLAGE WITH WATER MILL AMONG TREES

Painted probably between 1660 and 1670. Oil on canvas
37 1/8 × 51 1/8 in. (94.3 × 129.8 cm.)
Acquired in 1911

VILLAGE AMONG TREES

Dated 1665. Oil on panel
30 × 43 1/2 in. (76.2 × 110.5 cm.)
Acquired in 1902

Elements the artist repeated throughout his career—variegated foliage, picturesque cottages, a winding road, and a sky with wind-swept clouds—can be seen in both of these landscapes. But if Hobbema's repertory of motifs was limited, he managed nevertheless to invest his paintings with considerable freshness and variety.

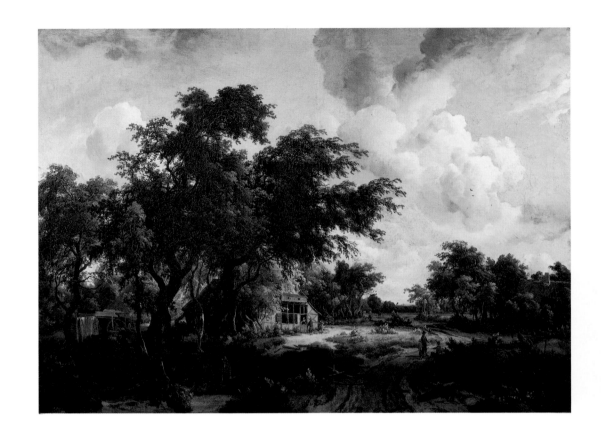

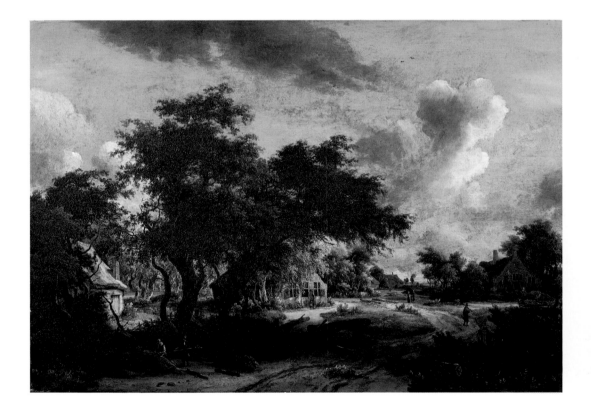

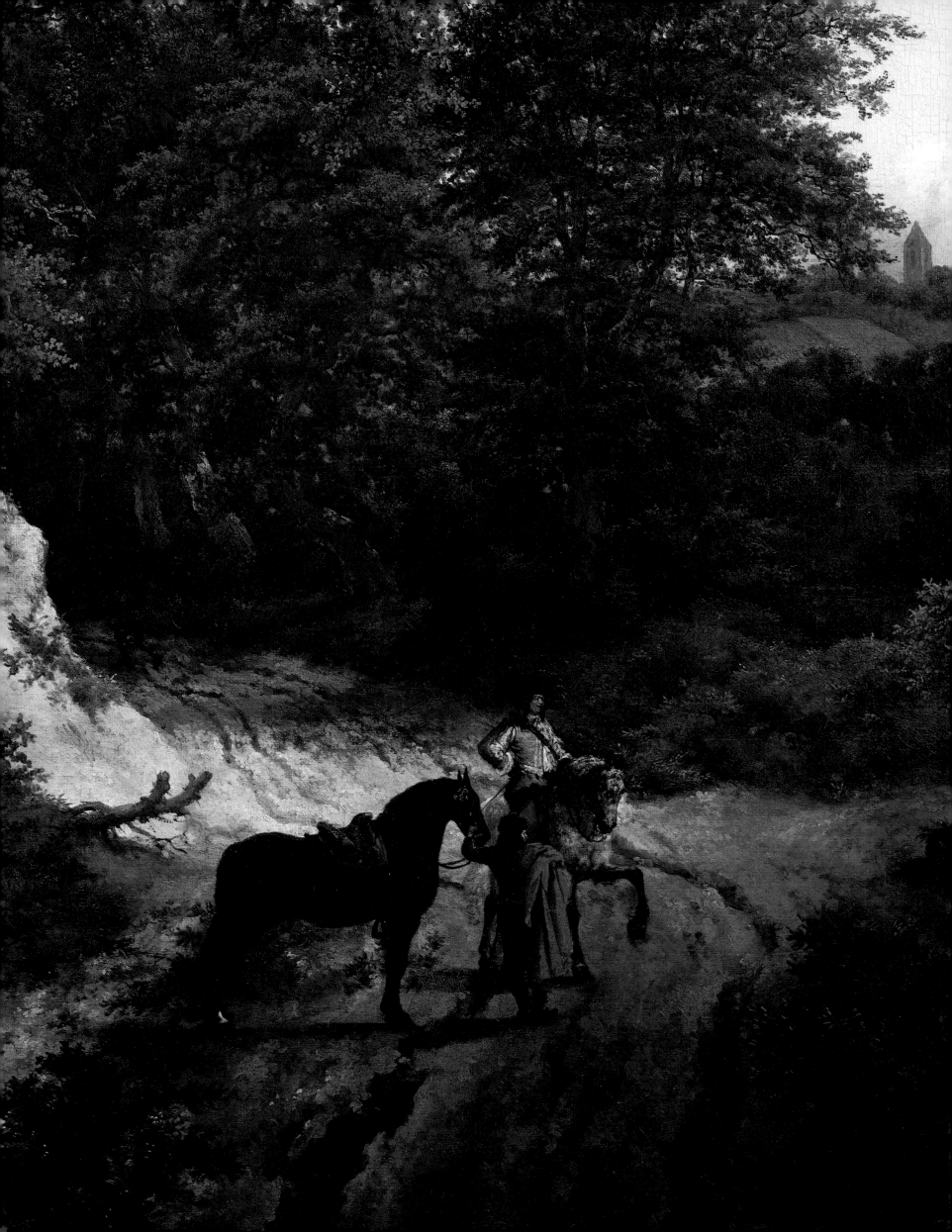

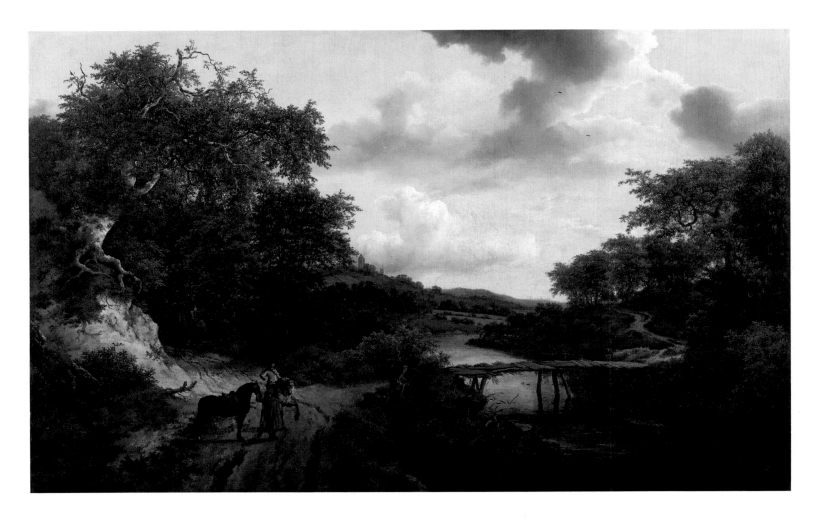

JACOB VAN RUISDAEL
1628/29–1682

Born in Haarlem, where he had an early exposure to painting through his father's art dealing and framing business, Ruisdael entered the painters' guild there in 1648, presumably after studying with his uncle Salomon van Ruysdael. By 1657 he was living in Amsterdam, where he seems to have spent the rest of his life. His many paintings, drawings, and etchings are devoted entirely to landscape. Ruisdael depicted a broad range of scenery, from the flat, watery landscape around Haarlem to thickly wooded mountains and forests.

LANDSCAPE WITH A FOOTBRIDGE

Dated 1652. Oil on canvas
38 3/4 × 62 5/8 in. (98.4 × 159.1 cm.)
Acquired in 1949

Although the exact locality of this landscape has not been determined, the hilly conformation of the countryside, as well as the date of the work, suggest that the site may have been in the province of Overijssel, near the Dutch-German frontier, where Ruisdael visited in 1650. Previously he had generally depicted the flatter countryside of central Holland. The painting demonstrates the youthful artist's special gift for rendering subtle effects of light, evident in the pale sun that filters through the clouds to dapple the landscape and reflect from the surface of the stream. The realistic treatment of the gnarled oak tree at left is typical of his close observation of nature. The figures apparently were added by another hand, as was Ruisdael's usual practice.

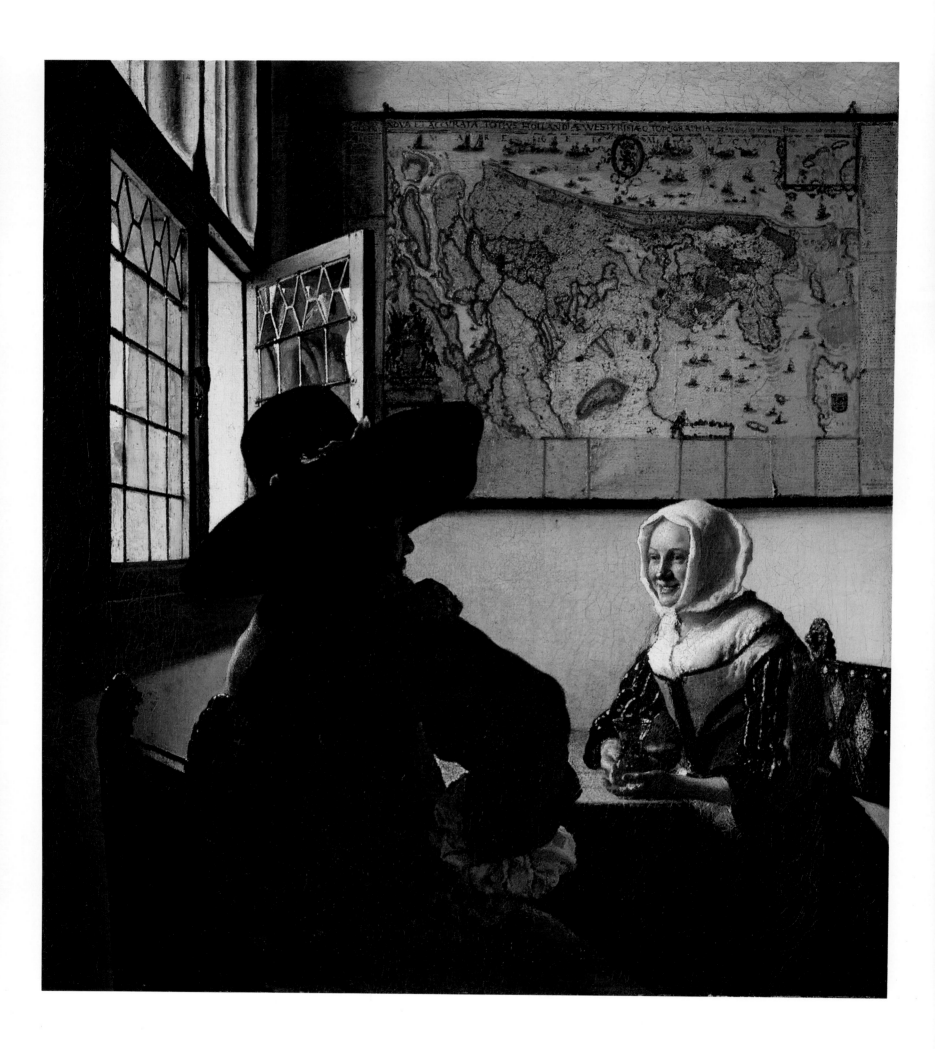

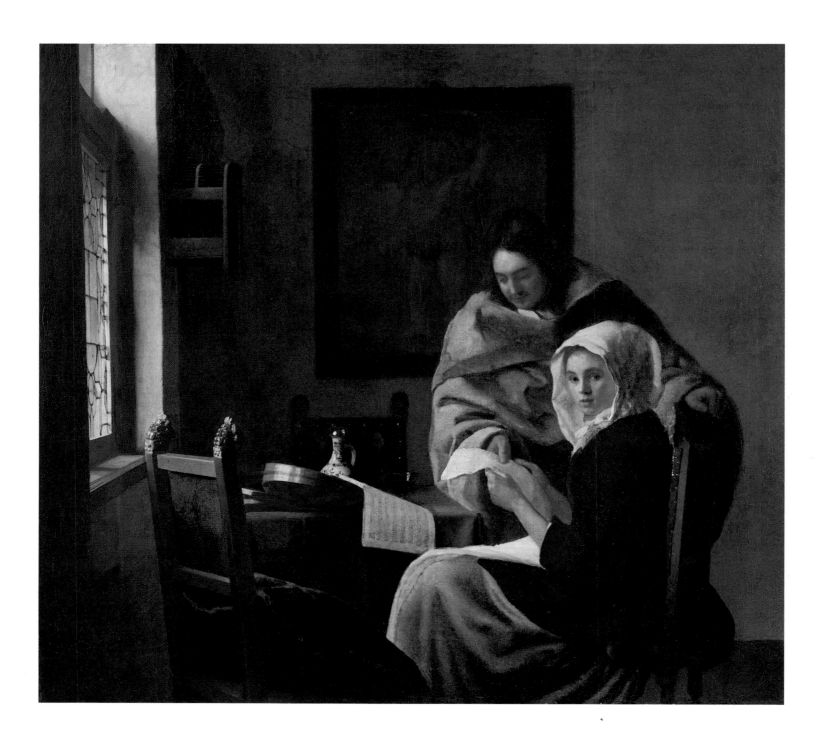

JOHANNES VERMEER
1632–1675

Vermeer was born in Delft and apparently spent his whole life there. Although nothing is known of his early years and training, he was influenced by the Caravaggesque painters of Utrecht and by Carel Fabritius, who may have been his teacher. In 1653 he became a member of the Guild of St. Luke in Delft. Vermeer did not paint many pictures and sold very few, although he commanded high prices. He may have supplemented his income by art dealing. In 1696, two decades after his death, his widow sold twenty-one of his works. Only about thirty-five paintings are now accepted as being by Vermeer.

OFFICER AND LAUGHING GIRL
Painted between 1655 and 1660. Oil on canvas
19 7/8 × 18 1/8 in. (50.5 × 46 cm.)
Acquired in 1911

In what may be one of the first works of his mature style, Vermeer transforms the theme of a girl entertaining her suitor, already popular in Dutch art, into a dazzling study of light-filled space. The dark foil of the officer's silhouette dramatizes both the illusion of depth and the brilliant play of light over the woman and the furnishings of the chamber. The map of Holland on the far wall, oriented with west at the top, was first published in 1621. Both the map and the chairs appear in other paintings by Vermeer.

JOHANNES VERMEER

GIRL INTERRUPTED AT HER MUSIC
Painted c. 1660. Oil on canvas
15 1/2 × 17 1/2 in. (39.3 × 44.4 cm.)
Acquired in 1901

Music-making, a recurring subject in Vermeer's interior scenes, was associated in the seventeenth century with courtship. In this painting of a duet or music lesson momentarily interrupted, the amorous theme is reinforced by the picture of Cupid with raised left arm dimly visible in the background; the motif is derived from a popular book on emblems of love published in 1608 and symbolizes fidelity to a single lover.

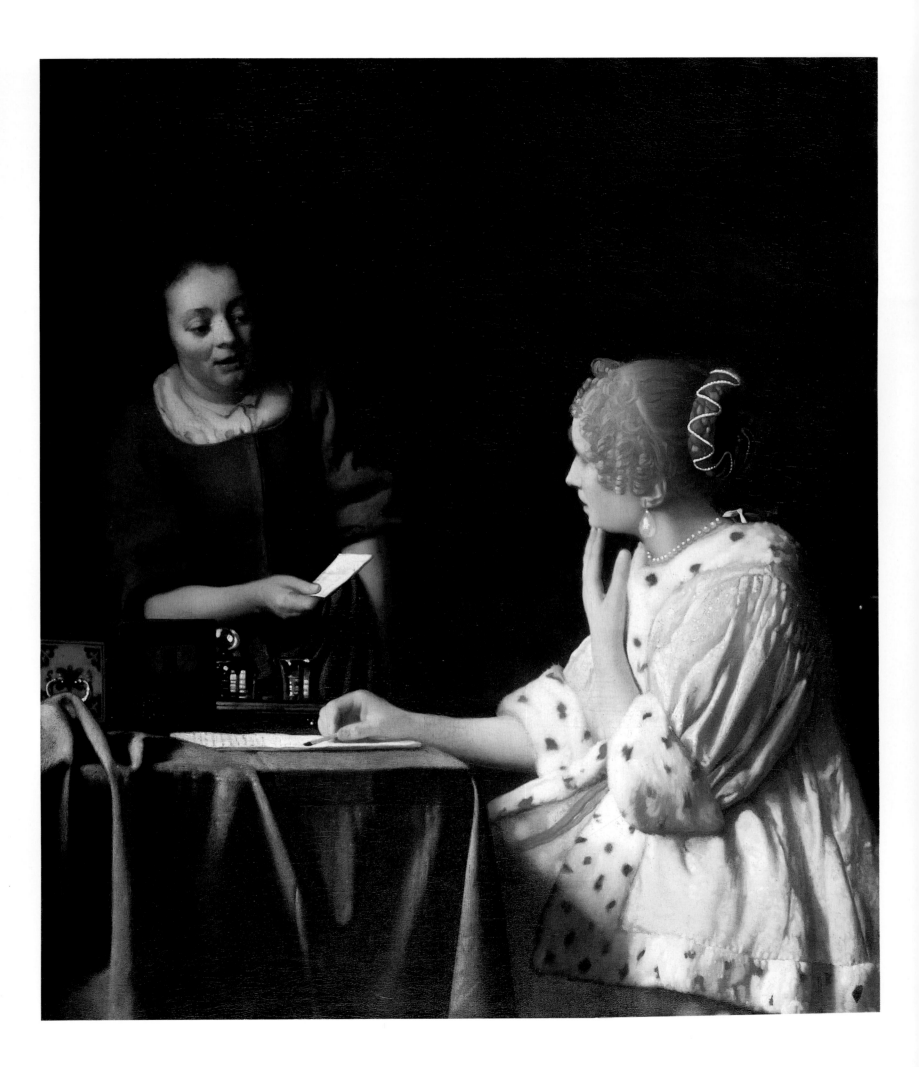

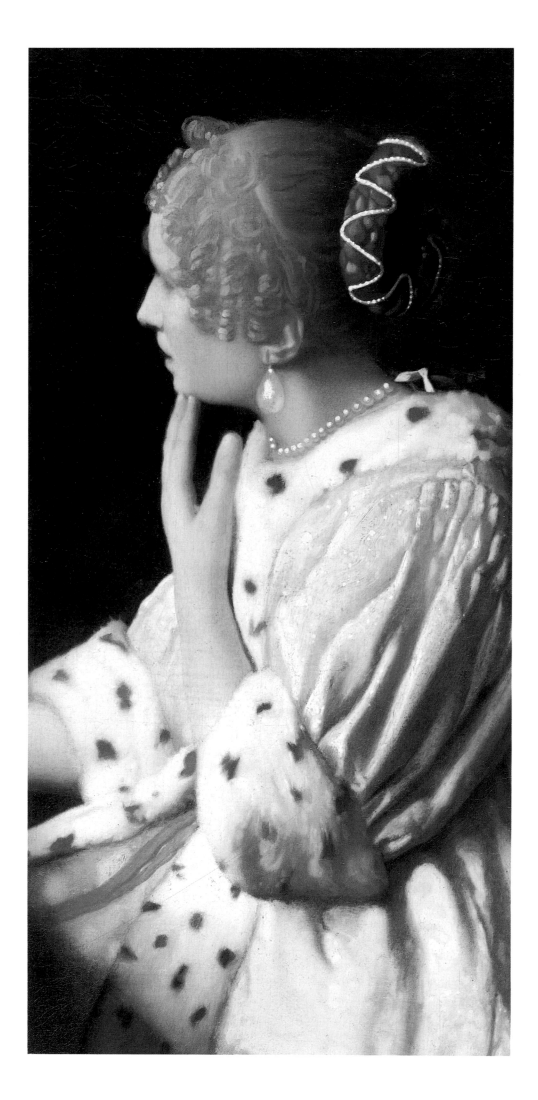

JOHANNES VERMEER

MISTRESS AND MAID

Painted probably between 1665 and 1670. Oil
on canvas
35 1/2 × 31 in. (90.2 × 78.7 cm.)
Acquired in 1919

The subject of writing and receiving letters,
which recurs frequently in Vermeer's work, is
given an exceptional sense of dramatic tension
in this painting of two women arrested in some
moment of mysterious crisis. The lack of final
modeling in the mistress' head and figure and
the relatively plain background indicate that
this late work by Vermeer was left unfinished.
Nevertheless, the artist seldom if ever surpassed
the subtly varied effects of light seen here as it
gleams from the pearl jewelry, sparkles from the
glass and silver objects on the table, and falls
softly over the figures in their shadowy setting.
Bought by Mr. Frick in 1919, the year of his
death, this painting was his last purchase and
joined Rembrandt's *Self-Portrait,* Holbein's *Sir
Thomas More,* Bellini's *St. Francis,* and Velázquez'
King Philip IV among his favorite acquisitions.

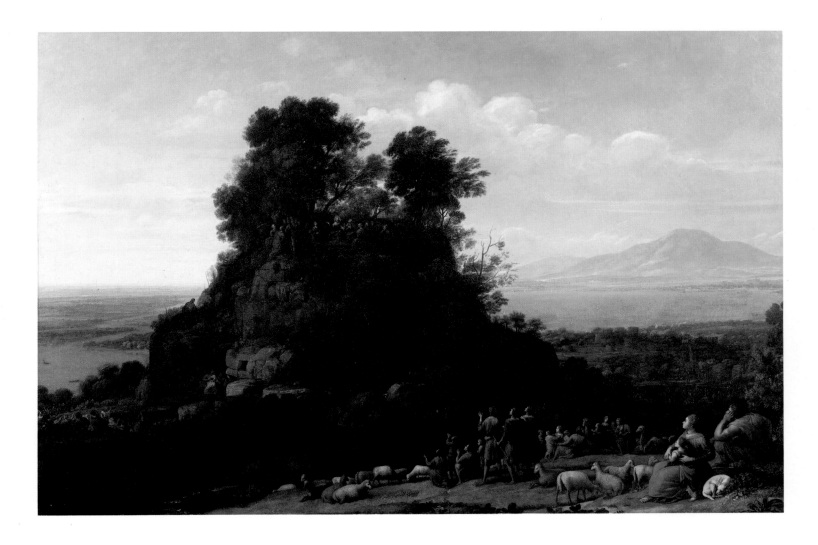

CLAUDE LORRAIN
1600–1682

Claude Gellée, who was called Lorrain after his native province of Lorraine, settled in Rome perhaps as early as 1613 and spent nearly all of his adult life there. His early work was chiefly in fresco, of which little remains, but his fame is based on landscape canvases, often with Biblical or mythological subjects. Patronized principally by the Italian nobility, he also enjoyed an international reputation. Among the many later painters influenced by his work, the most vocal admirer was Turner.

THE SERMON ON THE MOUNT

Painted in 1656. Oil on canvas
67 1/2 × 102 1/4 in. (171.4 × 259.7 cm.)
Acquired in 1960

Christ, surrounded by the Twelve Apostles, is shown preaching to the multitude from the wooded summit of Mount Tabor, as described in the Gospel of Matthew (5:1–2): "When he saw the crowds he went up the hill. There he took his seat, and when his disciples had gathered round him he began to address them." It was in this discourse that Jesus set forth the principles of the Christian ethic through the Beatitudes and instituted the Lord's Prayer. The crowds that Matthew described as "astounded at his teaching" are vividly depicted by Claude among the absorbed and gesticulating foreground figures, whose diminishing sizes enhance the dramatic spatial effects of the vast and airy landscape.

The artist has compressed the geography of the Holy Land, placing on the right the distant Mount Lebanon and the Sea of Galilee—with the towns of Tiberias and Nazareth on its shore—and on the left the Dead Sea and the river Jordan.

Executed for François Bosquet, Bishop of Montpellier, the painting later entered the collection of Alderman William Beckford at Fonthill House in Wiltshire, where it suffered minor damage in a fire that almost totally destroyed its companion picture, *Queen Esther Approaching the Palace of Ahasuerus.*

The Sermon on the Mount was the product of preparatory drawings ranging from topographical layouts to compositional and figural studies, including one showing the central group of Christ and the Apostles in a configuration somewhat different from that of the painting (Teylers Museum, Haarlem). Upon completing the picture, the artist made a careful copy of it in the *Liber Veritatis* (British Museum), an album of drawings in which he recorded his paintings in chronological sequence; it was there that he noted when and for whom it had been executed.

The Sermon on the Mount is unusual among Claude's landscapes both for its exceptional size and for its large central mass, but in its magical luminosity it is characteristic of his finest achievements.

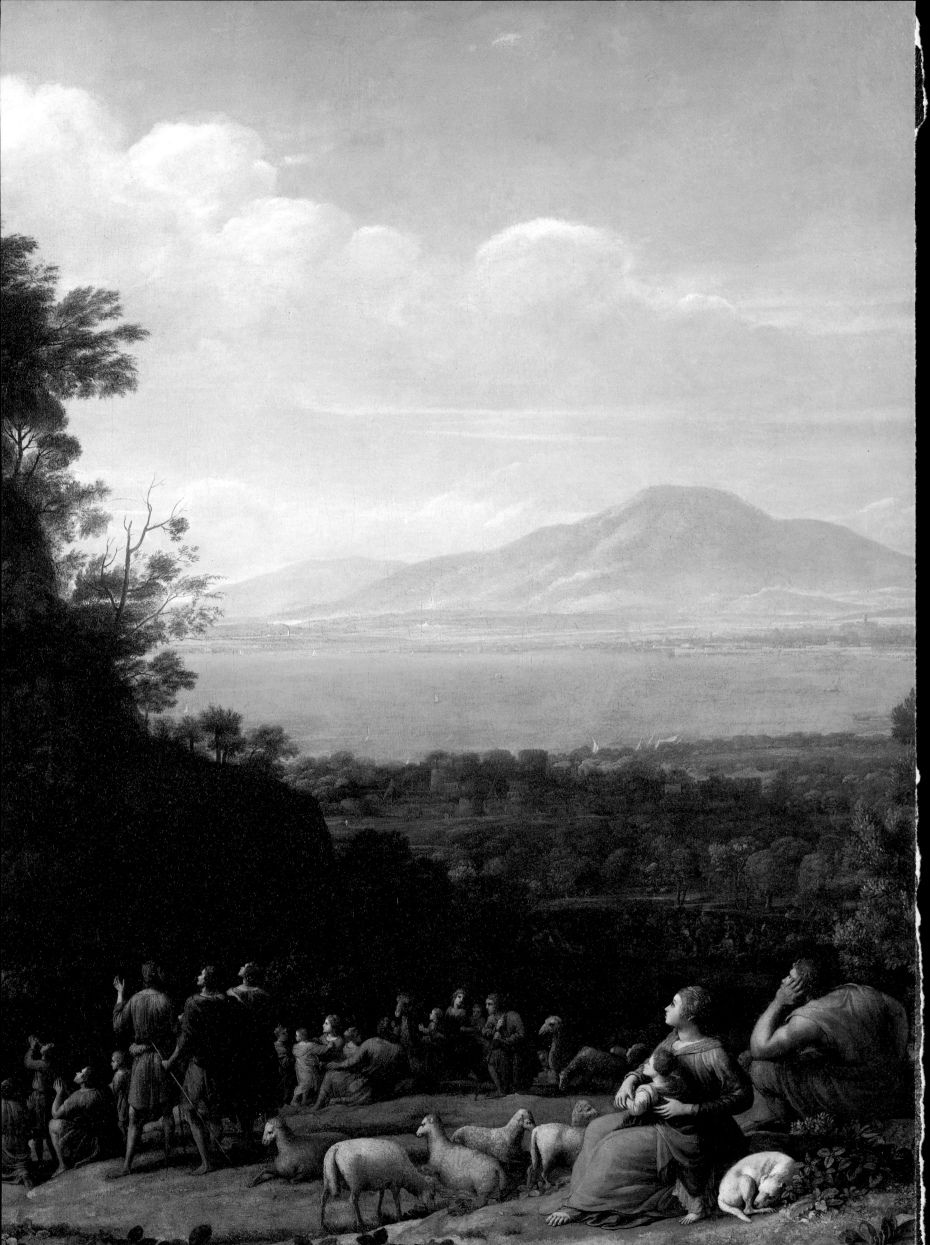

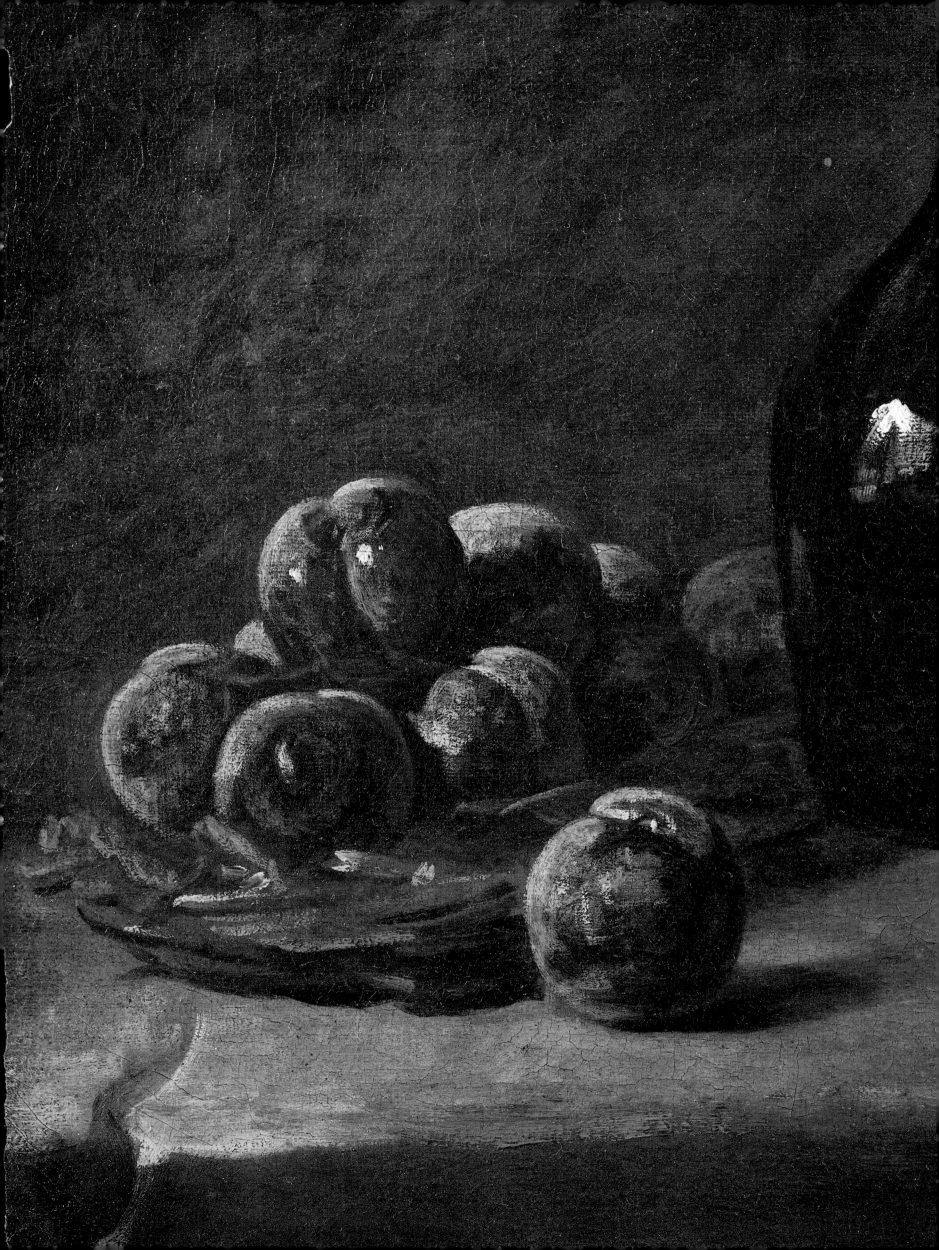

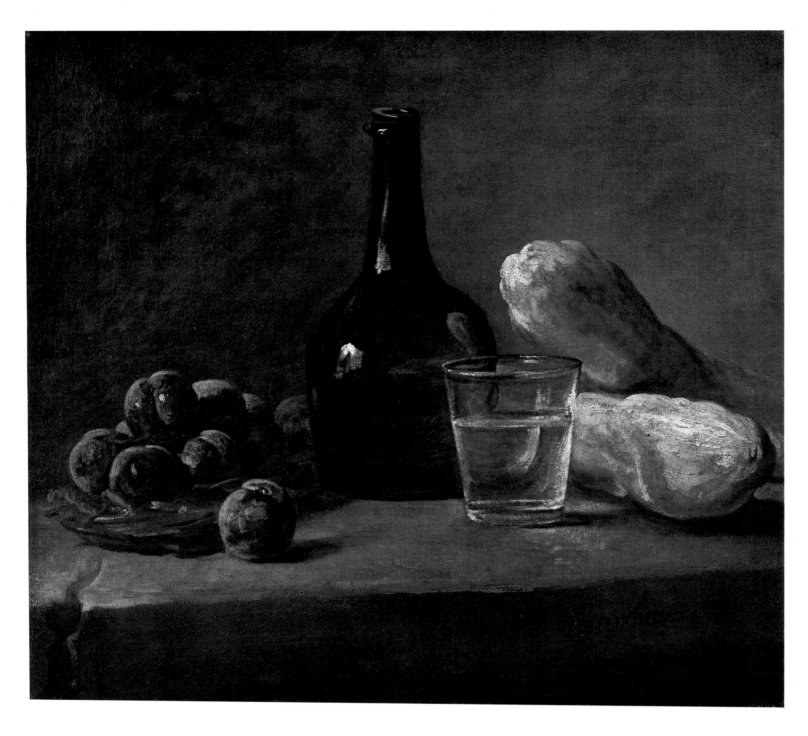

JEAN-SIMÉON CHARDIN
1699–1779

The son of a cabinetmaker, Chardin was born in Paris and never strayed far from the capital. Trained probably under Cazes and Coypel, the young artist was associated first with the Academy of St. Luke in 1724, but four years later he was received into the Royal Academy as a "painter of animals and fruits." By his first wife, Marguerite Saintard—who died in 1735, only four years after their marriage—he had a son, Jean-Pierre, who would develop as a painter and die under mysterious circumstances in Venice in 1767; his second marriage, in 1744, was to Françoise-Marguerite Pouget. Chardin's work appeared at the Salon for the first time in 1737 and thereafter regularly until the year of his death. The artist participated actively in the affairs of the Academy, occupying for nearly twenty years the post of Treasurer, which entailed the delicate responsibility of deciding how each Salon would be hung. Louis XV honored him with commissions, pensions, and lodgings in the Louvre. Chardin's still lifes and domestic scenes were esteemed equally by the general public and by contemporary connoisseurs throughout Europe.

STILL LIFE WITH PLUMS

Painted probably c. 1730. Oil on canvas
17 3/4 × 19 3/4 in. (45.1 × 50.2 cm.)
Acquired in 1945

The only still life in The Frick Collection is a classic example painted by an undisputed master of the genre, probably quite early in his career. Shunning the lavish and complex productions of his Dutch and Flemish predecessors, Chardin simplified the number and type of ingredients in his still lifes, then arranged these familiar household objects in compositions of an architectonic order. Yet it was the illusionistic realism of such pictures that the artist's contemporaries marveled at, and that led Diderot to speak of their "magic." It was to Diderot that Chardin revealed the source of his prodigious tactile sense, saying it was by touch and not by sight that he judged, say, the roundness of pine kernels (or here, of plums), rolling them gently between his thumb and forefinger. Modern eyes appreciate too the rich, creamy surfaces of his paintings, which seem to breathe and have a life of their own.

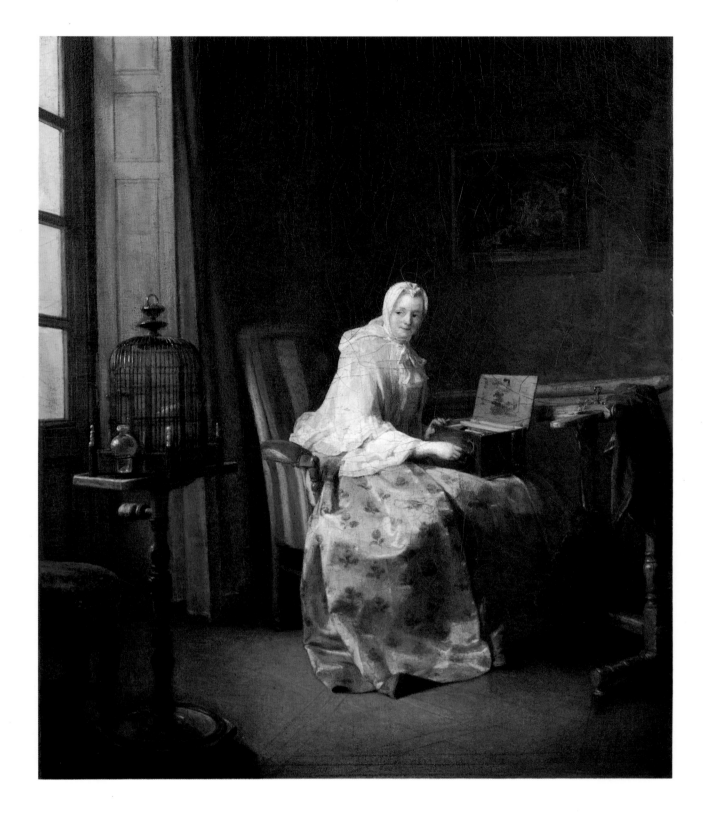

JEAN-SIMÉON CHARDIN

LADY WITH A BIRD-ORGAN

Painted in 1753(?). Oil on canvas
20 × 17 in. (50.8 × 43.2 cm.)
Acquired in 1926

It is curious that the artist's first royal commission—in 1751—should also have been his last figural composition. In fact, Chardin would afterward paint nothing but still lifes or an occasional portrait, not even completing the companion picture to the *Lady with a Bird-Organ*

that had been ordered for Louis XV. In the Frick canvas, which may well be a replica Chardin made in 1753 of the original painting delivered to the King two years earlier and now in the Louvre, the artist has depicted a middle-class lady—perhaps his second wife—training a caged canary to sing by playing an eighteenth-century precurser of the phonograph known as a bird-organ. The title of the picture when exhibited at the Salon of 1751—*A Lady Varying Her Amusements*—refers to the subject's having put aside her embroidery to play with the bird.

As the final example of Chardin's depictions of figures in interiors, the *Lady with a Bird-Organ* contrasts markedly with his earlier images of robust servants whose simple forms dominate their picture space. Different too are the porcelain-like finish of this picture (albeit abraded) and its muted, silvery coloration. One might almost assume that the artist felt obliged to be on his best behavior in presenting his work to his monarch, but these qualities are actually deliberate echoes of seventeenth-century Dutch masters then much in vogue.

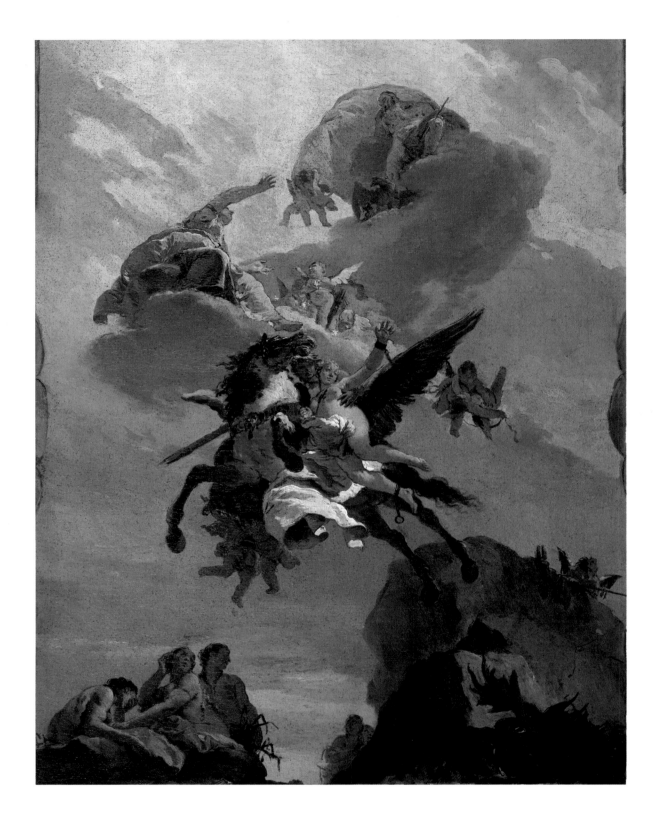

GIOVANNI BATTISTA TIEPOLO

1696–1770

Tiepolo's brilliant talents, especially as a decorator of palaces, villas, and churches, won him fame far beyond his native Venice; already by the age of thirty he was referred to as "celebre Pittor." Tiepolo worked for patrons not only throughout North Italy but also in Würzburg and Madrid. A prolific artist, he painted— both in oils and in fresco—religious, historical, and mythological subjects.

PERSEUS AND ANDROMEDA

Painted probably in 1730. Oil on paper, affixed to canvas
20 3/8 × 16 in. (51.8 × 40.6 cm.)
Acquired in 1918

The painting is a study for one of Tiepolo's four ceiling frescoes in the Palazzo Archinto, Milan, which was destroyed by bombing in 1943. A fresco in the main salon, representing an *Allegory of the Arts*, bore the date 1731.

According to legend, Cassiopeia, Queen of Ethiopia, had angered the Nereids by boasting that she and her daughter Andromeda were as beautiful as they. To punish her presumption, Neptune sent flood waters and a sea monster to ravage the land. Learning from an oracle that his daughter must be sacrificed to the monster in order to save his people, King Cepheus had Andromeda chained to a rock by the sea. The hero Perseus saw her and, moved by her beauty, rescued Andromeda, sweeping her skyward on his winged horse, Pegasus. The luminous heavens, illusionistically conceived to be seen from below, open to reveal Minerva and Jupiter seated on gold-tinged clouds.

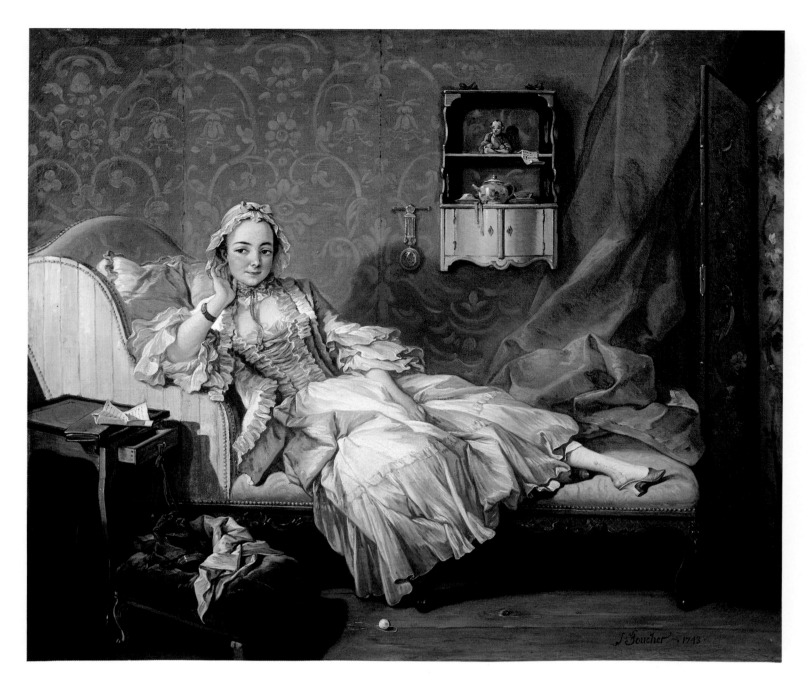

FRANÇOIS BOUCHER
1703–1770

The son of a painter, Boucher was born in Paris and trained first with his father, then briefly with François Lemoine. In 1723 he won the Academy's first prize for painting but was denied the sojourn in Rome that normally resulted from the competition. To earn his living the young artist produced reproductive engravings throughout the 1720s, notably after drawings and paintings by Watteau. Returning from a prolonged stay in Rome—where he went on his own—Boucher was accepted into the Academy in 1731, and three years later he was made a full member. Eventually he held the Academy posts of Professor, Rector, and finally Director. Boucher's marriage in 1734 resulted in two daughters, who married the artists Deshays and Baudouin, and a son, Juste-Nathan, who would specialize in drawing architectural fantasies. Boucher's work appeared at the Salon of 1737 and frequently thereafter. While his virtuoso productions were much admired, the artist had his critical detractors as well, particularly Diderot, who lamented his lack of natu-

ralness. Boucher was awarded many commissions by the King (including the painting of his Easter eggs) and by Madame de Pompadour. He also held high posts at both the Beauvais and Gobelins tapestry factories and was named "premier peintre" to Louis XV in 1765. Although the content and style of Boucher's art suggest a sybaritic character, the artist often worked twelve hours a day. He died in his studio in the Louvre. Among his many pupils were Deshays, Fragonard, Gabriel de Saint-Aubin, and Ménageot.

MADAME BOUCHER

Dated 1743. Oil on canvas
22 1/2 × 26 7/8 in. (57.2 × 68.3 cm.)
Acquired in 1937

When Marie-Jeanne Buseau (1716–after 1786) posed so pertly for this informal portrait ten years after her marriage to Boucher, she was twenty-seven and the mother of three children. She frequently served as model for her husband, and in later life she painted miniature repro-

ductions of his more popular pictures and made engravings after his drawings. Besides offering such a candid image of the artist's wife, the portrait provides a fascinating glimpse of a room in the apartment to which Boucher had moved the year before he signed this canvas—on the Rue de Grenelle-Saint-Honoré. The porcelain figurine and tea service on the hanging étagère reflect Boucher's taste for the Oriental bric-a-brac so fashionable throughout the eighteenth century. In its composition the portrait is a witty parody of the classical Renaissance depictions of Venus by Giorgione and Titian, and as such the picture has acquired the sobriquet "Boucher's Untidy Venus."

ARCHITECTURE AND CHEMISTRY

PAINTING AND SCULPTURE

FRANÇOIS BOUCHER

THE ARTS AND SCIENCES

Painted probably between 1750 and 1752. Oil
on canvas
Panels on pp. 86, 89: 85 1/2 × 30 1/2 in.
(217.2 × 77.5 cm.); those on pp. 87, 88:
85 1/2 × 38 in. (217.2 × 96.5 cm.)
Acquired in 1916

Although many details concerning the origins
of Boucher's delightful *Arts and Sciences* panels
remain unclear, it seems likely that they once
decorated an octagonal library adjoining
Madame de Pompadour's bedroom in the Châ-
teau de Crécy, near Chartres, the first property
the Marquise acquired after her official recogni-
tion as royal mistress in 1745. The panels were
referred to in the press during the spring of
1752, two of their subjects were copied on a gold
box dated 1753–54, and *Fishing* appeared on a

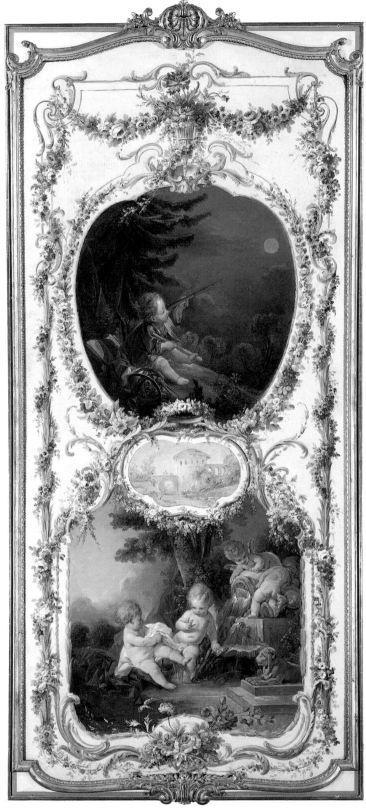

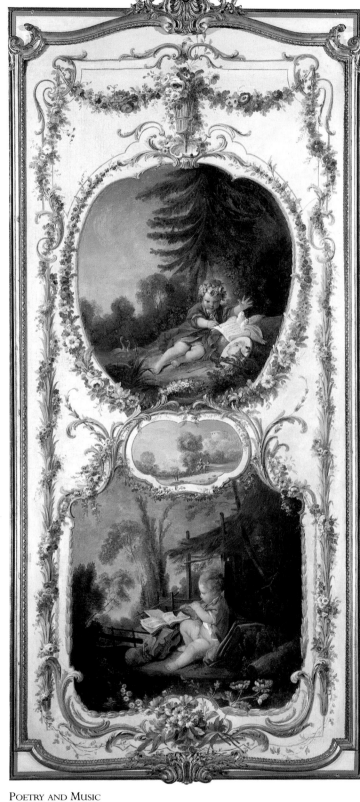

ASTRONOMY AND HYDRAULICS

POETRY AND MUSIC

Sèvres flowerpot in 1754. Nevertheless, it would seem that before serving as wall decorations, Boucher's figural compositions—as their shapes suggest—had first been utilized as designs for chair backs and seats. Indeed, tapestries were woven after them by Neilson at the Gobelins manufactory in the spring of 1752; they were upholstered to furniture frames delivered to Bellevue, another of Madame de Pompadour's residences at the time, and examples of them have survived to this day. After

belonging to Lord Pembroke in the nineteenth century, the *Arts and Sciences* canvases were acquired by Mr. Frick in 1916 and were installed on the second floor of his New York residence, in his wife's boudoir.

The subjects of the panels probably were chosen more to flatter their patron than to follow any traditional iconographic pattern. Almost every one can be interpreted as an allusion to Madame de Pompadour's patronage of the arts and sciences, including her support

at just this time of the Diderot–d'Alembert *Encyclopédie*, whose range of inquiry may also be reflected in the paintings. Thus, one can note in reference to each of the sixteen subjects some relevant detail concerning Madame de Pompadour: for *Astronomy*, the twenty books on that subject in her library and the presence of a telescope at her Château de Saint-Ouen; for *Hydraulics*, the ingenious waterworks and fountains at Crécy, recently designed by the physicist Deparcieux; for *Poetry*, the hundreds of

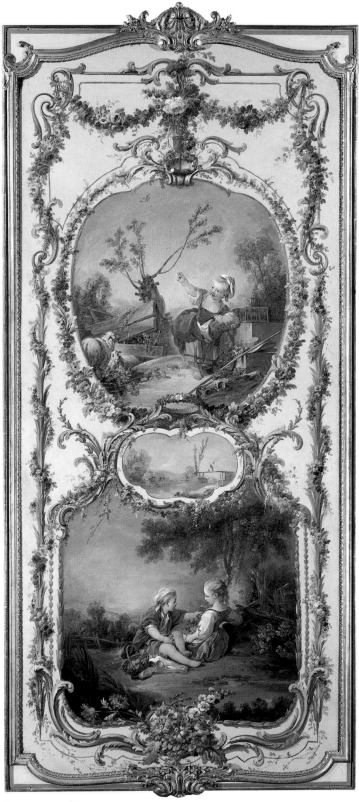

FOWLING AND HORTICULTURE

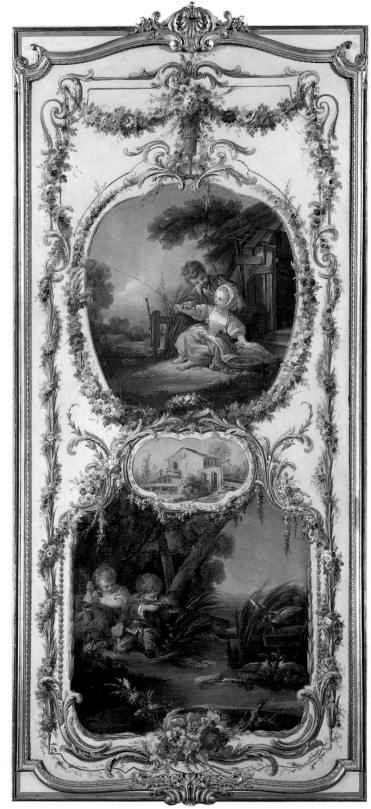

FISHING AND HUNTING

FRANÇOIS BOUCHER

volumes of French verse that constituted the most extensive segment of her library; for *Music,* her remarkable skill at the clavichord; for *Fowling,* the Marquise's collection of rare and exotic birds, as well as the humble hens that the King especially liked; for *Horticulture,* her knowledge of botany and her supervision of the new gardens at Crécy, designed by Garnier de l'Isle; for *Fishing*—a subject difficult to relate to the Marquise—conceivably a reference to her maiden name, Poisson ("fish"); for *Hunting,* one of the

chief occupations of the court and the King's favorite pastime; for *Architecture*—a lifelong passion of Madame de Pompadour—her current project with the architect Lassurance for the enlargement of Crécy; for *Chemistry,* her interest in the experiments at the new porcelain factory of Vincennes, as well as her investments in the glass factory at Bas-Meudon; for *Painting* and *Sculpture,* the extensive patronage of both these arts by the Marquise, who herself drew and engraved; for *Comedy* and

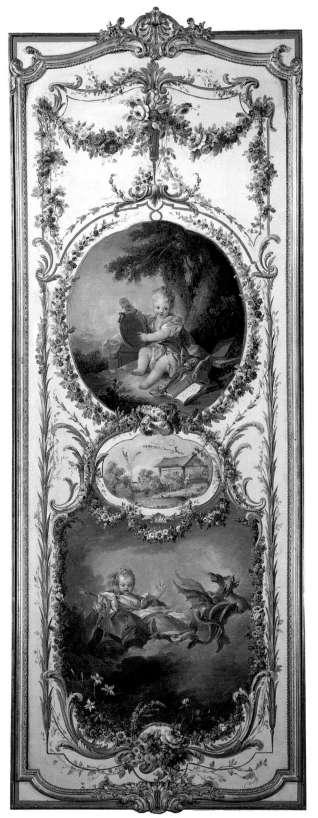

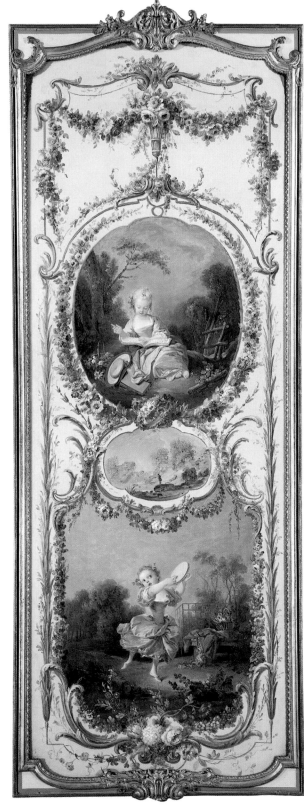

COMEDY AND TRAGEDY SINGING AND DANCING

Tragedy, the evidence of her performances in both private and court theaters, as well as her patronage of dramatic authors; for *Singing* and *Dancing,* her vocal training with Jéliotte of the Opéra and her innumerable appearances at court balls.

One final personal reference in these panels to their patron may be noted. Visitors to the Boucher Room at The Frick Collection will find there a copy of the marble bust of a girl by François-Jacques-Joseph Saly that Boucher introduced in the scene of *Sculpture.* Although opinions on the identity of the subject of the bust have varied, her appearance in so many paintings by Boucher suggests that the girl was none other than Madame de Pompadour's beloved daughter, Alexandrine d'Étiolles (1744–54).

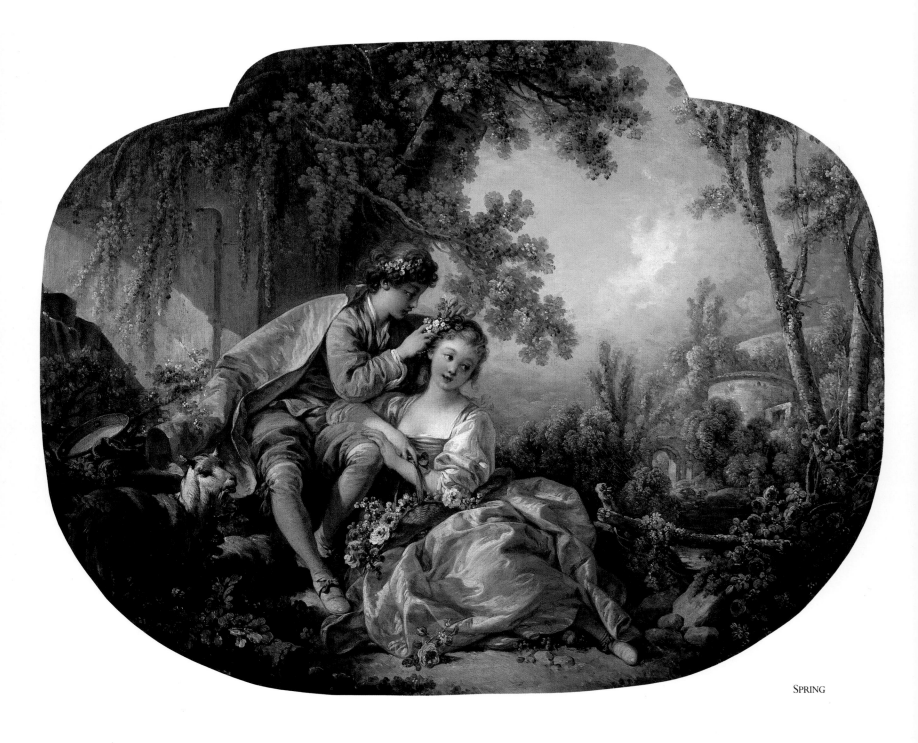

SPRING

FRANÇOIS BOUCHER

THE FOUR SEASONS

Dated 1755. Oil on canvas
22 1/2 × 28 3/4 in. (57.2 × 73 cm.)
Acquired in 1916

Jean Daullé's engravings after *The Four Seasons* identify the owner of the paintings as Madame de Pompadour. The four canvases probably were designed as overdoors for one of the Marquise's many residences, but it is not known which one. Boucher's shield-shaped compositions, of which three are dated 1755, were later extended by another hand onto rectangular canvases; the present curvilinear templates expose only the original body of each.

In these representations of the age-old subject of the Four Seasons, Boucher broke with the tradition of depicting the labors performed at various times of the year, characteristically choosing to illustrate pleasant pastimes instead. The amorous subjects of *Spring* and *Autumn,* described as *pastorales* in the sale catalogue of the collection of the Marquis de Marigny (Madame de Pompadour's younger brother and heir), recall the *fêtes galantes* invented by Boucher's great predecessor Watteau, whereas the sledding scene of *Winter,* with the heroine swathed in furs and accompanied by a Tartar, evokes the eighteenth-century European fascination with the glamour of Russia. Both *Autumn* and *Winter* closely resemble compositions by Watteau that Boucher had engraved in

his youth, but the backgrounds of all of the *Seasons*, especially the frosted one of *Winter,* reveal Boucher's particular skills as a landscapist. The bathers of *Summer* depend from a far older pictorial tradition that would subsequently be continued by Renoir, Cézanne, and Picasso.

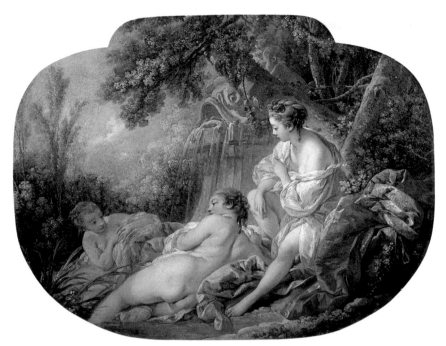

SUMMER

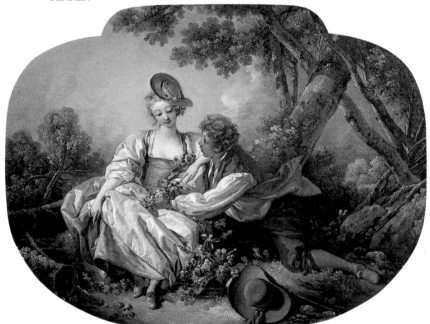

AUTUMN

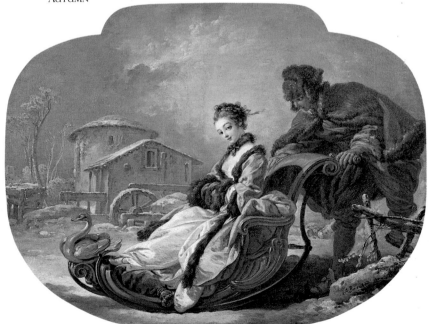

WINTER

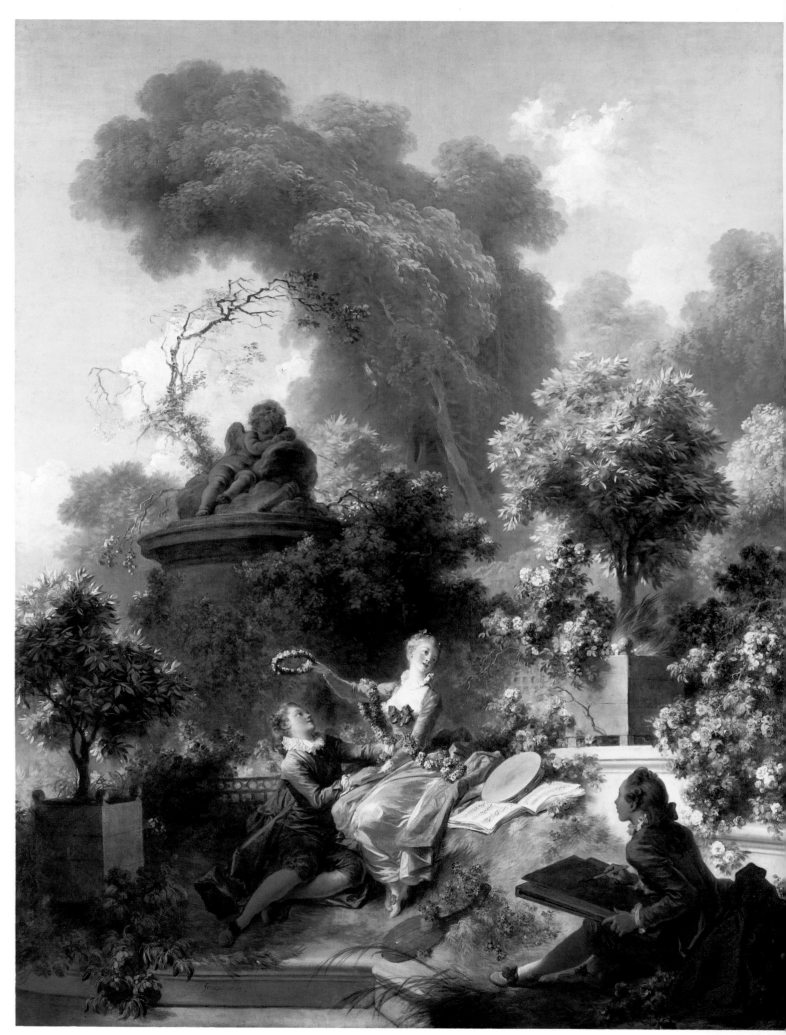

THE LOVER CROWNED

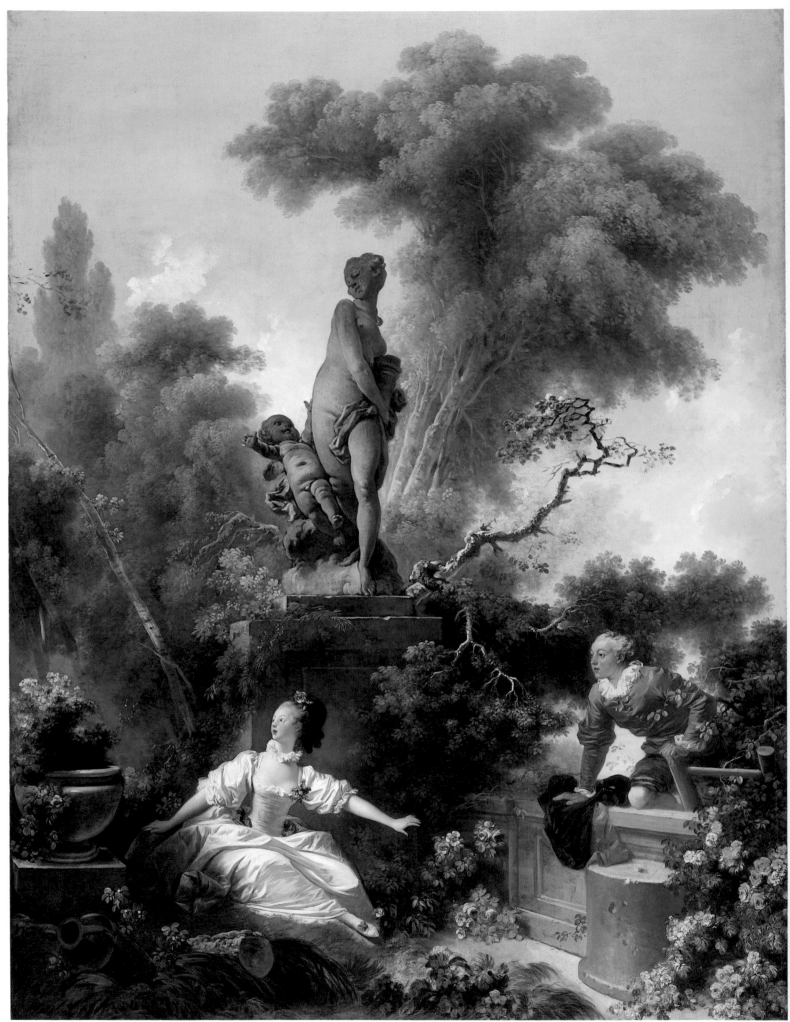

THE MEETING

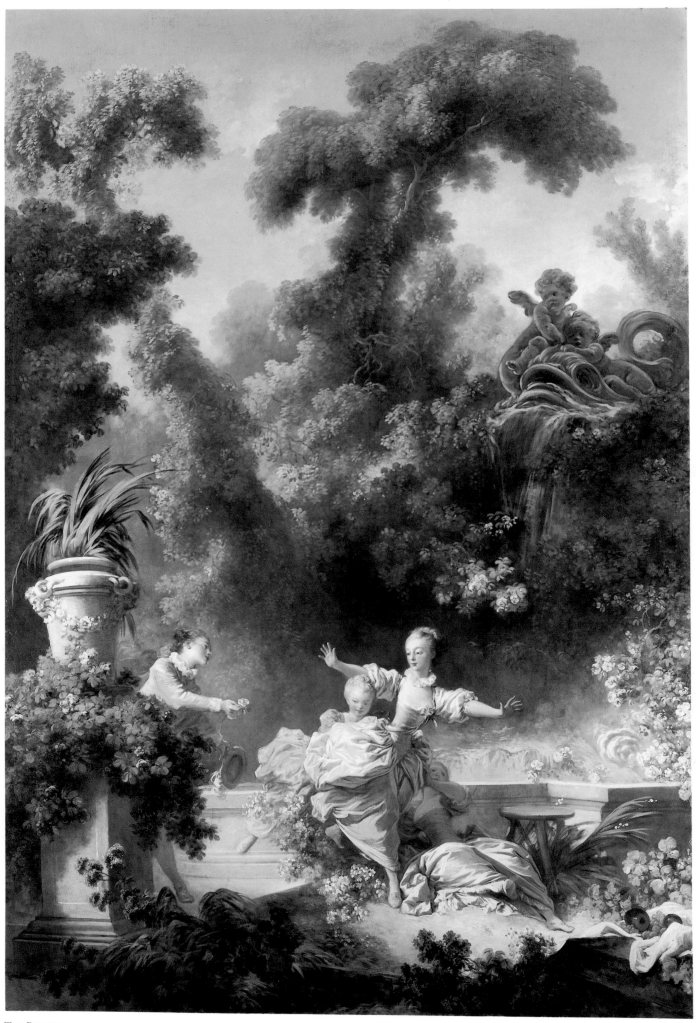

THE PURSUIT

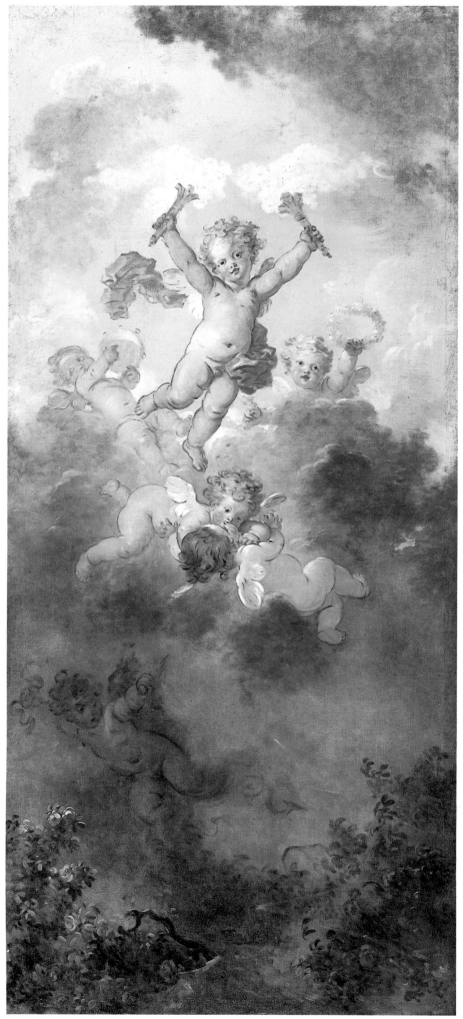

Love Triumphant

JEAN-HONORÉ FRAGONARD
1732–1806

Born in Grasse, Fragonard was still a child when his family moved to Paris. He studied briefly with Chardin, then entered the atelier of Boucher. In 1752 he won the Prix de Rome, and after three years of preparation under Carle Vanloo he left to study in Italy. His Coroesus Slays Himself to Save Callirhoe, *which was bought by Louis XV in 1765, won the artist membership in the Academy, a residence in the Louvre, and the title "peintre du roi." At this moment Fragonard seemed to the art establishment the most promising painter of his generation, but he never pursued an official career, preferring instead to work for a rich private clientele. In 1773–74 he made a second trip to Italy. His activity as an illustrator, etcher, and painter of romantic subjects continued until the Revolution. Because of ill health Fragonard retired to Grasse in 1790, but a year later he was back in Paris. Under the sponsorship of David he held various administrative posts at the Muséum des Arts—the present Musée du Louvre. His new eminence was short-lived, however; he died poor and almost forgotten.*

THE PROGRESS OF LOVE

Painted in 1771–73 and 1790–91. Oil on canvas
Panels on pp. 92–97, 99: c. 125 in. (317.5 cm.)
in height, those on p. 98: c. 59 in. (150 cm.);
their widths are too varied to list in full.
Acquired in 1915

Although *The Progress of Love* is generally regarded as the artist's collective masterpiece and is considered one of the greatest decorative ensembles of the eighteenth century, many aspects of the paintings' history and meaning remain unclear. Nevertheless, the impact of Fragonard's evocation of love in all its nuances remains as powerful today as does the impression he has left here of an artist ecstatically happy with his work.

The history of the paintings is linked with the career of the Comtesse Du Barry, the mistress of Louis XV, who received from her lover in 1769 a property at Louveciennes, a village near Versailles. After making certain changes to the old château that stood there, Madame Du Barry commissioned Claude-Nicolas Ledoux to design a pavilion on the estate that could be used for entertaining. This building, instantly acclaimed for its neoclassical modernity, was inaugurated on September 2, 1771. For its apse-shaped gaming room Fragonard was commissioned, probably early in that same year, to paint four large canvases that would be described in an inventory of 1772 as depicting "the four ages of love" (see pp. 92–95). It is known that Fragonard was working on these canvases during 1771. By July of 1772, Bachaumont, a chronicler of current events, was writing of the paintings as being in place at Louveciennes. But

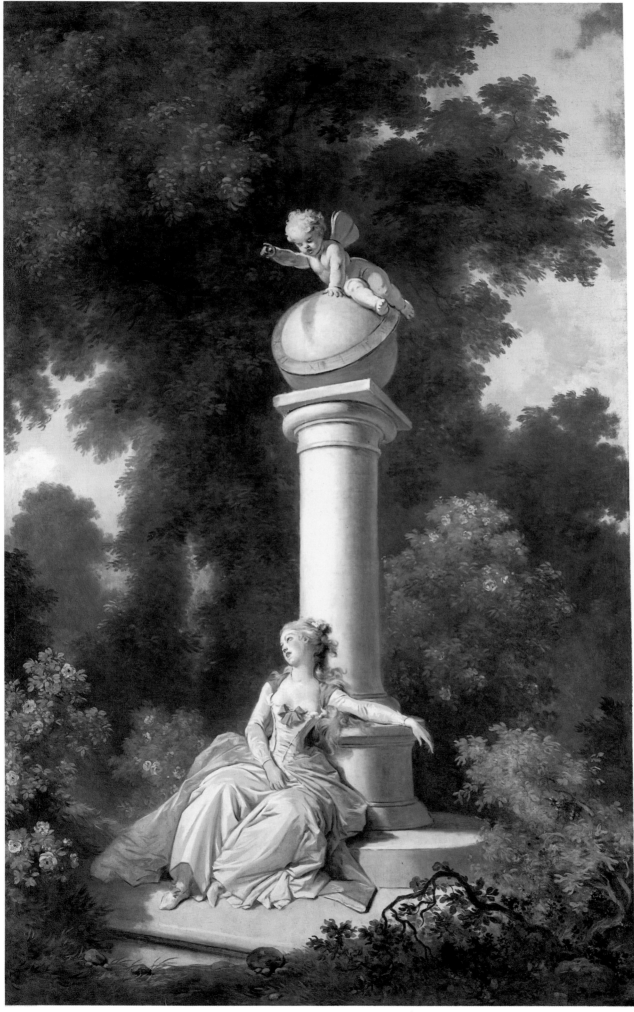

REVERIE

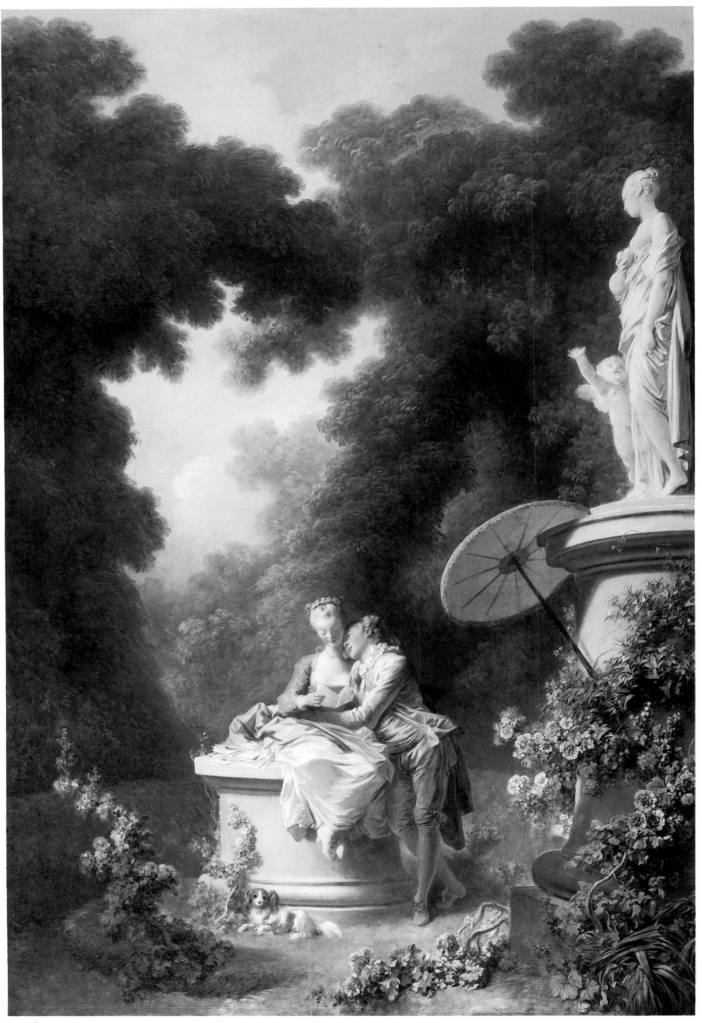

LOVE LETTERS

LOVE
THE AVENGER

LOVE
THE JESTER

JEAN-HONORÉ
FRAGONARD

an inventory of Louveciennes in 1774 described Fragonard's canvases as "having been returned to the painter" and replaced by works of Joseph-Marie Vien, two of which had been exhibited at the Salon the previous year. Ironically, the title *The Progress of Love* now assigned to Fragonard's series was that originally given to the paintings by Vien that came to supplant them.

What happened? In addition to possible temperamental difficulties between artist and patron that might have led to this rejection of the paintings, two other causes seem likely. Bachaumont's sly remark in 1772 that Fragonard's paintings "seem to be allegorical references to the adventures of the mistress of the house," joined to the undeniable resemblance between contemporary portraits of Louis XV and the red-coated lover scaling the wall in *The Meeting,* could justifiably have alerted Madame Du Barry that her decorations might be a source of embarrassment to the monarch, whom she was trying to lure into marriage at this time. On the other hand, as one obsessed with fashion Madame Du Barry may have come to see Fragonard's exuberant work as outmoded within the context of Ledoux's avantgarde pavilion, for which Vien's deliberately classicizing work, albeit insipid, appeared more obviously in harmony.

Whatever the case, Fragonard retained the paintings until 1790, rolled up or possibly, as has recently been suggested, installed in his studio. During the year he passed in his cousin Maubert's villa at Grasse, he painted ten additional canvases to complete the ensemble, and sold them to his host.

The closest one can come to understanding the artist's intentions with *The Progress of Love* is to see, in what is now the Musée Fragonard at Grasse, the copies La Brély made of the panels in 1898, installed where the originals had been. The initial impression is of being transported into a lush, natural panorama, as the four *Hollyhocks* panels and the backgrounds of the large canvases merge with the landscape visible through the windows. Within this magic garden, the four original canvases from Louveciennes can be seen as romantic incidents that advance from an attempted seduction *(The Pursuit),* to an assignation *(The Meeting),* to consummation or marriage *(The Lover Crowned),* and then to the calm prolongation of a happy union *(Love Letters). Love Triumphant* dominated the room from its position over the central fireplace, where the fiery lower portion of the panel merged illusionistically with the real flames beneath it. The four overdoors of putti added their witty allusions to various moods or states of love—carefree, giddy, determined, angry. Finally, with *Reverie* the embittered artist may well have had his revenge on Madame Du Barry, by evoking in this desolate figure the solitude of a mistress whose lover was now dead.

LOVE
THE SENTINEL

LOVE
PURSUING
A DOVE

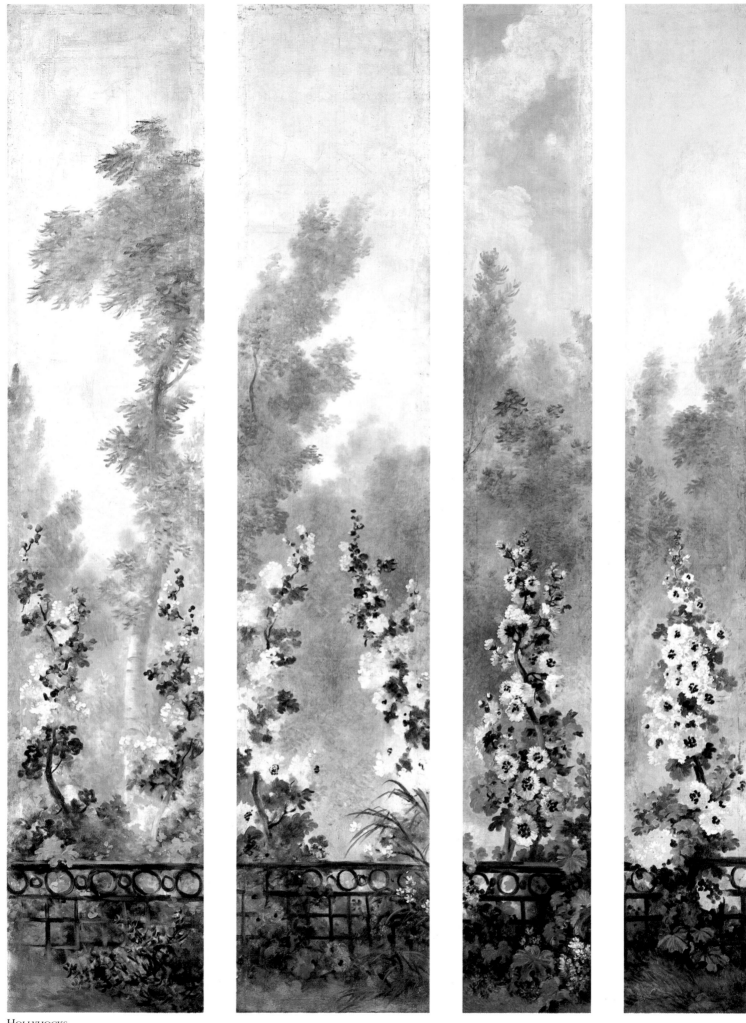

HOLLYHOCKS

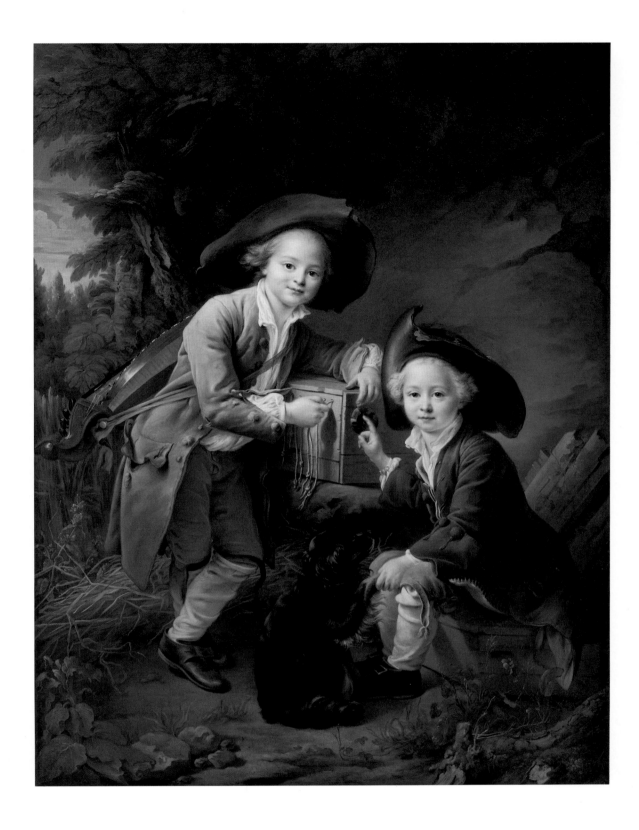

FRANÇOIS-HUBERT DROUAIS
1727–1775

Drouais was of Norman extraction but spent all his life in and around Paris. After studying with his father, a miniaturist, he worked in the studios of Carle Vanloo, Natoire, and Boucher. In 1757 he executed his first royal commission, and the following year he was received as a full member in the Academy. Succeeding Latour and Nattier, Drouais became the most prominent French portraitist of the mid eighteenth century, painting courtiers, foreign aristocrats, writers, and fellow artists. Drouais' son, Germain-Jean, was a promising history painter who died at twenty-five.

THE COMTE AND CHEVALIER DE CHOISEUL AS SAVOYARDS

Dated 1758. Oil on canvas
54 7/8 × 42 in. (139.4 × 106.7 cm.)
Acquired in 1966

The standing boy with a hurdy-gurdy at his back is Marie-Gabriel-Florent-Auguste, Comte de Choiseul-Beaupré (1752–1817). Beside him, pointing to a peep-show box, sits his younger brother, Michel-Félix-Victor, Chevalier de Choiseul-Daillecourt (1754–1815). The boys were cousins of the celebrated Duc de Choiseul, foreign minister under Louis XV. In costuming his subjects as Savoyards, the itinerants from Savoy who wandered over France working at odd jobs and in street fairs to support the families they left at home, Drouais probably intended to depict the brothers as models of filial devotion—a conceit reinforced by the presence of the faithful dog. It may be noted that the boys' disheveled garments are made of sumptuous velvet and that their buttons are of gold.

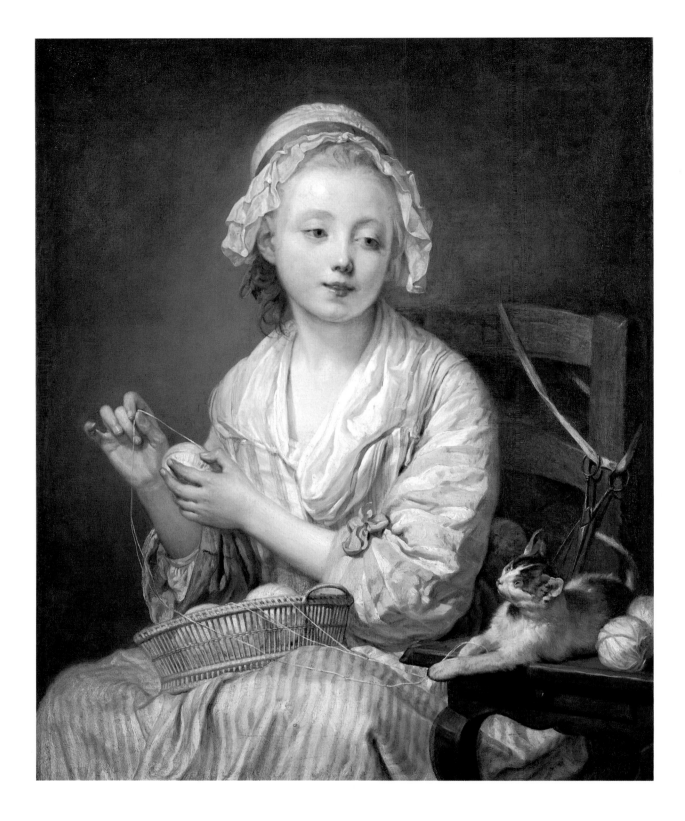

JEAN-BAPTISTE GREUZE
1725–1805

*Greuze left his native Burgundy for Paris about 1750
and studied with Natoire at the Academy. Named an
associate member in 1755, he first exhibited at the
Salon that same year and a few months afterward
began a long sojourn in Italy. He was made a full
Academy member in 1769, but only in the category of
genre painters, despite his efforts to be recognized as a
history painter. Stung by this incident, Greuze dissoci-
ated himself from the Academy and its exhibitions until
1800. The artist's dramatic and often moralizing genre
scenes, his brilliant drawings, and his incisive portraits
won him wealth, great popular acclaim, and the
enthusiastic support of Diderot.*

THE WOOL WINDER

Painted probably in 1759. Oil on canvas
29 3/8 × 24 1/8 in. (74.6 × 61.3 cm.)
Acquired in 1943

Like much of Greuze's early work, *The Wool
Winder* owes something to Chardin's genre pic-
tures of the 1730s, which in turn recall the
Dutch seventeenth-century genre scenes the
French were collecting avidly in the early eigh-
teenth century. But Greuze's pictures are usu-
ally, as here, more whimsical and anecdotal, as
well as more refined in execution. The letter B
carved into the top rail of the chair suggests that

the subject may have been a younger sister of
the artist's wife, Anne-Gabrielle Babuti, whom
he married in January of 1759. *The Wool Winder,*
exhibited the same year, is related to a series of
portraits of his new family that Greuze
exhibited in 1759 and 1761—likenesses of his
wife, of her brother, and of her father, in addi-
tion to one of himself.

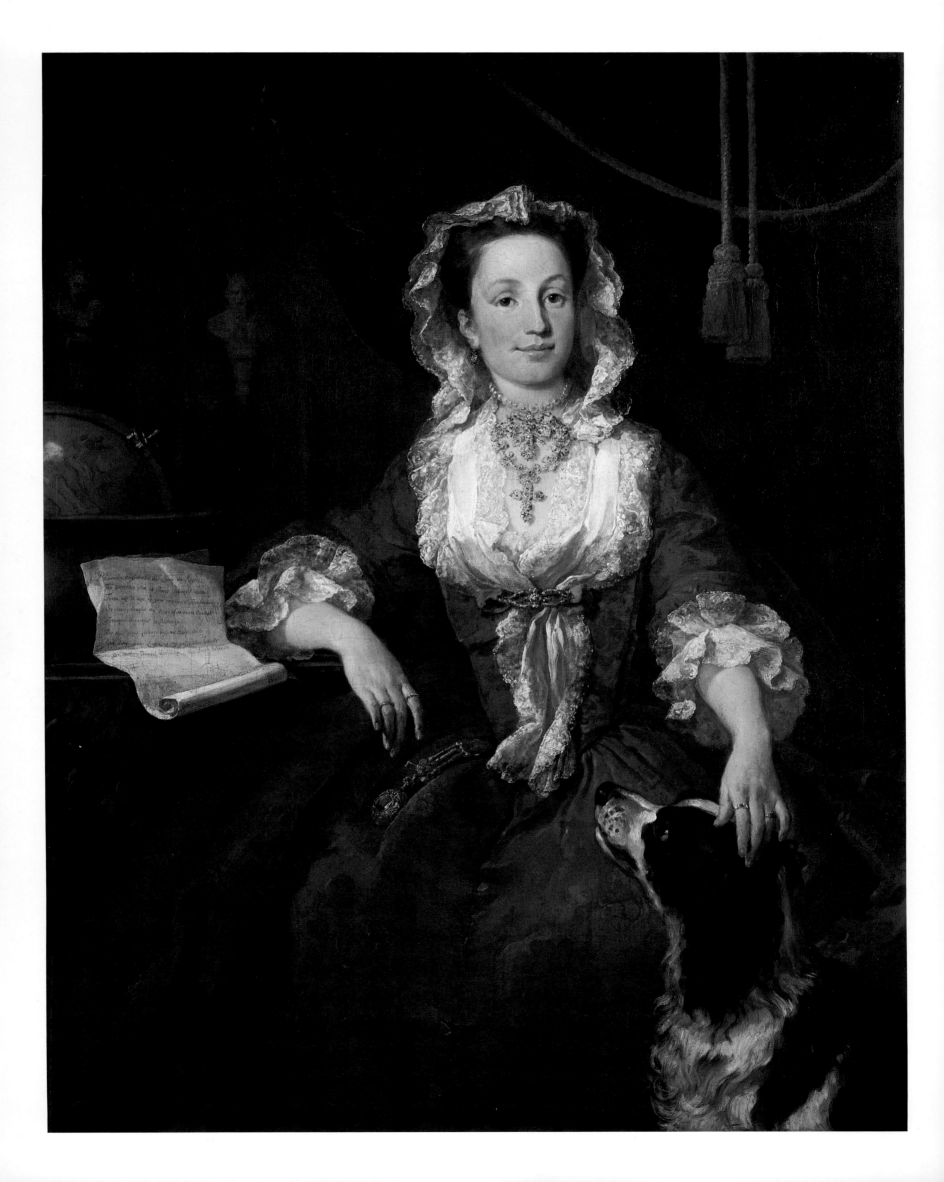

WILLIAM HOGARTH
1697–1764

*A life-long resident of London, Hogarth was appren-
ticed to an engraver of silver plate at fifteen and later
studied drawing with Thornhill. His fame among his
contemporaries derived chiefly from the series of moral
satires that he engraved after his own oil paintings and
disseminated to a wide public. Hogarth was a leading
figure at the St. Martin's Lane Academy and the
author of an autobiography and a treatise on
aesthetics.*

MISS MARY EDWARDS

Dated 1742. Oil on canvas
49 3/4 × 39 7/8 in. (126.4 × 101.3 cm.)
Acquired in 1914

Mary Edwards (1705–43), one of the richest
women of her time, repudiated her marriage to
an extravagant husband, although this was tan-
tamount to declaring her son illegitimate. She
was Hogarth's friend and arguably his most
significant patron during the decade 1733–43.
The monumental portrait of Miss Edwards,
wearing magnificent jewels and a striking red
dress, is a masterpiece in the series of Hogarth's
commanding middle-class portraits, which
includes the famous *Captain Coram*. The open
scroll prominently displayed beside the subject
champions the virtues of liberty and property
that she would have appreciated as manager of a
great fortune.

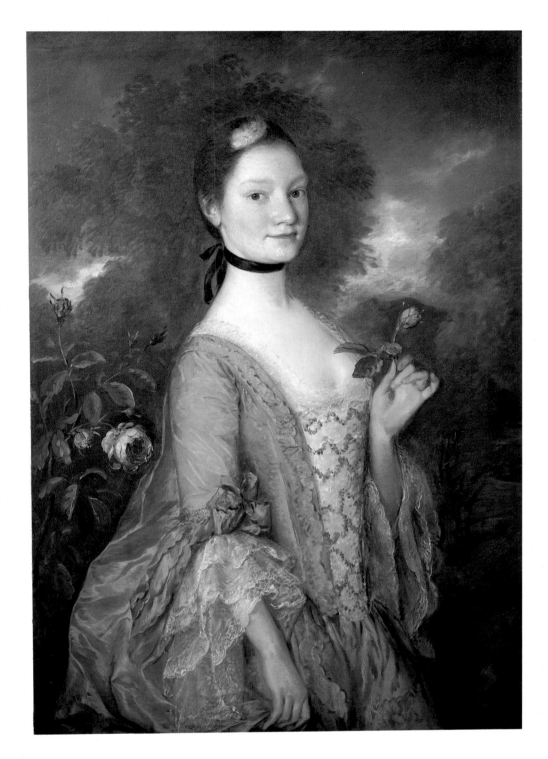

THOMAS GAINSBOROUGH
1727–1788

*A native of Suffolk, Gainsborough was trained in
London in the milieu of Hogarth and the popular
French rococo. He worked in Sudbury and Ipswich and
rose to fame as a portrait painter in the fashionable
resort of Bath. Gainsborough joined the Royal Acad-
emy as a founding member and in 1774 returned to
London, where he became Reynolds' major competitor.
He later was patronized by the royal family. Although
he claimed to prefer landscape painting to portraiture,
Gainsborough excelled at capturing the likenesses of
Georgian society.*

LADY INNES

Painted c. 1757. Oil on canvas
40 × 28 5/8 in. (101.6 × 72.7 cm.)
Acquired in 1914

The sitter was probably Sarah, daughter and
heiress of Thomas Hodges of Ipswich, who
married Sir William Innes, Captain of the Sec-
ond Light Dragoons, in 1766 and died in 1770.
The mannered formality of the young lady's
pose is characteristic of Gainsborough's early
Ipswich period, while the softly brushed back-
ground looks forward to the artist's mature
style.

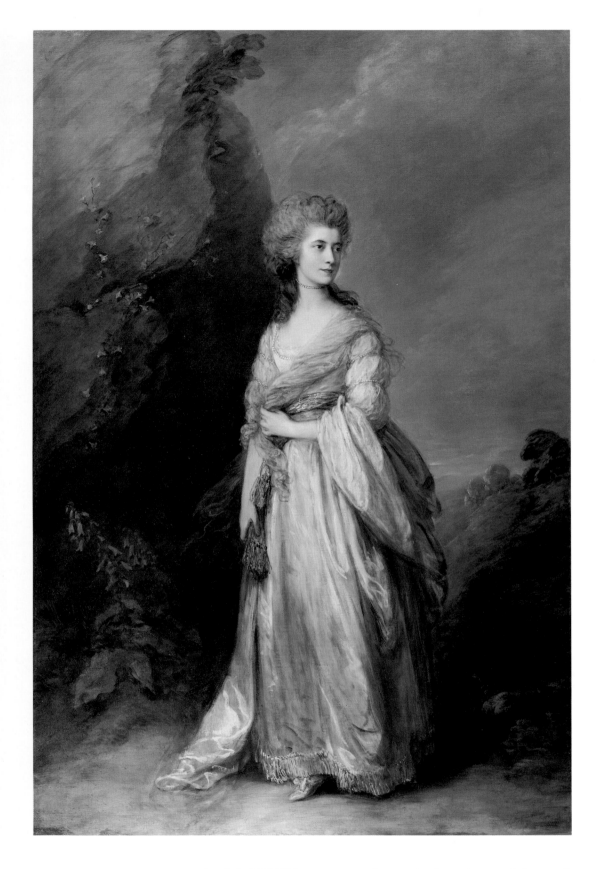

THOMAS GAINSBOROUGH

THE HON. FRANCES DUNCOMBE

Painted c. 1777. Oil on canvas
92 1/4 × 61 1/8 in. (234.3 × 155.2 cm.)
Acquired in 1911

Frances Duncombe was born in 1757, the only daughter of Anthony Duncombe and Frances Bathurst. Gainsborough's portrait of her reveals the artist's admiration for Van Dyck, not only in its elegant proportions, graceful pose, and Arcadian setting, but even in the costume, which recalls fashions of the seventeenth century. It was probably painted while the subject was living with the family of the Earl of Radnor, into which her stepmother married; the Earl commissioned from Gainsborough a number of portraits in the grand style to complement his collection of Old Masters. In 1778 Frances married John Bowater of Woolwich, who suffered various reverses and went to debtors' prison despite the considerable fortune she brought him. Frances died seventeen years after her husband in 1827.

THOMAS GAINSBOROUGH

MRS. PETER WILLIAM BAKER

Dated 1781. Oil on canvas
89 5/8 × 59 3/4 in. (227.6 × 151.8 cm.)
Acquired in 1917

Jane (d. 1816), daughter of James Clitherow of Boston House, Middlesex, married Peter Baker of Ranston, Dorsetshire, in 1781—the year of this portrait. The windswept natural setting, which recalls the landscape paintings of Gainsborough's late years, invests this classically simple composition with a feeling of movement and drama.

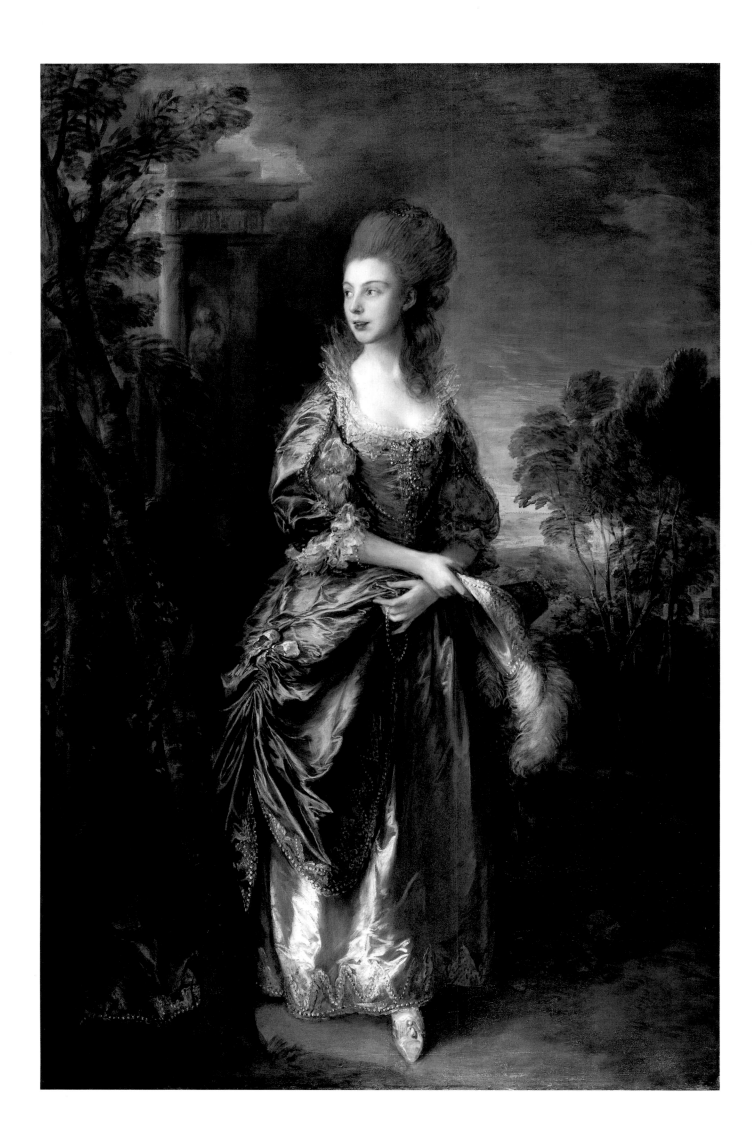

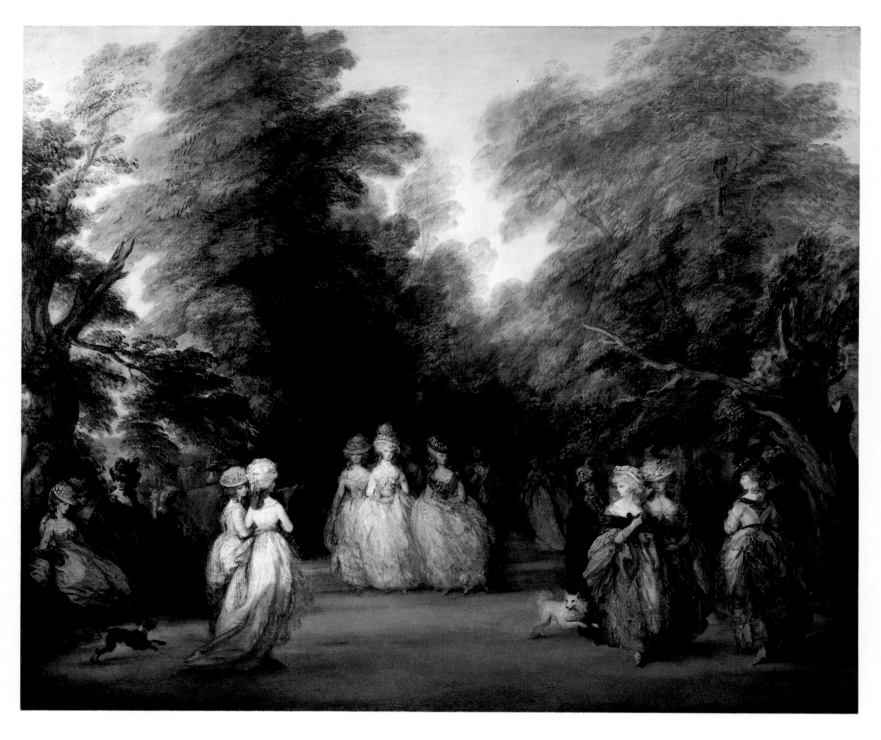

THOMAS GAINSBOROUGH

THE MALL IN ST. JAMES'S PARK

Painted probably in 1783. Oil on canvas
47 1/2 × 57 7/8 in. (120.6 × 147 cm.)
Acquired in 1916

St. James's Park was near Gainsborough's London residence, Schomberg House, in Pall Mall. The long tree-lined avenue called the Mall, which runs south of St. James's Palace, was a fashionable place for strolling in the eighteenth century. This composition is unusual among the artist's later works and recalls, as several contemporary critics remarked, the *fêtes galantes* of Watteau. The feathery foliage and rhythmic design led one observer to describe the painting as "all aflutter, like a lady's fan." Another reported that the artist composed the painting partly from dolls and a model of the park.

The large proportion of the canvas devoted to the setting testifies to Gainsborough's abilities as a landscape painter and to his pioneering interest in the picturesque. Attempts to identify the ladies in the central group as the daughters of George III and the background figure under the trees at right as the artist himself are attractive but unsubstantiated.

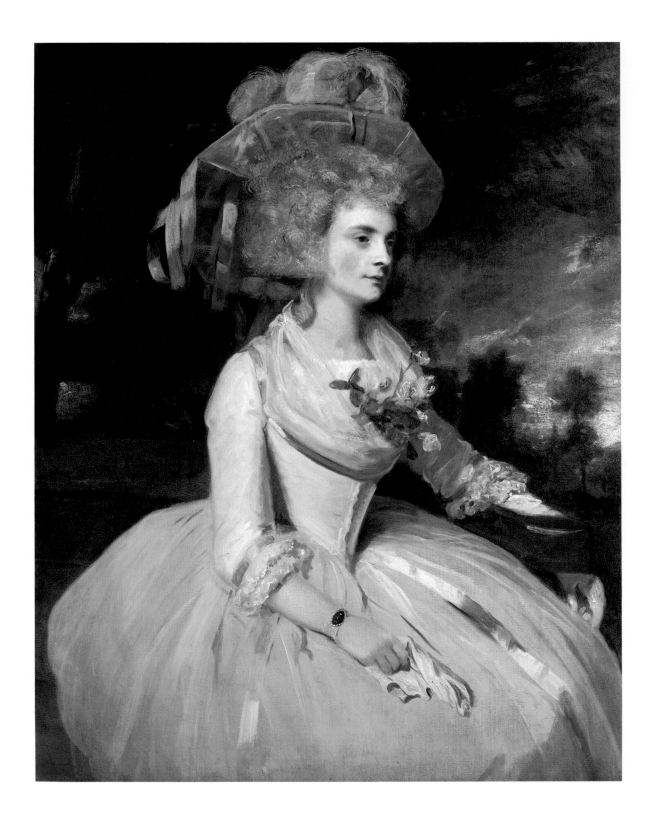

SIR JOSHUA REYNOLDS
1723–1792

Born at Plympton, Devonshire, Reynolds served a brief apprenticeship under Thomas Hudson in London before launching his career as a portrait painter in Plymouth. Between 1749 and 1752 he was in Italy, where the study of ancient art and the Italian masters profoundly affected his style. Soon after his return he became the most fashionable portraitist in London. Reynolds was a prolific painter whose variety of approach was envied by his rival, Thomas Gainsborough. As the first President of the Royal Academy, Reynolds delivered a series of "Discourses" that were highly influential in shaping British aesthetic theory.

He was a close friend of some of the leading personalities of his time, including Dr. Johnson, Goldsmith, Burke, and Garrick.

LADY SKIPWITH

Painted in 1787. Oil on canvas
50 1/2 × 40 1/4 in. (128.3 × 102.2 cm.)
Acquired in 1906

Selina Shirley (1752–1832) was married in 1785 to Sir Thomas George Skipwith of Newbold Hall, Warwickshire. Lady Skipwith had a reputation as a skilled horsewoman, and a nephew recorded that "there was something rather for- midable in her powdered hair and [the] riding habit or joseph which she generally wore." Reynolds' notebooks show that he painted her in May of 1787. The natural pose and setting and the fresh, free handling of paint are typical of the artist's late style, partly in response to the work of Gainsborough.

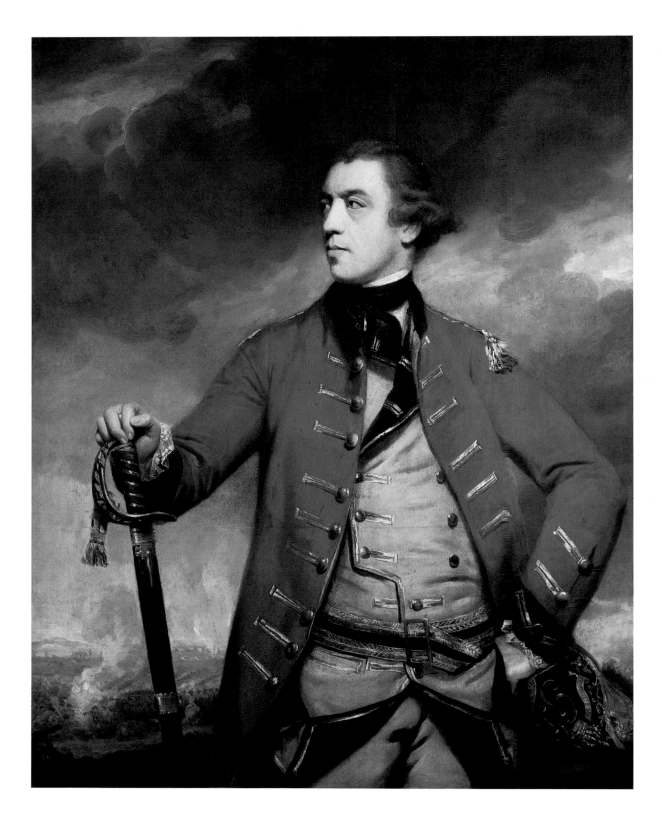

SIR JOSHUA REYNOLDS

GENERAL JOHN BURGOYNE

Painted probably in 1766. Oil on canvas
50 × 39 7/8 in. (127 × 101.3 cm.)
Acquired in 1943

Best remembered as the British commander
who in 1777 surrendered to American forces at
Saratoga, John Burgoyne (1722–92) was also
known in his day as a dandy, gambler, actor,
amateur playwright, and Member of Parlia-
ment. This portrait may have been commis-
sioned by his senior officer, Count La Lippe, as
a memento of their Portuguese campaign of
1762. It is presumably the portrait that resulted
from a sitting by General Burgoyne noted in
Reynolds' ledger for May of 1766; Burgoyne's
uniform is that of the Sixteenth Light Dragoons
as it was worn until that month. The composi-
tion, with the dashing figure silhouetted before
a low horizon and cloudy sky, was to become a
classic type in Romantic portraiture.

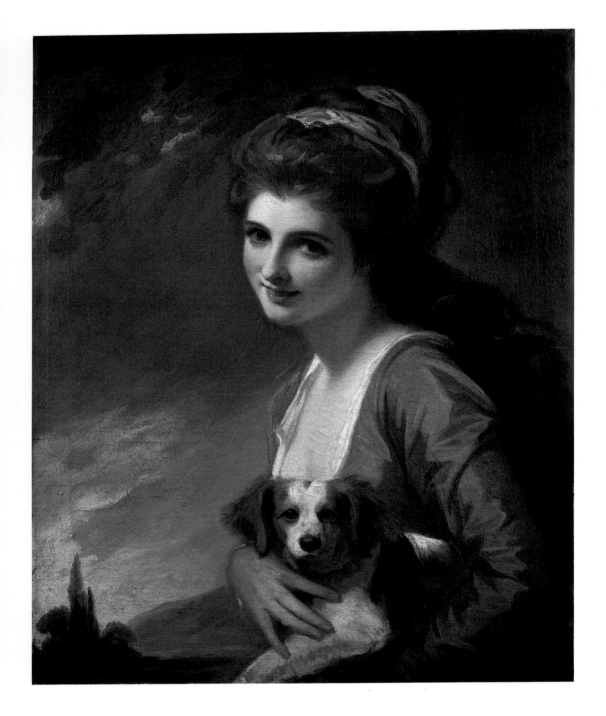

GEORGE ROMNEY

THE COUNTESS OF WARWICK AND HER CHILDREN

Painted 1787–89. Oil on canvas
79 3/4 × 61 1/2 in. (202.6 × 156.2 cm.)
Acquired in 1908

Henrietta Vernon (1760–1838), daughter of Richard Vernon, the so-called Father of the Turf, became at sixteen the second wife of George Greville, Earl of Warwick. Horace Walpole mentioned her and her sister in his letters and also wrote verses to them. Romney has depicted the Countess with two of her nine children, presumably Henry Richard and Elizabeth, in a composition that recalls the group portraits Van Dyck painted in England.

GEORGE ROMNEY
1734–1802

Largely self-taught, Romney practiced in London after traveling to Paris and Italy. Although he never joined the Royal Academy, he became one of the most fashionable portraitists of his time. Romney's ambitions to be a history painter, evident in his many drawings, were never realized in his painted work.

LADY HAMILTON AS 'NATURE'

Painted in 1782. Oil on canvas
29 7/8 × 24 3/4 in. (75.8 × 62.9 cm.)
Acquired in 1904

Emma Hart (1765–1815) was a woman of great beauty and charm who rose from humble origins to international fame. Charles Greville, whose mistress she was and who commissioned this portrait, educated her in music and liter-

ature, and Greville's uncle, Sir William Hamilton, British ambassador to Naples, brought her to Italy, where they were married. There she entertained company with her "attitudes"—a kind of Romantic aesthetic posturing achieved with the aid of shawls and classical draperies. Emma attracted the attention of Lord Horatio Nelson, with whom she had a notorious romantic liaison until his death at the Battle of Trafalgar. Although she inherited money from both Hamilton and Nelson, her extravagance led her into debt, and she died in poverty. This portrait was the first of more than twenty that Romney painted of his "divine lady," many in the guise of characters from history, mythology, and literature.

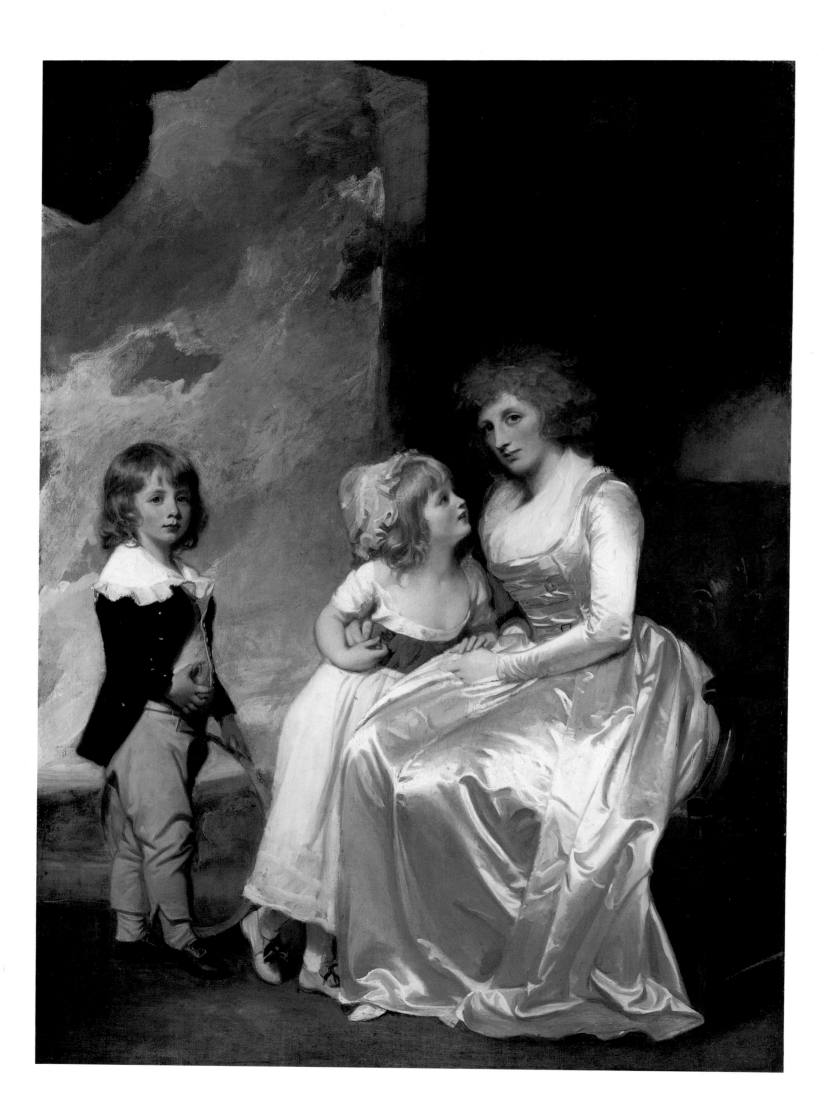

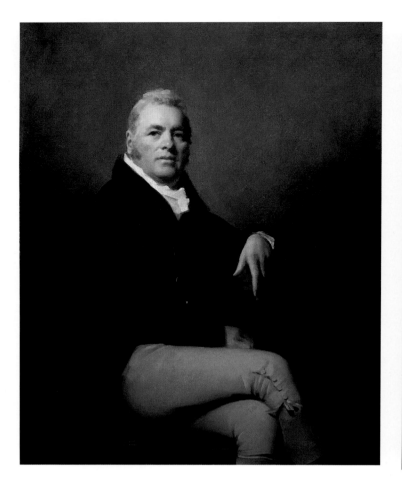
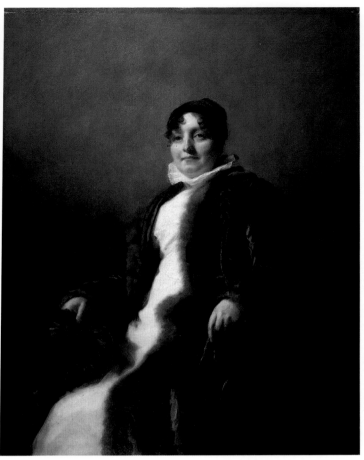

SIR HENRY RAEBURN
1756–1823

Born at Stockbridge, now a part of Edinburgh, Raeburn received his earliest training as a goldsmith's apprentice and may have gotten his start as a drafts- man producing miniatures for the jeweler's lockets. By the age of twenty he had painted his first full-length portrait in oils, but little is known about this early period of his career. His marriage around 1780 made him financially independent. In 1784 Raeburn spent two months in Joshua Reynolds' studio in London and then, on the master's advice, traveled to Rome to broaden his experience. He returned to Edinburgh in 1786 and soon earned a reputation as the foremost Scottish portrait painter. The Royal Academy elected Raeburn to membership in 1815, and in 1822 he was knighted by George IV and named His Majesty's Limner for Scotland.

JAMES CRUIKSHANK
Painted between c. 1805 and 1808. Oil on canvas
50 × 40 in. (127 × 101.6 cm.)
Acquired in 1911

MRS. JAMES CRUIKSHANK
Painted between c. 1805 and 1808. Oil on canvas
50 3/4 × 40 in. (128.9 × 101.6 cm.)
Acquired in 1905

James Cruikshank (d. 1830), of Langley Park, Montrose, Forfarshire (now County Angus), was a businessman who made a large fortune from sugar plantations in the British West Indies. In 1792 he married Margaret Helen (d. 1823), daughter of the Rev. Dr. Alexander Gerard of Aberdeen. They had six children. No record for the commission of these pendant portraits has been found, but a dating of be- tween 1805 and 1808 has been suggested on stylistic grounds. Raeburn took a very straight- forward approach to his sitters and developed a distinctive technique in which broadly brushed detail and strong unmodulated contrasts of light and dark give his figures a sculptural quality. In 1801, Joseph Farington described Raeburn's portraits as having "an uncommonly true appearance of Nature."

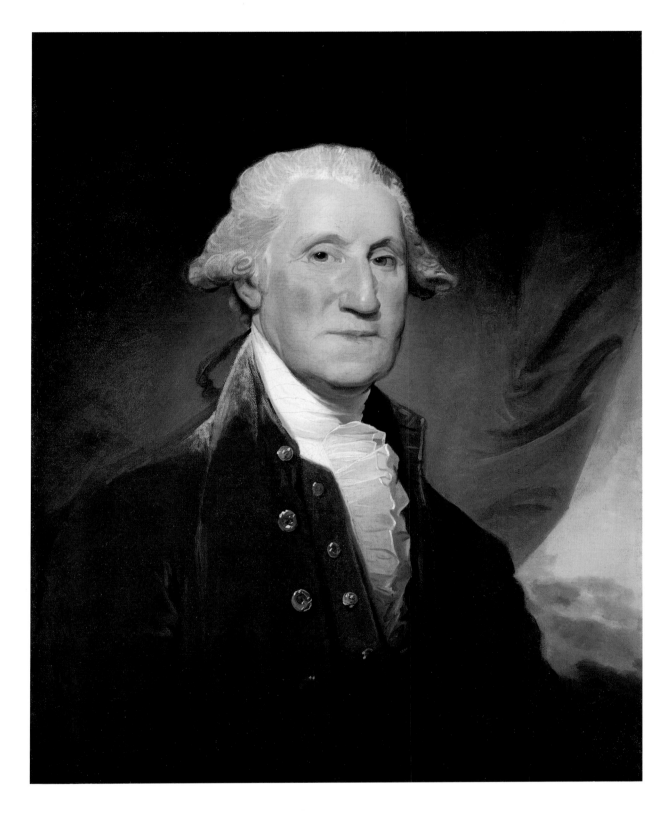

GILBERT STUART
1755–1828

Stuart was born in North Kingstown, Rhode Island, and received his first training in Newport with the Scottish painter Cosmo Alexander. He accompanied Alexander to Scotland, but after his teacher's death in 1772 he returned to America. In 1775 Stuart moved to London, where soon afterward he entered the studio of his compatriot Benjamin West. Back in America in the early 1790s, Stuart became the leading portraitist of his day in New York, Philadelphia, and Boston.

GEORGE WASHINGTON

Painted 1795–96. Oil on canvas
29 1/4 × 24 in. (74.3 × 60.9 cm.)
Acquired in 1918

Stuart earned a fortune producing replicas of the three portraits he painted from life of the first President of the United States. The Frick canvas is thought to be one of two copies painted by the artist for the Philadelphia merchant John Vaughan. It belongs to the group known as the "Vaughan type," although it differs from the related versions in the color of the coat and in the treatment of the background. Stylistically the portrait recalls the work of Stuart's English contemporaries, such as Romney and Hoppner.

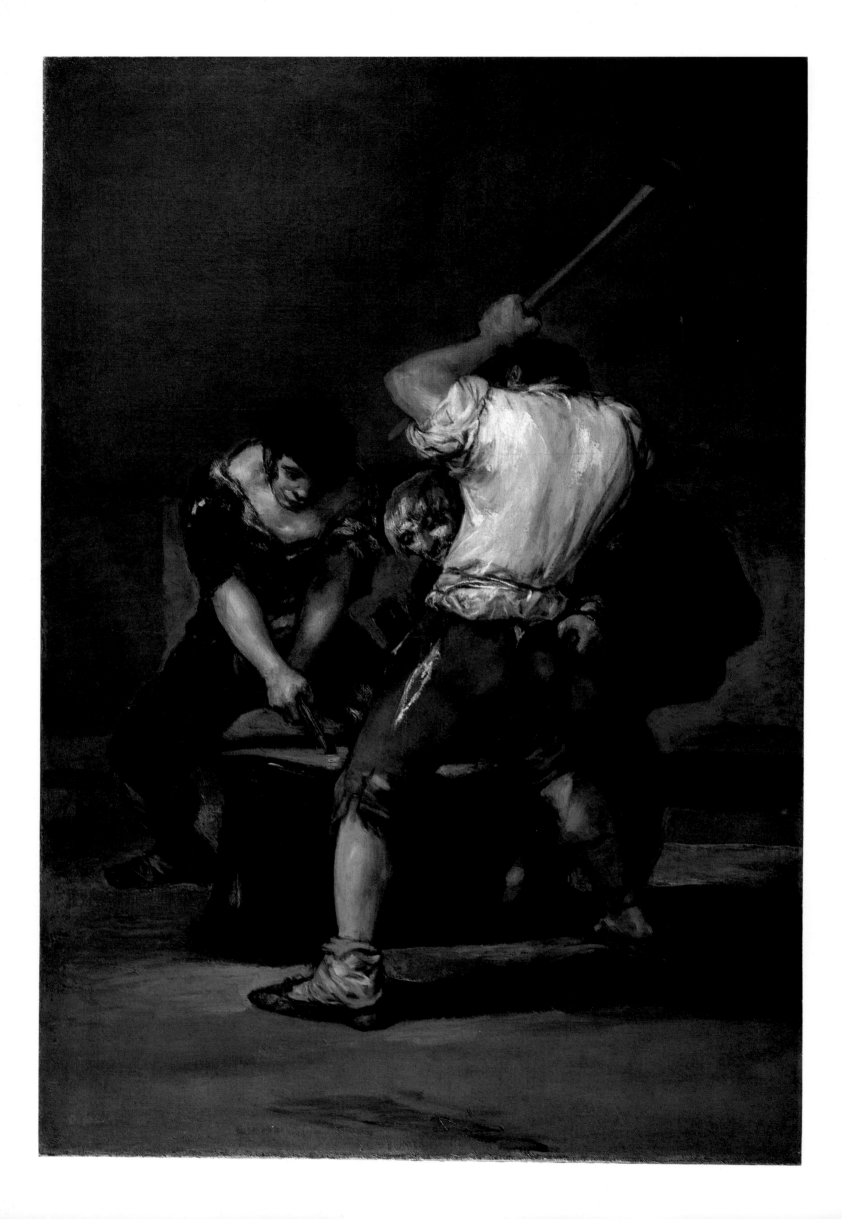

FRANCISCO DE GOYA Y LUCIENTES
1746–1828

Born in Fuendetodos, Goya served his apprenticeship in nearby Saragossa and then studied with Francisco Bayeu in Madrid. He was in Italy in 1770/71, and in 1774 he became a designer for the Royal Tapestry Factory. Appointed court painter to Charles III in 1786, he continued to hold that post under Charles IV and Ferdinand VII. In addition to portraits, Goya painted historical, religious, and genre subjects, bitter satires, and demonological fantasies; he also was a brilliant graphic artist. In 1824, out of favor with the court, he left Spain and settled in Bordeaux, where he died.

THE FORGE

Painted between c. 1815 and 1820. Oil on canvas
71 1/2 × 49 1/4 in. (181.6 × 125.1 cm.)
Acquired in 1914

The composition of this great canvas derives from traditional depictions of the forge of Vulcan, the metalworker of the Olympian gods. Goya translates that mythological theme into contemporary language, using sturdy laborers in working clothes as a subject suitable for dignified, monumental treatment. The rough, vigorous application of paint and the somber coloring heighten the power and intensity of the figures and their actions.

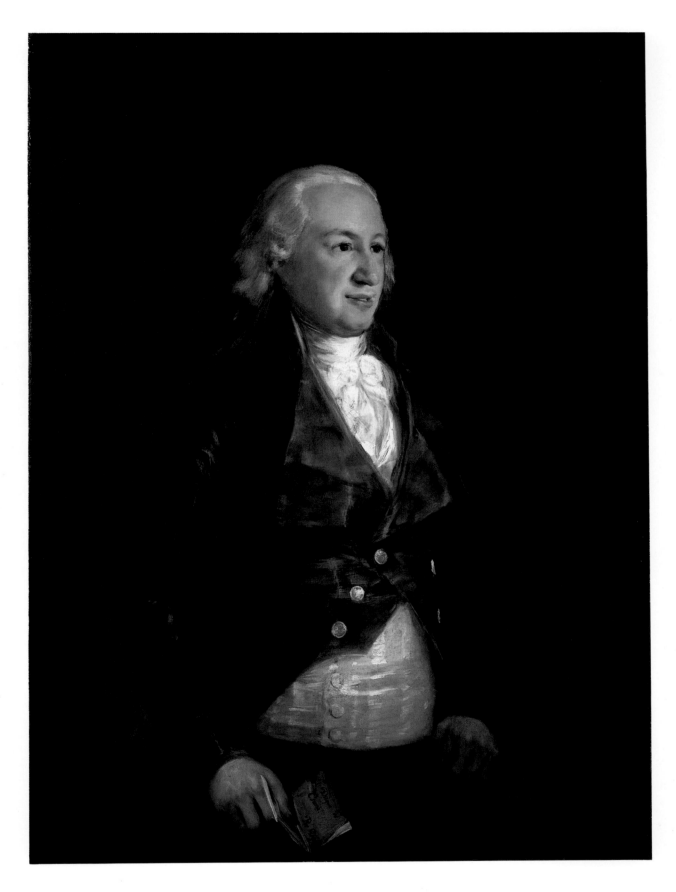

FRANCISCO DE GOYA Y LUCIENTES

DON PEDRO, DUQUE DE OSUNA

Painted probably between 1790 and 1800. Oil on canvas
44 1/2 × 32 3/4 in. (113 × 83.2 cm.)
Acquired in 1943

Don Pedro de Alcántara Téllez-Girón y Pacheco (1755–1807), ninth Duque de Osuna, was one of Spain's wealthiest and most talented noblemen during the reigns of Charles III and Charles IV. An enthusiastic and enlightened patron of the arts and sciences, the Duke seems in this portrait to exhibit the responsive, keen-witted personality that made him a popular figure with the intelligentsia of his day. After the royal court, he and his wife were Goya's most faithful patrons, commissioning more than twenty-four works including portraits, religious subjects, and a famous set of decorative canvases for their country palace outside Madrid.

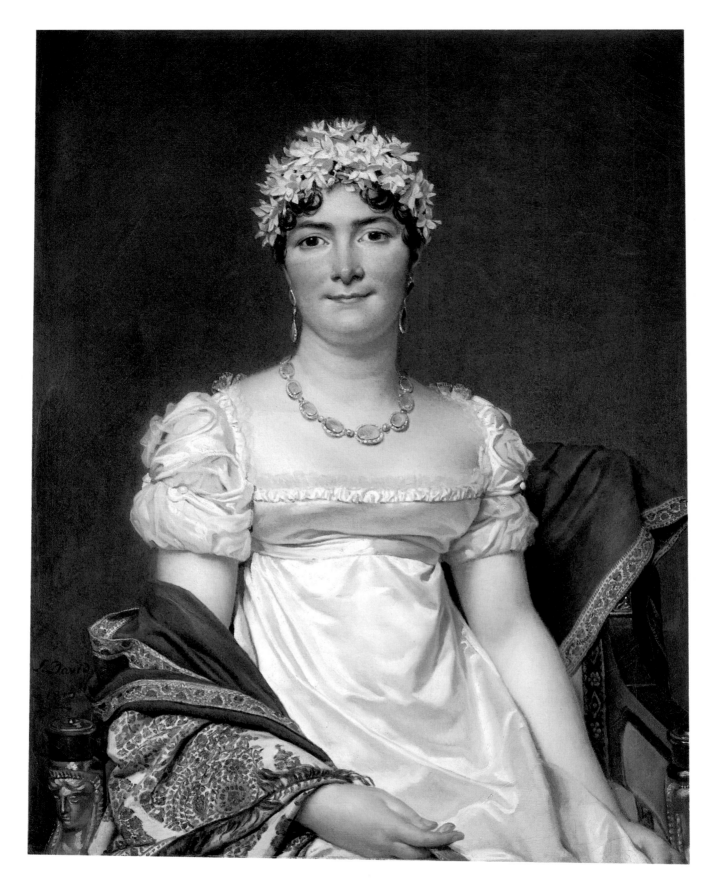

JACQUES-LOUIS DAVID
1748-1825

Born in Paris, David studied with Vien, whom he accompanied to Italy after winning the Prix de Rome in 1774. The leading painter of France a decade later, he played a major political role in the Revolution and set down some of its greatest images. David served Napoleon as his official painter. After the Emperor's fall, he went into exile in Brussels, where he died.

THE COMTESSE DARU

Dated 1810. Oil on canvas
32 1/8 × 25 5/8 in. (81.6 × 65.2 cm.)
Acquired in 1937

David signed this portrait at four o'clock on March 14, 1810. He had executed it as a surprise for Comte Daru, who had obtained for David his payment for *Le Sacre,* the vast painting of the coronation of Napoleon and Josephine. The subject's character, so sympathetically conveyed by David, was characterized by her admirer Stendhal as "forceful, frank, and jolly."

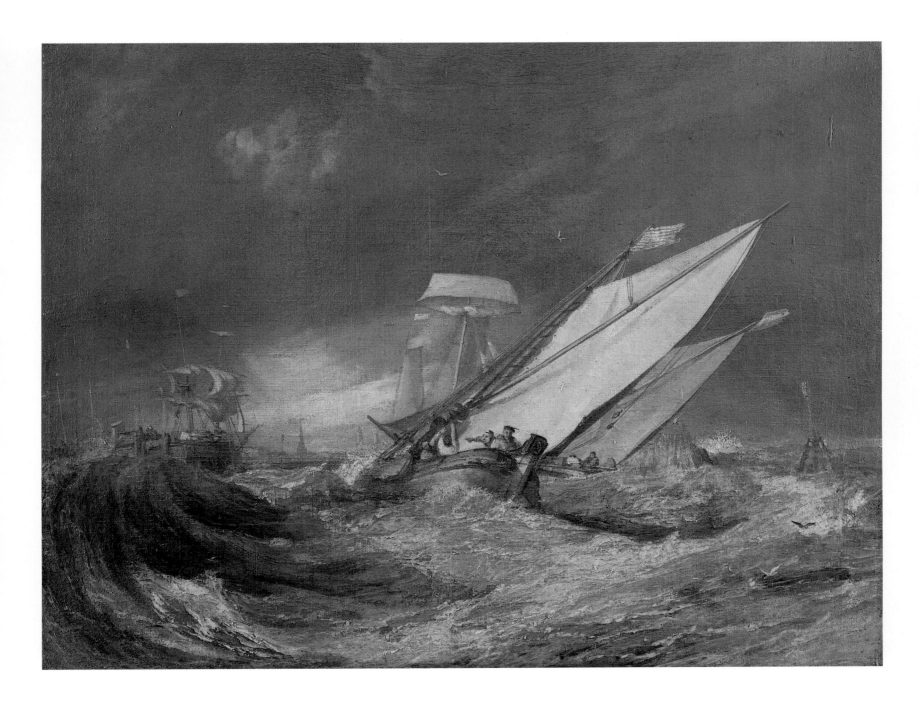

JOSEPH MALLORD WILLIAM TURNER
1775–1851

Turner entered the Royal Academy Schools at the age of fourteen and began his career painting watercolors. His first employment was as a topographical draftsman, in which capacity he traveled around England in the early 1790s. In 1796 he exhibited his first oil painting, and by 1799 he was an associate member of the Royal Academy. He became a full Academician in 1802. Influenced by Reynolds and the eighteenth-century landscapist Richard Wilson, Turner intended to unite landscape with the noble genre of history painting. He traveled extensively in England and on the Continent and made innumerable sketches, many of which he used as the basis for paintings and prints. Turner's style changed considerably over his long career, but, while his late works demonstrate the increasing dominance of abstract pictorial qualities, he never abandoned his interest in subject matter. His pictures have a poetic depth that is unsurpassed in British landscape painting.

FISHING BOATS ENTERING CALAIS HARBOR

Painted c. 1803. Oil on canvas
29 × 38 3/4 in. (73.7 × 98.4 cm.)
Acquired in 1904

In July of 1802, during the temporary Peace of Amiens, Turner began his first visit to the Continent. He recorded his arrival at Calais in several sketches, which he later worked up into this canvas and the much larger *Calais Pier* now in the National Gallery, London. The churning water and stormy skies in both works recall Dutch seascapes of the seventeenth century, which had an early and lasting influence on Turner's style. The motif of the storm-tossed boat in which man was pitted against nature was a favorite in the early Romantic period.

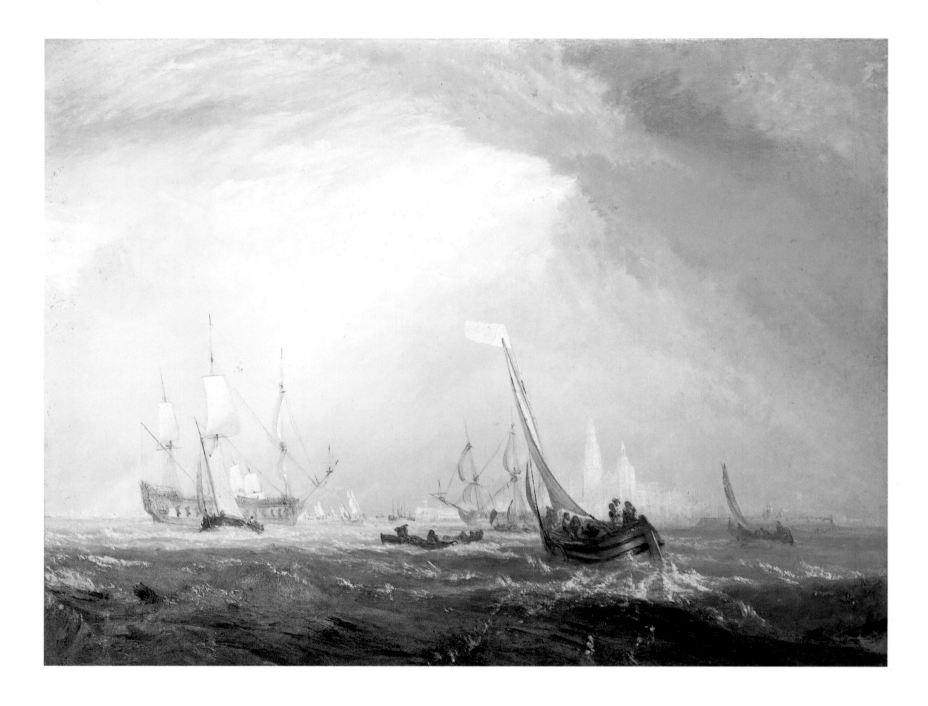

JOSEPH MALLORD WILLIAM TURNER

ANTWERP: VAN GOYEN LOOKING OUT FOR A SUBJECT

Painted in 1833. Oil on canvas
36 1/8 × 48 3/8 in. (91.8 × 122.9 cm.)
Acquired in 1901

Turner visited Antwerp in 1817 and again in 1825, recording his impressions in his sketchbooks. A view of the city is visible in the background of this painting. The reference in the title and the inscription VAN G on the stern of the nearest boat identify the turbaned figure standing in that vessel as the Dutch landscapist Jan van Goyen. Like Turner, Van Goyen visited Antwerp and executed paintings based on sketches done there. This allusion to a seventeenth-century Dutch painter is not unique in

Turner's titles—witness his *Rembrandt's Daughter* and *Port Ruysdael.* At the time this work was exhibited, its cold coloring attracted comment for its grayness, in contrast to Turner's typically yellow tonalities. A contemporary reviewer noted that Turner's "cold style is, if possible, more powerful than his warm," singling out this painting as "the most powerful instance of what we advance."

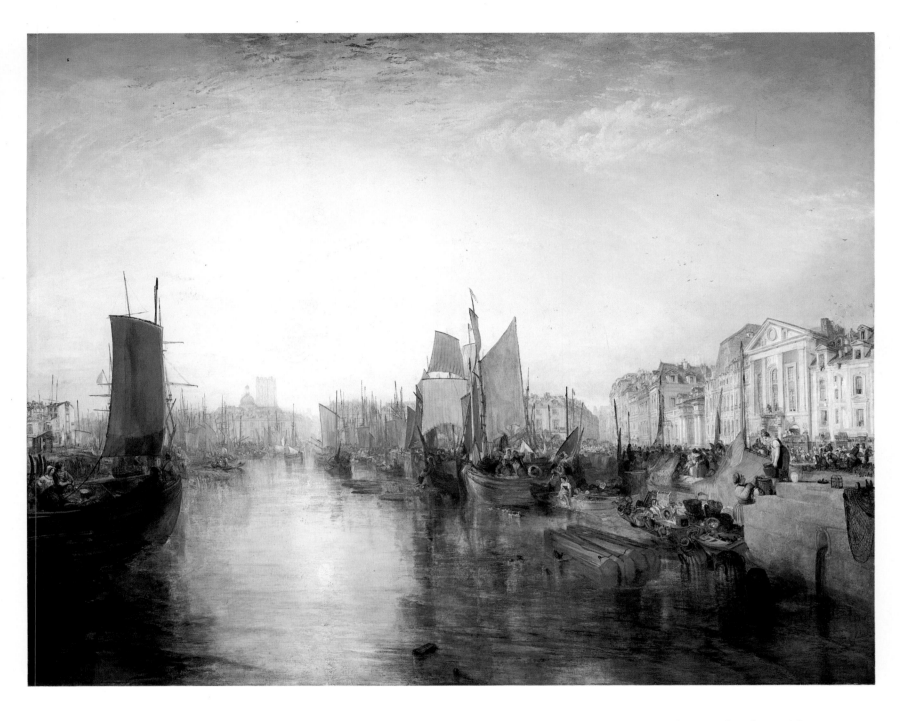

JOSEPH MALLORD WILLIAM TURNER

THE HARBOR OF DIEPPE

Dated 182[6?]. Oil on canvas
68 3/8 × 88 3/4 in. (173.7 × 225.4 cm.)
Acquired in 1914

Dieppe is one of Turner's three large exhibition pieces representing northern Continental ports, another being his scene of Cologne now also in The Frick Collection. Sketches for the present painting date from the late summer of 1821 and record a number of buildings that still stand. When *Dieppe* was shown in the Royal Academy exhibition of 1825, it received mixed reviews. The intense luminosity of the painting was deemed inappropriate for a northern climate and displeased some contemporary critics, one of whom called it a "splendid piece of falsehood." Another, however, wrote: "Not even Claude in his happiest efforts, has exceeded the brilliant composition before us." The apparent inconsistency of the inscribed date with the picture's exhibition in 1825 may indicate that Turner reworked *The Harbor of Dieppe* at the same time he exhibited *Cologne* in 1826.

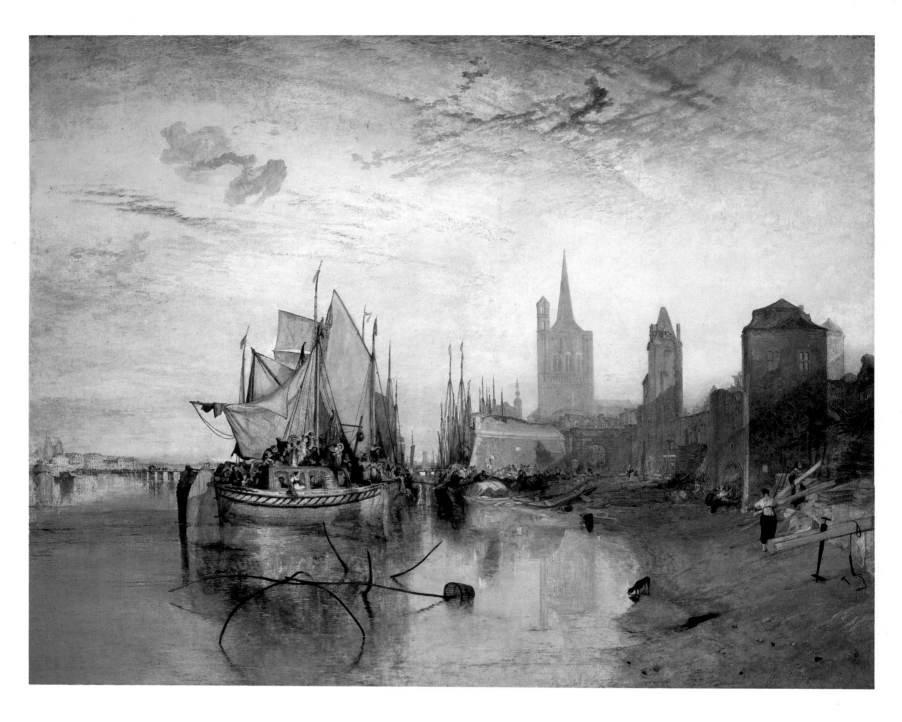

JOSEPH MALLORD WILLIAM TURNER

COLOGNE: THE ARRIVAL OF A PACKET-BOAT: EVENING

Painted in 1826. Oil and possibly watercolor on canvas
66 3/8 × 88 1/4 in. (168.6 × 224.1 cm.)
Acquired in 1914

The composition is based on sketches Turner made while touring the Rhine in 1817 and again in 1825. Among the discernible structures are, from the foreground back: the Kostgassepforte gate before the Frankenturm; the sixteenth-century Bollwerk and the archway over the entrance to the Zollstrasse; the Stapelhaus; and the church of Gross St. Martin. Turner achieved the high-keyed color and transparency of watercolor painting in this monumental canvas, and it is possible that he did combine the media of oil and watercolor, as suggested in a letter in which he warned his father: "you must not by any means wet it, for all the colour will come off." A questionable story associated with the painting was recorded by Ruskin, who described how Turner quixotically covered the golden sky with a wash of lampblack at the start of the Royal Academy exhibition of 1826 in order not to detract from two portraits by Lawrence that hung to either side of it. A contemporary reference to the painting's "glitter and gaud" casts doubt on this anecdote.

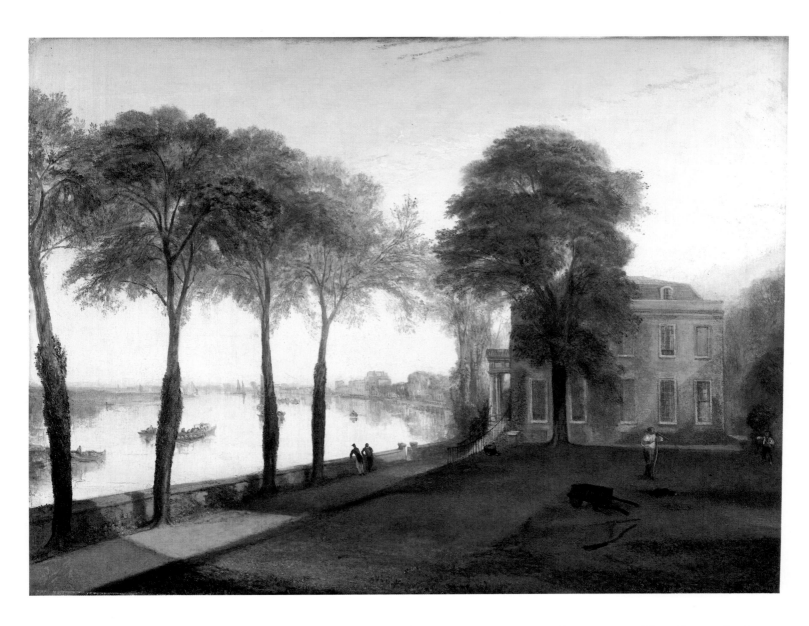

JOSEPH MALLORD
WILLIAM TURNER

MORTLAKE TERRACE: EARLY
SUMMER MORNING

Painted in 1826. Oil on canvas
36 5/8 × 48 1/2 in. (93 × 123.2 cm.)
Acquired in 1909

This canvas painted for William Moffatt depicts his estate at Mortlake, on the Thames just west of London. Like so many of Turner's works, it is based on numerous preparatory drawings, in which the artist recorded the topography and studied various ways of balancing the mass of the house and land against the open river and sky. A companion view of the terrace and river on a summer evening as seen from a ground-floor window of the house is in the National Gallery, Washington. Shown in the same Royal Academy exhibition of 1826 as the more ambitious painting of Cologne, *Mortlake Terrace* was praised for its "lightness and simplicity." Turner's penchant for a luminous shade of yellow is again a dominant feature of the painting.

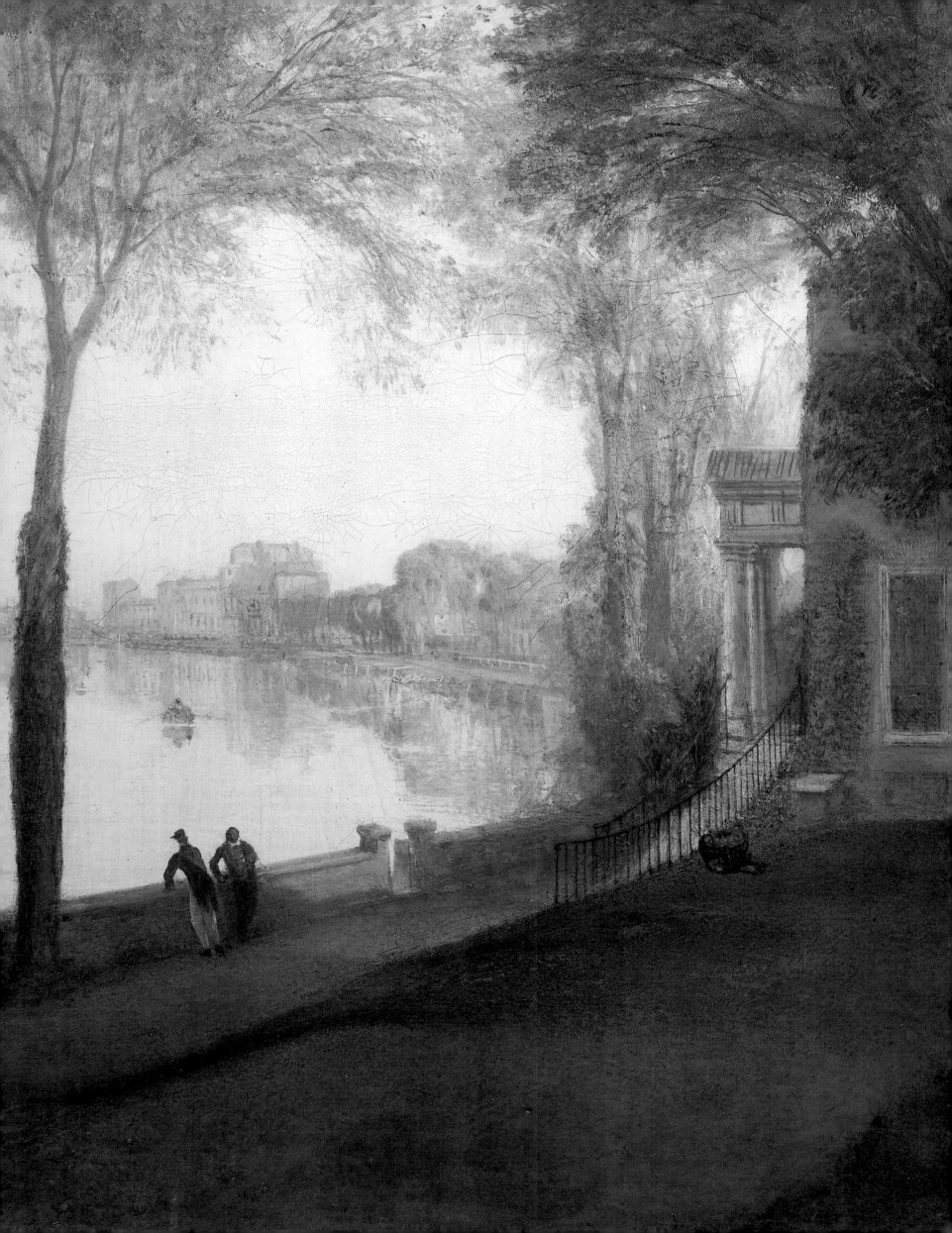

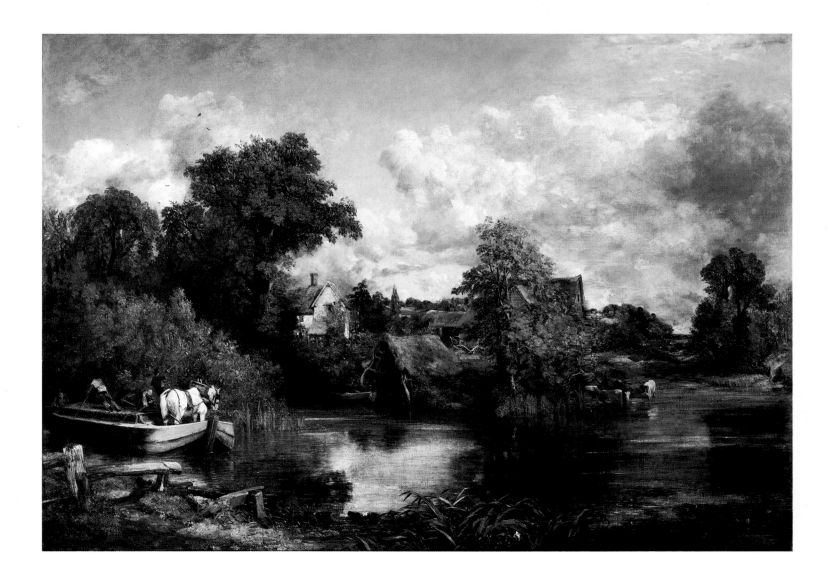

JOHN CONSTABLE
1776–1837

Constable left his native Suffolk in 1799 to study at the Royal Academy, of which he became an associate in 1819 and a full member only in 1829. His landscapes, which depict chiefly the Suffolk countryside, had a deep influence on his contemporaries, particularly the French. His elaborately finished exhibition pieces were based on numerous sketches painted outdoors directly from nature. The naturalism and simplicity of Constable's approach to the English landscape have been compared to the poetry of his early Romantic contemporaries, such as Wordsworth.

THE WHITE HORSE

Dated 1819. Oil on canvas
51 3/4 × 74 1/8 in. (131.4 × 188.3 cm.)
Acquired in 1943

The painting depicts a tow-horse being ferried across the river Stour in Suffolk, just below Flatford Lock at a point where the tow-path switched banks. Constable, who described the scene as "a placid representation of a serene, grey morning, summer," went on in later years to comment: "There are generally in the life of an artist perhaps one, two or three pictures, on which hang more than usual interest—this is mine." The painting was well received when it was exhibited at the Royal Academy exhibition of 1819, and it was purchased by Constable's friend Archdeacon John Fisher. Constable bought back the painting in 1829 and kept it the rest of his life. There is a full-scale oil sketch for *The White Horse* in the National Gallery, Washington.

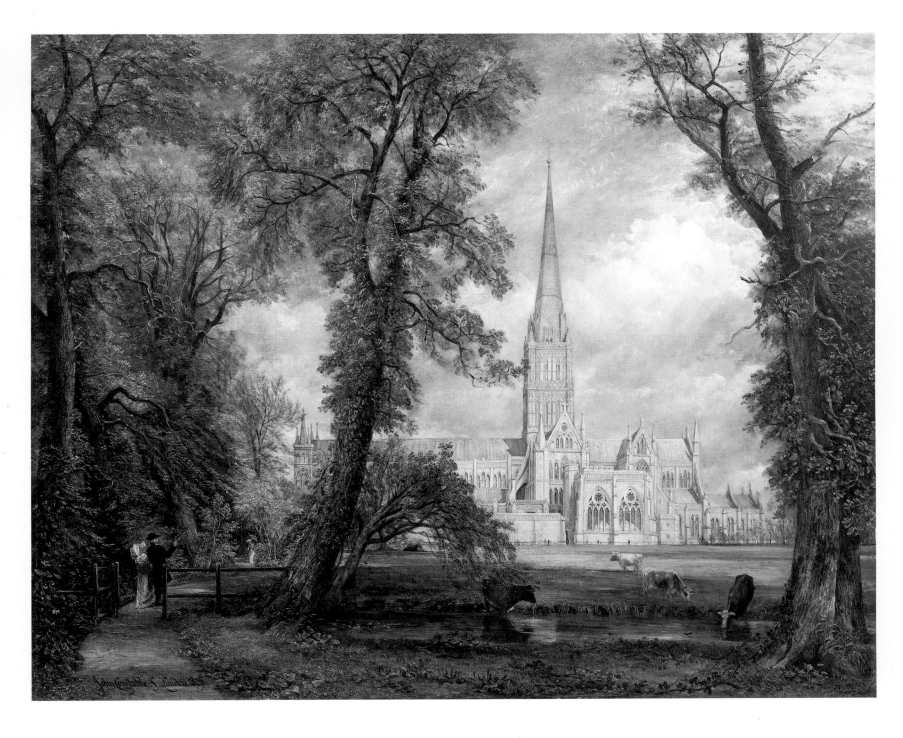

JOHN CONSTABLE

SALISBURY CATHEDRAL FROM THE BISHOP'S GARDEN

Dated 1826. Oil on canvas
35 × 44 1/4 in. (88.9 × 112.4 cm.)
Acquired in 1908

Constable painted several views of the south façade of Salisbury Cathedral for his intimate friends Dr. John Fisher, Bishop of Salisbury, and the Bishop's nephew Archdeacon John Fisher, who had purchased *The White Horse*. Constable's first version of the Cathedral, done for the Bishop (now in the Victoria and Albert Museum), had a dark, cloudy sky. In response to the owner's objections to its ominous atmosphere, Constable painted this version with a sunnier sky and a more open composition. As in the earlier canvas, Constable included the figure of the Bishop pointing out the Cathedral's spire to his wife, and beyond them a young lady holding a parasol, presumably one of their daughters. The Bishop had died by the time the picture was completed, but it was acquired by his family. Two favorite subjects of nineteenth-century artists—a medieval ecclesiastical monument and a dramatic landscape—are particularly well united through the arrangement of tree trunks and branches echoing the rising lines of the Cathedral spire.

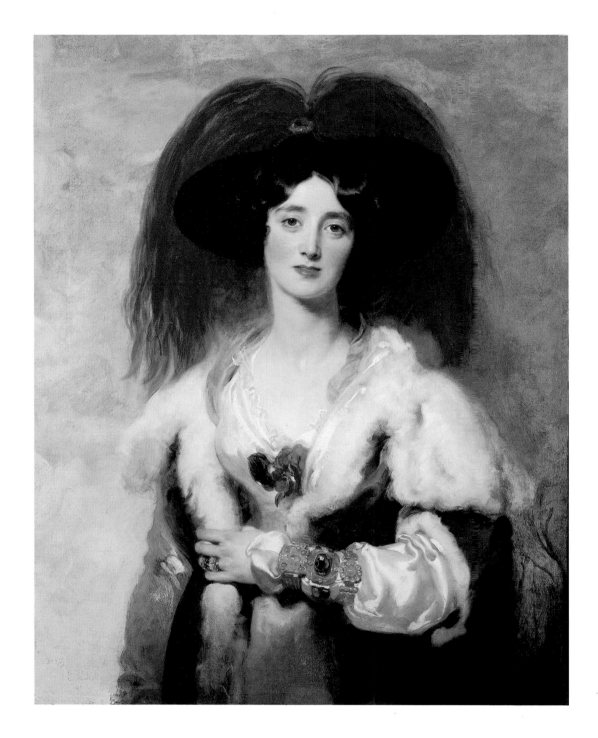

SIR THOMAS LAWRENCE
1769-1830

Born in Bristol, Lawrence spent his childhood in Devizes, Oxford, Weymouth, and Bath. His remarkable artistic talent was recognized when he was only ten. In 1787 he moved to London and entered the Royal Academy Schools, where he received great encouragement from Sir Joshua Reynolds. Upon Reynolds' death Lawrence was appointed Painter to the King, George III, and in 1820 he became President of the Royal Academy. Lawrence was also patronized by the King's son, the Prince Regent—the future King George IV —who commissioned an important series of portraits of sovereigns, statesmen, and generals that hangs in the Waterloo Chamber at Windsor Castle. From 1790 to 1830, Lawrence received a steady stream of commissions, and his portraits earned him a reputation on the Continent unequaled by any earlier British painter.

LADY PEEL

Painted in 1827. Oil on canvas
35 3/4 × 27 7/8 in. (90.8 × 70.8 cm.)
Acquired in 1904

Julia Floyd (1795–1859) was married in 1820 to the British statesman Sir Robert Peel, who twice served as Prime Minister and was an avid patron of Lawrence. The Frick portrait apparently was inspired by Rubens' painting of Susanna Fourment known as the *Chapeau de paille*, which Peel had acquired in 1823. When Lawrence's *Lady Peel* was first exhibited at the Royal Academy in 1827, a critic claimed it to be among "the highest achievements of modern art." Lawrence's flamboyant and virtuoso style has come to epitomize the spirit of the Regency period.

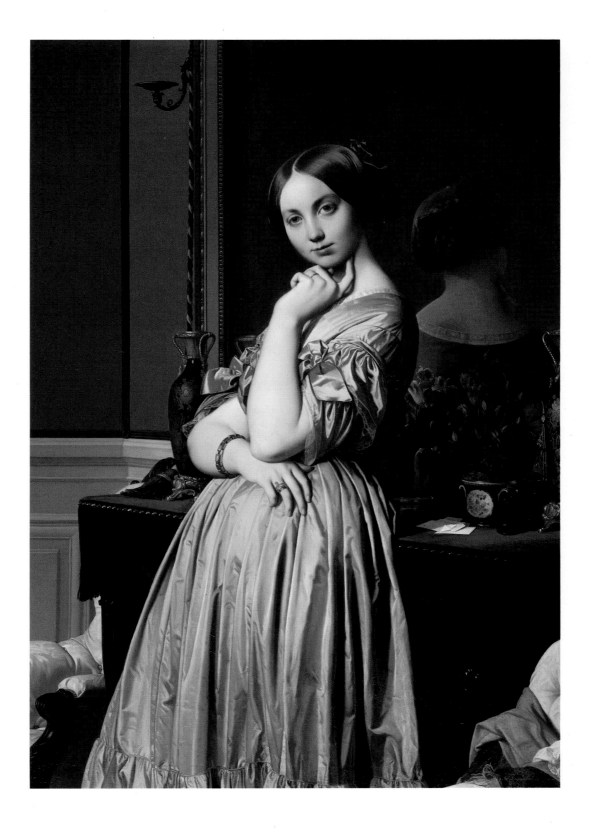

JEAN-AUGUSTE-DOMINIQUE INGRES
1780–1867

Born in Montauban, Ingres studied first in nearby Toulouse and then with David in Paris. He won the Prix de Rome in 1801 and was in Italy from 1806 until 1824, when his Vow of Louis XIII *was exhibited with great success at the Salon. He spent the following decade in Paris, where he received official honors and attracted many pupils, but his work was severely criticized in 1834. He then returned to Rome for seven years as Director of the French Academy. His final years were spent in Paris.*

THE COMTESSE D'HAUSSONVILLE

Dated 1845. Oil on canvas
51 7/8 × 36 1/4 in. (131.8 × 92 cm.)
Acquired in 1927

Louise, Princesse de Broglie (1818–82) and granddaughter of Madame de Staël, married at the age of eighteen. Her husband was a diplomat, writer, and member of the French Academy, and she herself published a number of books, including biographies of Robert Emmet and Byron. For her time and her elevated social caste, she was outspokenly independent and liberal. This portrait, begun in 1842, was the fruit of several false starts and a great many preparatory drawings, including full-scale studies of the raised left arm, the head, and its reflection. According to a letter written by the artist, the finished work "aroused a storm of approval." In it Ingres appears to have surprised the young lady in the intimacy of her boudoir, where she leans against an upholstered fireplace, having just discarded her evening wrap and opera glasses.

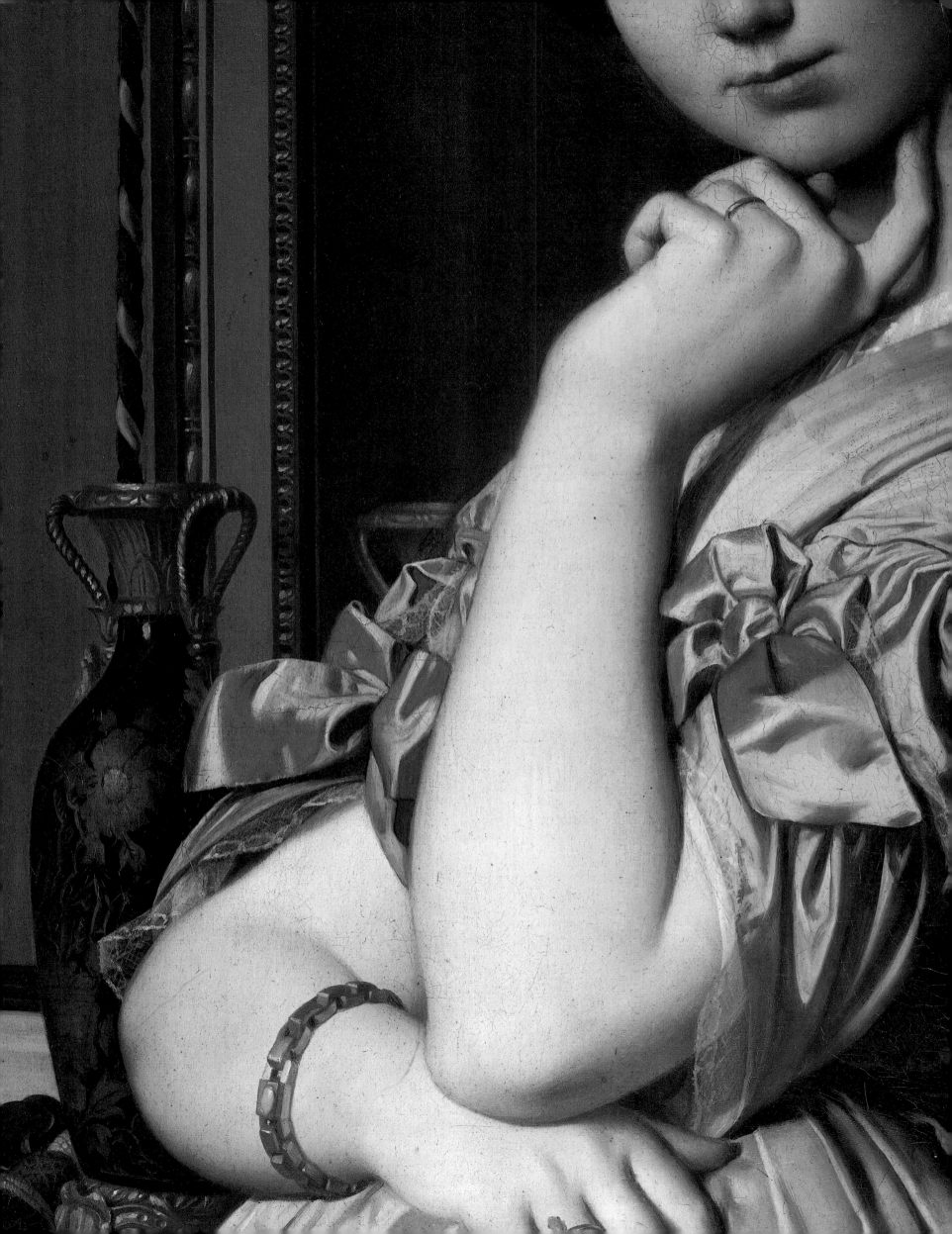

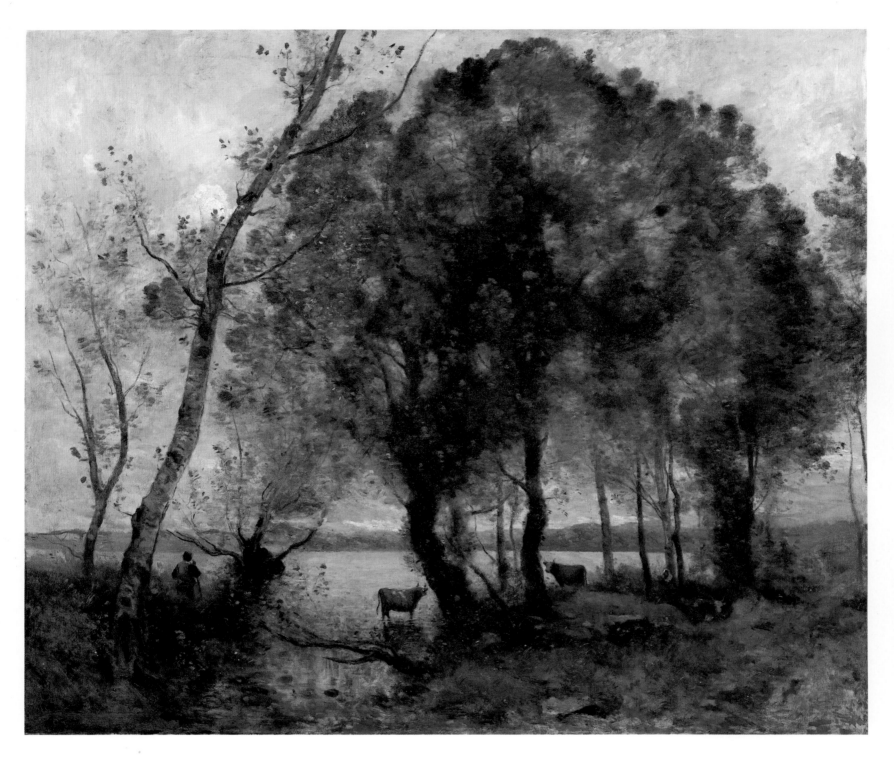

JEAN-BAPTISTE-CAMILLE COROT
1796–1875

Corot was born in Paris and studied there with the classicizing painters Michallon and Bertin before leaving in 1825 for three years in Italy. There he developed, by painting outdoors, a unique landscape style based on tonal values, although for pictures intended for exhibition he retained traditional classical or religious themes. He traveled widely in France after his return, working in the vicinity of Rouen, in the forest of Fontainebleau, and at Ville-d'Avray, near Paris, where his father had a country house. By the 1850s he had developed a blurry, poeticizing manner that won him great official and public favor, but which also inspired many imitators. Corot's late figural studies

mark a return to his more forceful early style, as well as showing some awareness of the work of his younger contemporaries such as Courbet and Manet. Although Corot was awarded many honors, he remained a man of great simplicity, remembered for his many benefactions toward fellow artists.

THE LAKE

Painted in 1861. Oil on canvas
52 3/8 × 62 in. (133 × 157.5 cm.)
Acquired in 1906

Corot exhibited this large, nearly monochromatic picture at the Salon of 1861. Critical reactions to it varied. Castagnary evoked most clearly the artist's approach to painting at this time, saying: *"The Lake* is a ravishing landscape, simple in composition and full of grandeur. . . . When he sets himself before his canvas it is—like a musician seating himself at the piano—in order to give voice to the inspiration that torments him. What he wants is to express his personal feelings, not nature that inspired them in him." But Thoré was less sympathetic to this approach, remarking of *The Lake*: "Mist covers the earth. One is not sure where one is and one has no idea where one is going. Corot's work is perhaps poetic, but it is not varied."

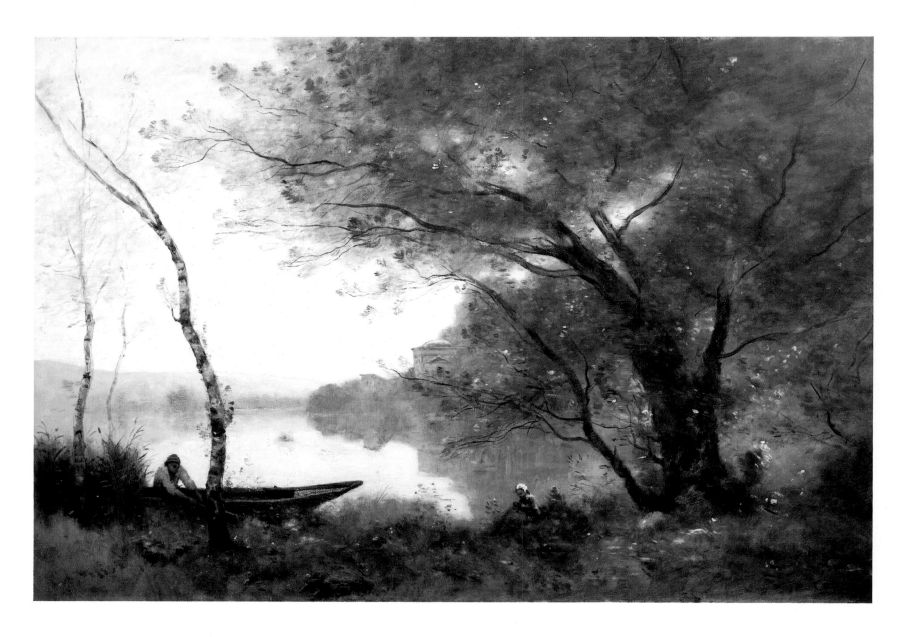

JEAN-BAPTISTE-CAMILLE COROT

THE BOATMAN OF MORTEFONTAINE

Painted between 1865 and 1870. Oil on canvas
24 × 35 3/8 in. (60.9 × 89.8 cm.)
Acquired in 1903

Although the park of Mortefontaine actually
exists, not far from Paris near Senlis, Corot's
landscape does not represent, in any realistic
sense, a particular place. Comparison of this
picture with the artist's preparatory drawing
for it, now also in The Frick Collection, reveals
much about Corot's working methods in the
1860s. While the foreground trees and the boat
appear in both, the distant point of land and the
domed, pedimented *tempietto* crucially located
at the center of the composition are not indi-
cated at all in the charcoal sketch. Further-
more, the sketch possesses an agitated, wind-
swept character that Corot deliberately calmed
in his painting, even to the point of showing the

punt in the act of being moored to the bank
rather than being pushed across the water by a
standing boatman. Also, what appears to be a
bobbing sailboat in the drawing is transformed
into a solid spot of land that serves as a point of
focus in the middle of the lake. In 1865, Corot
introduced a *tempietto* similar to that seen here
into the setting of his *Orpheus Saluting the Light,*
one of two decorative panels painted for Prince
Demidoff. There, even more obviously than in
The Boatman of Mortefontaine, the building is
intended to evoke the classical landscapes, real
or poetic, of Italy. All this rational manipulation
of effects on the part of the artist is dissimulated
by the feathery textures and cool, muted har-
monies of his picture.

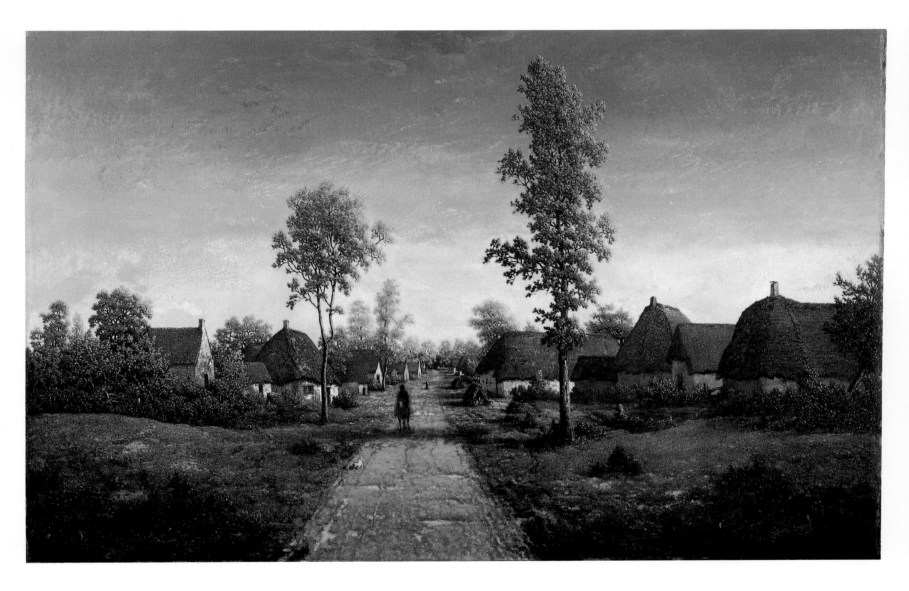

PIERRE-ÉTIENNE-THÉODORE ROUSSEAU
1812–1867

Rousseau was born and trained in Paris, where he studied first with Charles Rémond, then with Guillon Lethière. At an early age he began working from nature, inspired by the Dutch seventeenth-century landscapes he saw in the Louvre. He first exhibited at the Salon in 1831, but he had little success with his non-Academic landscapes until 1849, when he won a first-class medal. After the Revolution of 1848, Rousseau settled in the village of Barbizon with Millet, Daubigny, and others of the group that came to be known as the Barbizon School.

THE VILLAGE OF BECQUIGNY

Painted between 1857 and 1864. Oil on panel
25 × 39 3/8 in. (63.5 × 100 cm.)
Acquired in 1902

During a trip through Picardy in 1857, Rousseau was much taken by the unchanged, rustic appearance of Becquigny, a village not far from Saint-Quentin. With its low thatch-roofed huts it seemed to him a strange survival from an ancient past. The artist's first rendering of the village road, so reminiscent of Hobbema's famous *Avenue at Middelharnis* (National Gallery, London), delighted his friends with its freshness and brilliance, but Rousseau was less satisfied. In a letter to Sensier, he stated that while the "outline" of the picture had been settled, its "composition" was unfinished, adding: "but I understand by composition that which is within us and which penetrates as far as possible into the external reality of things...."

The recipient of this letter noted that the day before Rousseau sent the painting to the Salon of 1864 (entitled simply *A Village*), he repainted the whole sky. Influenced by the first Japanese prints he had seen, he changed it to a clear sapphire blue—a meteorological effect rarely witnessed in the skies of northern France. Although the picture attracted attention, the sky was widely criticized. Even Sensier noted that in it the artist had shown "an excess of invention." As a result of all this, Rousseau began to rework the sky once again, ultimately restoring its original softer tones.

The first owner of this important landscape, Frédéric Hartmann, succeeded in taking possession of his promised acquisition only by going with Sensier to Rousseau's Paris studio the day before the artist died and claiming it.

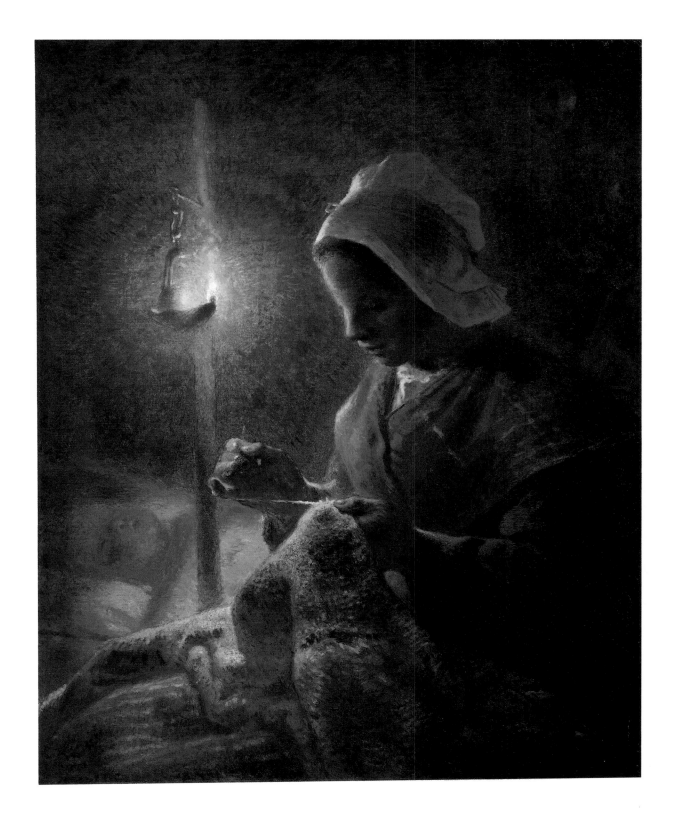

JEAN-FRANÇOIS MILLET
1814–1875

The son of Norman peasants, Millet studied in Cherbourg and then Paris. His work was shown in several Salons in the 1840s, but it was not until the Winnower of 1848 that he began to exhibit the peasant subjects that made him famous. In 1849 he moved to Barbizon, where he spent most of his remaining years.

WOMAN SEWING BY LAMPLIGHT

Painted in 1870–72. Oil on canvas
39 5/8 × 32 1/4 in. (100.7 × 81.9 cm.)
Acquired in 1906

It has been suggested that Millet's many scenes of peasant women and their families working by lamplight were inspired by his fondness for Latin bucolic poetry, especially certain lines from Virgil's *Georgics.* Similar treatments by Rembrandt and other Dutch painters may also have influenced his choice of themes, but ultimately this picture relates most closely to what

the artist was witnessing in his own home, as he wrote to a friend the year the canvas was completed: "I write this, today, November 6th at 9 o'clock in the evening. Everyone is at work around me, sewing, and darning stockings. The table is covered with bits of cloth and balls of yarn. I watch from time to time the effects produced on all this by the light of the lamp. Those who work around me at the table are my wife and grown-up daughters."

In addition to this important painting by Millet, Mr. Frick owned ten drawings and pastels by the artist.

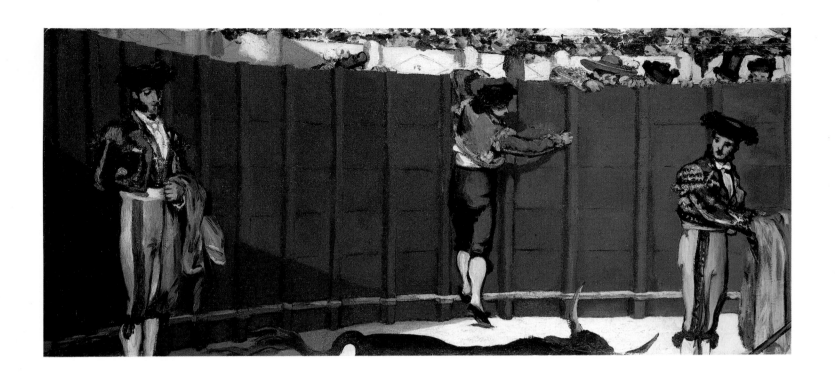

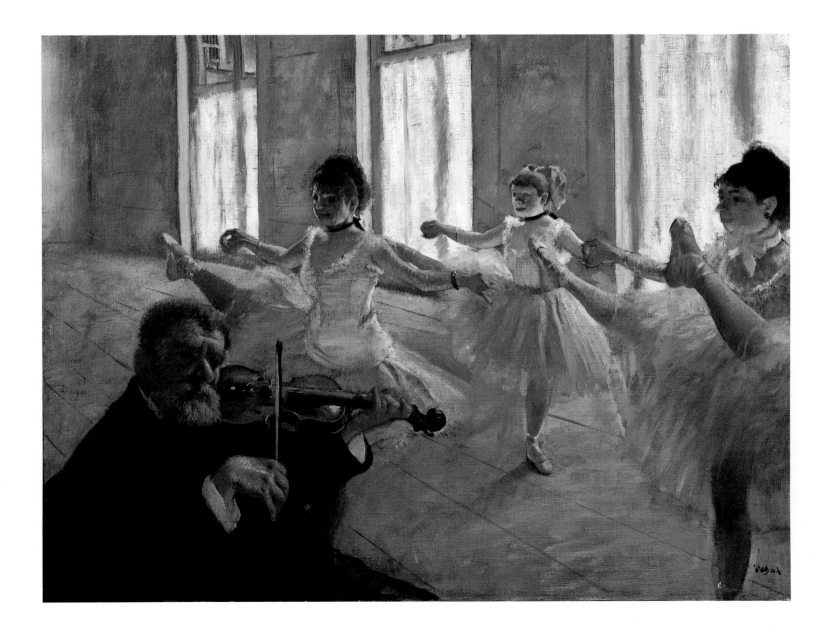

ÉDOUARD MANET
1832–1883

Born into a prosperous Parisian household, Manet studied with Couture between 1850 and 1856. After that he developed an individual technique utilizing half-tones as little as possible and employing a restricted palette rich in black. His subjects were drawn from contemporary life, often from its lower ranks. Although his early work included many Spanish themes and his style was influenced by Velázquez and Goya, Manet did not visit Spain until 1865. He first exhibited at the Salon in 1861, but two years later he showed at the Salon des Refusés, where his work was received with the ridicule that it would provoke throughout most of his career. After 1870 Manet adopted an Impressionist technique and palette and treated more lighthearted subjects than during the previous decade; nevertheless, he refused to take part in the Impressionist exhibitions organized by Degas. Baudelaire and Zola eventually became his friends and defenders, but the official recognition he longed for came to Manet only in the year before his death, when he was awarded the Legion of Honor.

THE BULLFIGHT *(above left)*

Painted in 1864. Oil on canvas
18 7/8 × 42 7/8 in. (47.9 × 108.9 cm.)
Acquired in 1914

In 1864 Manet exhibited at the Salon a painting entitled *An Incident in the Bullring.* The work was savagely caricatured and criticized, one writer describing its subject as "a toreador of wood killed by a horned rat." After the picture was returned from the Salon, Manet cut out two separate compositions from the canvas, possibly because he accepted the criticism as justified. The lower, larger section, now known as *The Dead Toreador,* is in the National Gallery, Washington. Both sections of the original canvas were subsequently reworked by the artist, the head of the bull being added to the Frick segment after the painting had been divided.

Unlike some of his American contemporaries, Mr. Frick showed little interest in the Impressionists. His acquisitions in this area were limited to this work by Manet, the paintings by Renoir and Degas reproduced here, and two landscapes by Monet, one of which he sold back. The other—*Banks of the Seine, Lavacourt*—has always remained in his Pittsburgh residence.

HILAIRE-GERMAIN-EDGAR DEGAS
1834–1917

Born in Paris, Degas entered the École des Beaux-Arts in 1855 to work with Louis Lamothe, one of Ingres' former pupils. He visited Italy the following year, resettled in Paris—where from 1865 until 1870 he exhibited at the Salon—and in 1872 went to New Orleans to live with relatives for several months. After his return to France he exhibited for eight years with the Impressionists. Degas' varied subjects, motifs drawn largely from urban life, encompassed dancers, working girls, women bathing, and race horses, but also included occasional landscapes. The artist experimented throughout his life with a variety of media, including oil, pencil, charcoal, pastel, watercolor, etching, lithography, monotypes, photography, and sculpture. His last public exhibition was held at Durand-Ruel's in 1893. Degas made occasional trips to Italy and England, and in 1880 he visited Spain and Tangier. He died, solitary and almost blind, in Paris.

THE REHEARSAL *(below left)*

Painted probably in 1878–79. Oil on canvas
18 3/4 × 24 in. (47.6 × 60.9 cm.)
Acquired in 1914

This painting is probably the canvas entitled *École de danse* that Degas entered in the fourth exhibition of the Impressionists in 1879. It then belonged to the artist's close friend Henri Rouart, and it was sold after Rouart's death in 1912 along with a number of other important works by Degas. Mr. Frick was the next private individual to own it, acquiring the painting a year and a half later.

The Rehearsal is one of many compositions devoted to the dance that the artist produced in the 1870s, apparently fascinated with the mechanization of the human body that the rigorous discipline of the ballet imposed. In the same exhibition of 1879 Degas showed two other pictures of dancers practicing with a violinist. In all of them the unidentified musician appears divorced from the events surrounding him, his age and stolid form providing a touching contrast to the doll-like ballerinas.

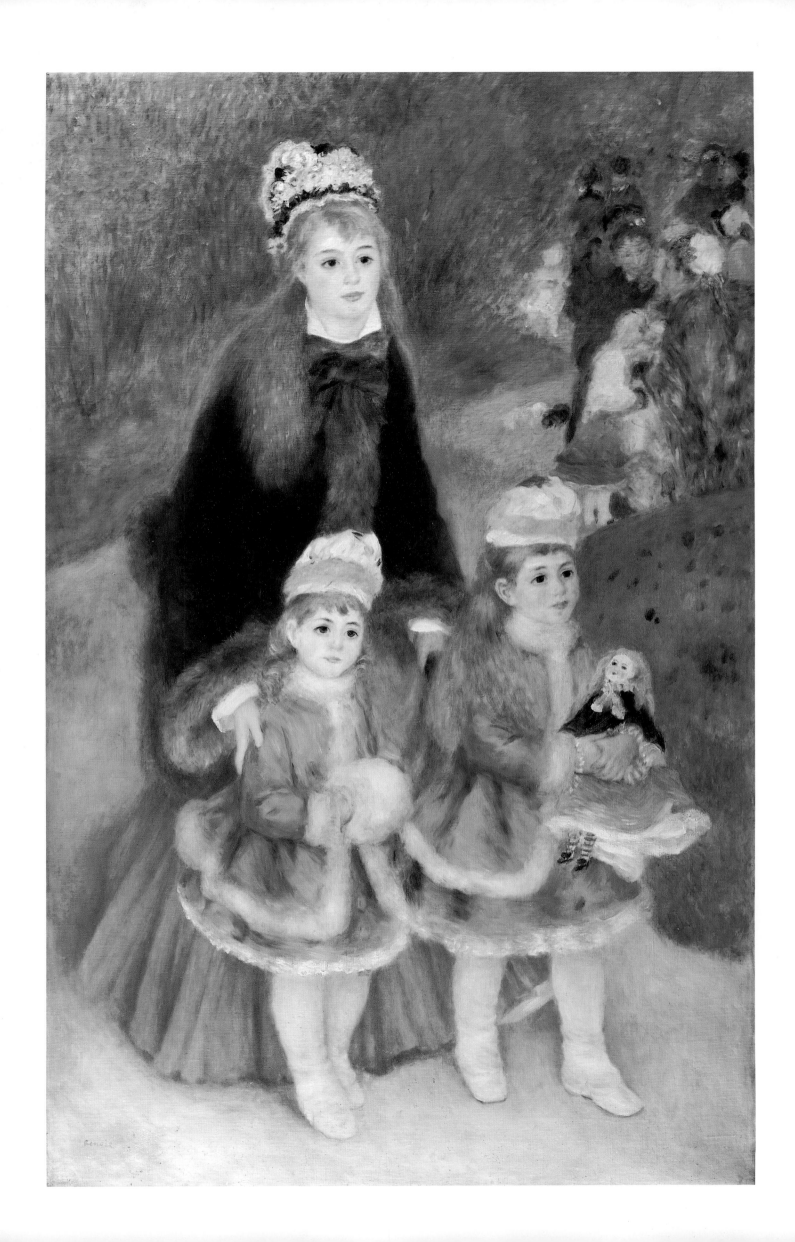

PIERRE-AUGUSTE RENOIR
1841–1919

Born in Limoges, Renoir was four when his family moved to Paris. He began his career as a painter of porcelain, but at twenty-one he entered Gleyre's studio and enrolled at the École des Beaux-Arts. He first showed at the Salon in 1864, and ten years later he took part in the inaugural Impressionist exhibition, which he hung. After visits to Algeria and Italy in 1881–82 his work began to diverge from that of the Impressionists toward a more classical tradition. Crippled with arthritis in old age, he nevertheless continued to paint and to produce sculpture. Renoir died at Cagnes.

MOTHER AND CHILDREN

Painted probably c. 1876–78. Oil on canvas
67 × 42 5/8 in. (170.2 × 108.3 cm.)
Acquired in 1914

The subjects of this delightful portrait have never been identified, but according to a plausible tradition they were two daughters of a prosperous Parisian family of Italian origin and their nurse, whom Renoir encountered in the park adjoining the church of La Trinité, not far from his studio. In quality and scale, and probably in date, the portrait is to be compared with Renoir's *Madame Charpentier and Her Children* (Metropolitan Museum), painted in 1878 and exhibited with great success the following year. The Frick portrait does not figure in the list of pictures shown either by the artist's dealer, Durand-Ruel, or by Renoir himself in public exhibitions prior to the twentieth century. Before belonging to Mr. Frick, *Mother and Children* was for a brief time in Potter Palmer's celebrated collection of Impressionist paintings in Chicago.

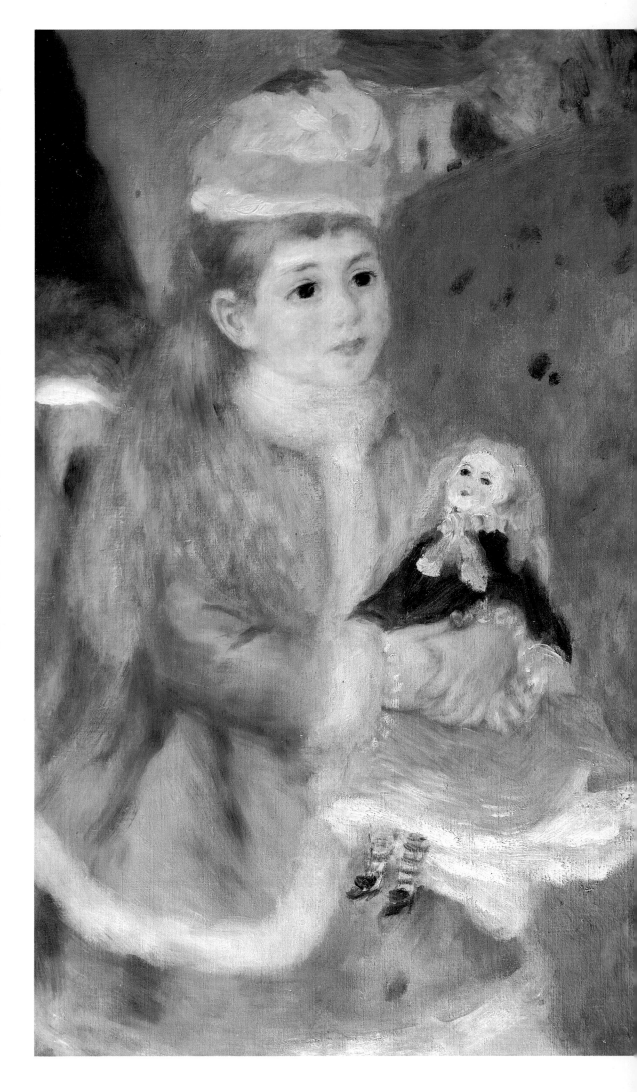

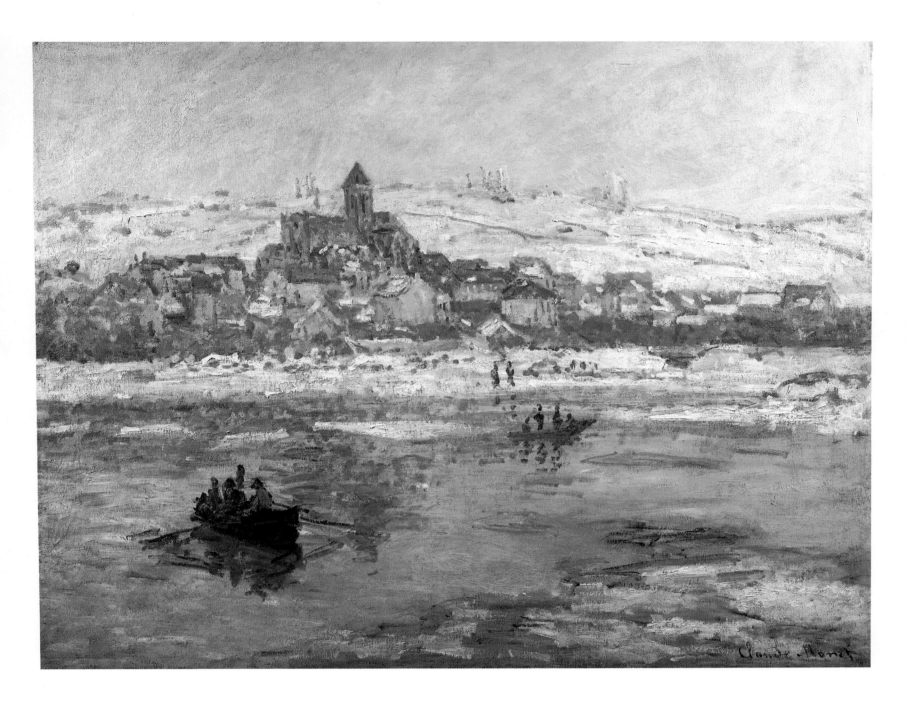

CLAUDE-OSCAR MONET
1840-1926

Parisian by birth, Monet was still a child when his family moved to Le Havre. There he later met Boudin, who convinced him to become a landscape painter. His artistic studies were interrupted by two years of military service in Algeria, but in 1862 he returned to Paris and worked briefly in Gleyre's studio, where he met Renoir, Bazille, and Sisley. He showed in the Salons of 1865 and 1866. In 1870, at the outbreak of the Franco-Prussian War, he went to England. Monet's Impression—Sunrise *was greeted with derision at the first Impressionist exhibition in 1874, and its title would be adopted mockingly to name the whole movement of Impressionism. Although extremely poor for many years, the artist gradually won recognition, comfort, and fame. He painted along the Seine, on the Riviera, by the English Channel, in Brittany, the Midi, Holland, London, and Venice, and, especially in his last years, in his own elaborate garden at Giverny. Monet died at Giverny.*

VÉTHEUIL IN WINTER

Painted in 1878 or 1879. Oil on canvas
27 × 35 3/8 in. (68 × 89.4 cm.)
Acquired in 1942

In 1878 Monet moved down the Seine from Argenteuil to Vétheuil, a small town on a bend in the river. Over the next few years he would paint Vétheuil from different points of view and in every season, as seen from the riverbanks, from the meadows, and from a boat he had arranged as a kind of floating studio. It was during the winter of 1878/79 that Monet executed this picture, looking back across the ice floes of the Seine toward Vétheuil's medieval church tower. On December 12, 1879, Dr. de Bellio, an avid collector of Monet's work, wrote to the artist that this was one canvas that would never leave his possession.

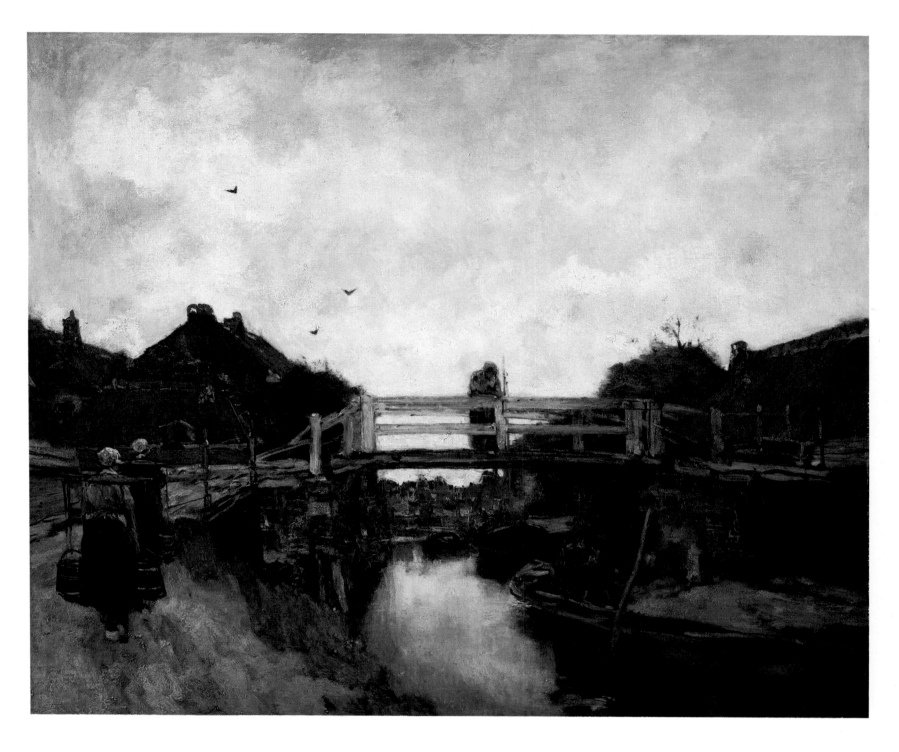

JACOBUS HENDRIKUS MARIS

1837–1899

Maris was born in The Hague and received his first training there. He studied in Antwerp, then went back to The Hague in 1857. During the late 1860s he worked in Paris, where he was influenced by the landscapes of the Barbizon painters. He returned to his native city in 1871, and subsequently became a leading figure in the Hague School of painting, as were his younger brothers Matthijs and Willem.

THE BRIDGE

Painted in 1885. Oil on canvas
44 3/8 × 54 3/8 in. (112.7 × 138.1 cm.)
Acquired in 1914

Looking at the somber grays and blacks of this village scene, with its shimmering silver-surfaced canal, it is hard to believe that a contemporary of Maris had complained of the extreme vividness of the colors in the painting. This critic later learned from Maris that he expected his pigments to reach a mellow maturity only after ten or twelve years from the time of their application. The artist clearly understood his craft, for today the subdued tones of the picture greatly enhance this powerful portrait of an ordinary, even drab, Dutch town, blanketed under clouds stirred by damp, gusty winds.

The site depicted is said to be near Rijswijk, on the outskirts of The Hague. A number of similar compositions by Maris, which include both oil sketches and a wash drawing, may be preparatory studies for the picture. An impression of Maris' own etching of this subject is in The Frick Collection.

Artists of the Hague School were much in fashion during Mr. Frick's years of collecting. He purchased a total of five paintings and three works on paper by Maris, as well as several paintings and drawings by other artists of his circle. In 1908 Mr. Frick sold *The Bridge,* but, evidently regretting his decision, he bought back the painting in 1914. The Hague School was to have a formative influence on the young Van Gogh and, somewhat later, on Mondrian.

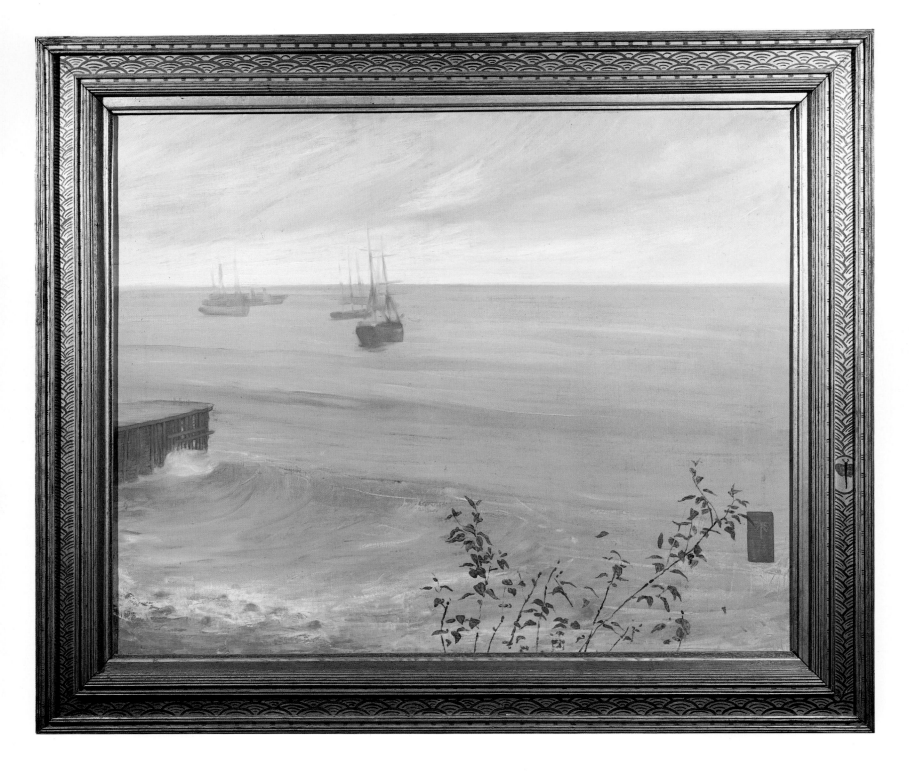

JAMES ABBOTT McNEILL WHISTLER
1834–1903

Born in Lowell, Massachusetts, Whistler spent part of his childhood and most of his mature life in Europe. After three years at the West Point Military Academy, he went in 1855 to London and then Paris, where he worked for two years in Gleyre's studio and later became an associate of Fantin-Latour, Legros, and Courbet. He exhibited in the Salon des Refusés in 1863, and throughout his career he associated with his more experimental contemporaries. Whistler's colorful personality and advanced style of painting involved him in many lively controversies.

THE OCEAN

Painted in 1866. Oil on canvas
31 3/4 × 40 1/8 in. (80.7 × 101.9 cm.)
Acquired in 1914

This painting, exhibited in London in 1892 as *Symphony in Grey and Green: The Ocean,* was one of several seascapes Whistler painted in 1866 during a visit to Valparaiso, Chile. The influence of Japanese prints on his work is apparent here in the high horizon, the decorative arrangement of bamboo sprays, and the butterfly monogram that appears both on the picture and on the frame, which was of Whistler's own design.

JAMES ABBOTT McNEILL WHISTLER

ROBERT, COMTE DE MONTESQUIOU-FEZENSAC

Painted 1891–92. Oil on canvas
82 1/8 × 36 1/8 in. (208.6 × 91.8 cm.)
Acquired in 1914

One of the last large paintings that Whistler
finished was this minimalist portrait of Robert,
Comte de Montesquiou-Fezensac (1855–1921),
a prominent figure in the social, artistic, and
intellectual world of Paris around 1900.
Although he published numerous volumes of
poetry, Montesquiou is probably best remem-
bered as one of the models for the character of
the Baron de Charlus in Proust's *Remembrance of
Things Past.*

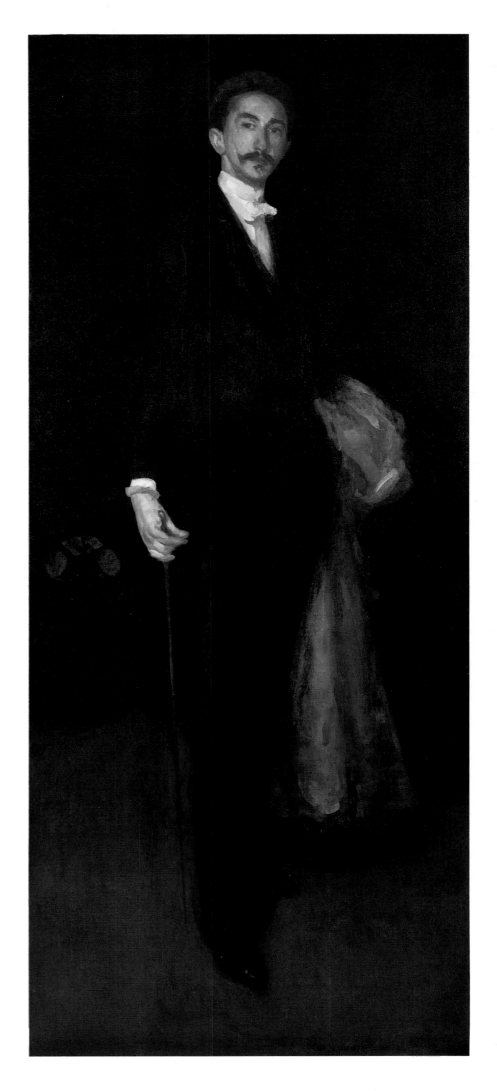

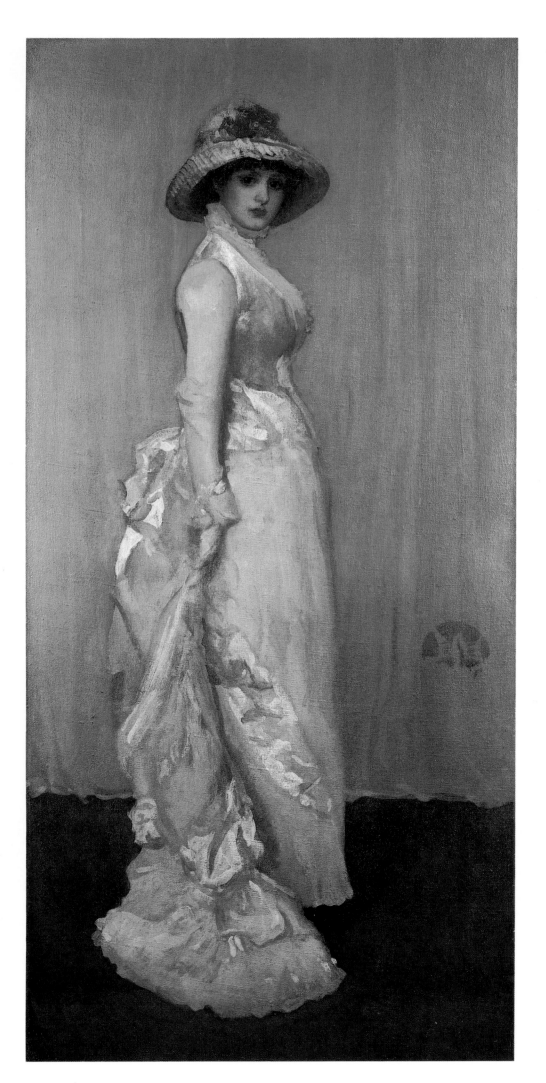

JAMES ABBOTT McNEILL WHISTLER

LADY MEUX *(left)*

Painted in 1881. Oil on canvas
76 1/4 × 36 5/8 in. (193.7 × 93 cm.)
Acquired in 1918

Valerie Susie Reece (c. 1856–1910) was the daughter of a stage carpenter at the Drury Lane Theatre but was brought up as an adopted child by Charles Langdon. In 1878 she married Henry Bruce Meux, a brewer who later succeeded to the Meux baronetcy. Although sometimes described as an actress, she seems to have been on the stage for only a single season, when she was very young. She once created a sensation by appearing at a hunt riding an elephant. This is the second of three portraits Whistler made of her and was originally called *Harmony in Pink and Grey.* The first portrait, *Arrangement in Black and White,* is in the Honolulu Academy of Arts, and the third apparently was destroyed by the artist before it was completed, as the result of a quarrel with the subject.

JAMES ABBOTT McNEILL WHISTLER

MRS. FREDERICK R. LEYLAND

Painted 1872–73. Oil on canvas
77 1/8 × 40 1/4 in. (195.9 × 102.2 cm.)
Acquired in 1916

Frances Dawson (1834–1910) was the wife of Frederick R. Leyland, a Liverpool shipowner, who was one of Whistler's chief patrons before they quarreled bitterly. The artist painted the famous Peacock Room, now in the Freer Gallery, Washington, for the Leylands' London home. The Frick portrait, originally entitled *Symphony in Flesh Colour and Pink,* apparently was never completely finished. Most of the surviving preparatory drawings are studies for Mrs. Leyland's gown, which Whistler designed.

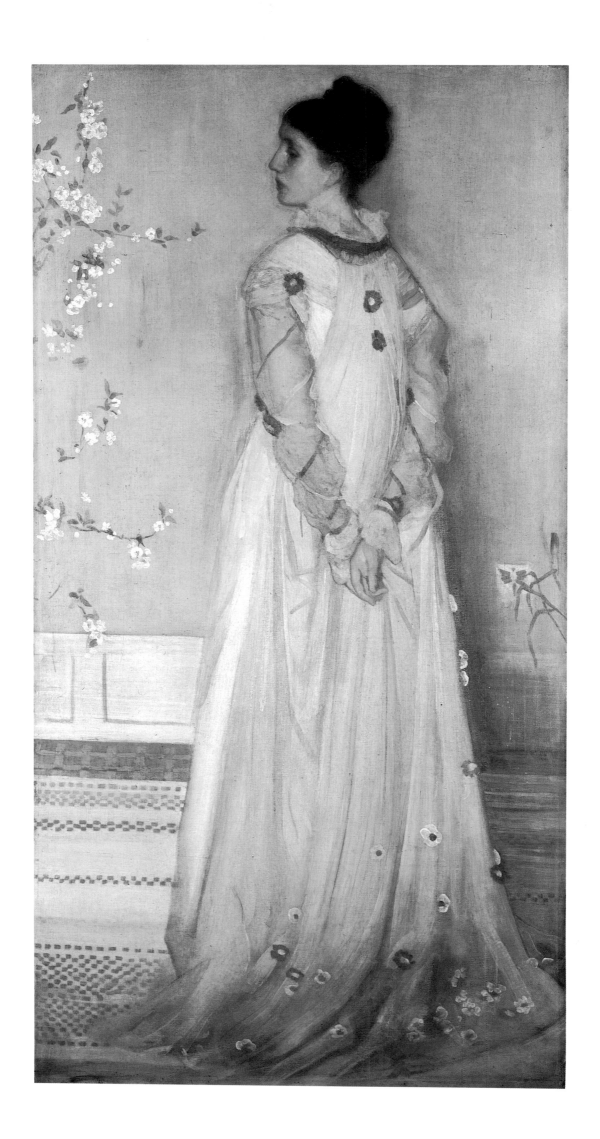

INDEX OF ARTISTS

ACKNOWLEDGMENTS

The following members of The Frick Collection staff assisted in the preparation of this book: Adrian Anderson, Robert Goldsmith, Martha Hackley, John Horvath, Fred Jakob, Karen Minkoff, Madeleine Skelley, Timothy Transillo, and Louise White.

Further information concerning all of the paintings in The Frick Collection can be found in Volumes I and II of *The Frick Collection: An Illustrated Catalogue* (1968) and in *The Frick Collection: Handbook of Paintings* (latest edition, 1990).